DRACOPEDIA
THE BESTIARY

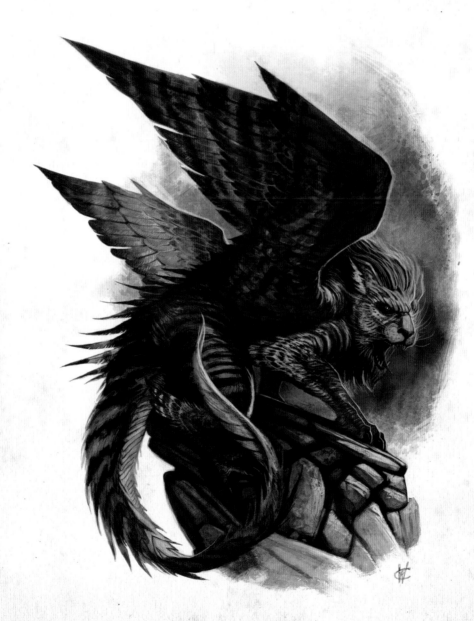

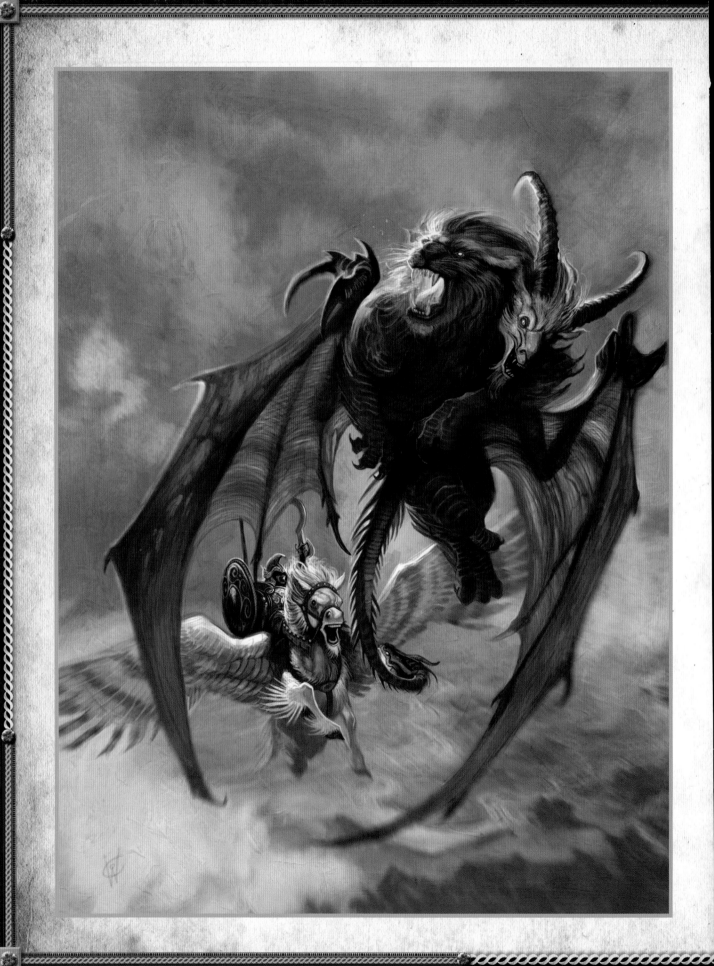

DRACOPEDIA
THE BESTIARY

An Artist's Guide to Creating Mythical Creatures

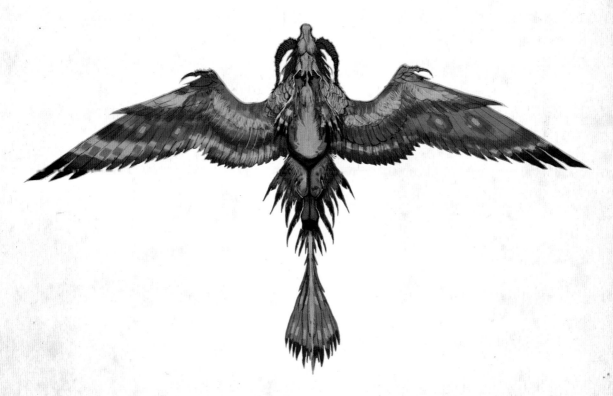

William O'Connor

IMPACT
CINCINNATI, OHIO
impact-books.com

TABLE OF CONTENTS

Introduction 6
Drawing Tools 8
Reference 9
Digital Tools 10
Animal Anatomy 12

ALPHYN 14

BURAQ 20

CHIMERA 26

DRAGON TURTLE 32

ENFIELD 36

FREYBUG 40

GRIFFIN 44

HIPPOGRIFF 52

IMP 58

JOROGUMO 62

KRAKEN 66

LEVIATHAN 72

MANTICORE 78

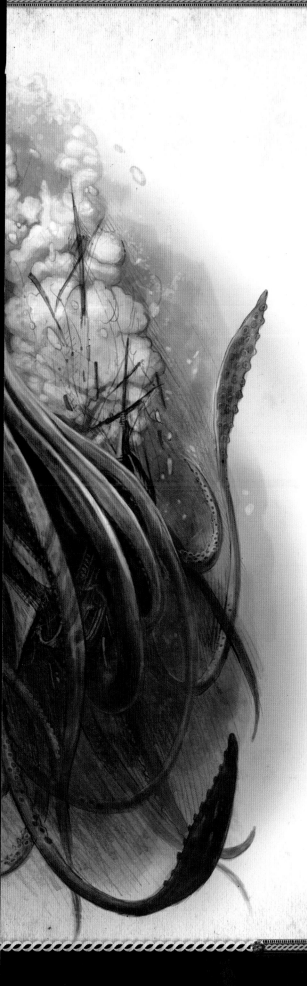

Naga 84

Owlursus 88

Pegasus 94

Questing Beast 98

Roc 104

Shedu 110

Tarasque 116

Unicorn 120

Vampire 126

Waterhorse 132

Xenobeast 138

Yeti 142

Zburator 148

Index *156*
About the Author *158*

INTRODUCTION

 FOR MILLENNIA HISTORIANS, ARTISTS AND SCIENTISTS have chronicled their ideas and discoveries of mythological and magical monsters in encyclopedias known as *bestiaries*. From Asia to America, Japan to the jungles of South Africa, the vast menagerie of exotic and legendary creatures has populated the imaginations of all cultures for centuries. Early bestiaries by classical authors like Aristotle and Herodotus included a wide range of exotic animals such as giraffes, leopards, elephants and rhinoceros. By the Middle Ages the bestiary had become very popular chronicling the mystical creatures of legend like the unicorn, dragon and chimera. Beautifully illustrated and fantastically detailed, these compendiums of magical monsters captivated the medieval mind. By the seventeenth century, however, the dawn of the Age of Reason and the scientific method abandoned the speculative nature of the bestiary for the more empirical study of botany and zoology. In 1735 Carl Linnaeus established the Linnaean taxonomic system in his writing *Systema Naturae*, which categorized the animals of the world into a codified system still in use today.

Dracopedia: The Bestiary is a modern reimagining of the ancient bestiary for contemporary artists, an A-to-Z guide to both the well-known and the rare animals of the legendary world.

THE CRYPTOZOOLOGY AND MORPHOLOGY OF MYTHICAL ANIMALS

The branch of science that is dedicated to the study of legendary or mythological animals known as *cryptids* is called *cryptozoology*. For the past century this science has gained in popularity and mainstream acceptance.

Morphology is a biology term denoting the study of the forms of animals and plants. The study of morphology is integral to the conception of mythological and legendary creatures. Morphology is just a big word for understanding why animals look the way they do, and why and how animals evolve into the forms we know.

By understanding the animals that exist in the real world, we artists can use the science of morphology to relate the form and function of animals to the design of the creatures that exist in our imaginations. Simply using the historical artistic reference of bestiaries and ancient art, we can begin to reverse-engineer the creatures of legend into realistic and believable animals using morphology. To that end the creatures in this book have been designed to look as if they have evolved in a natural manner on Earth. That means that all of the designs are based upon living creatures that are well known. Although you may design more exotic creatures for your own projects, the animals within are designed to look like they came from our planet, not an alien world or fantasy realm. With each beast, we discuss the important aspects of its morphology such as where the animal lives and what it eats.

The answers to these questions will help you conceptualize and design the morphology of the creatures. For example, fangs are unlikely on an animal that eats plants, and an animal with long legs for running probably won't live in a dense jungle. An animal that lives in the water might require webbed feet, and one that lives in the mountains could benefit from small cloven hooves for climbing rocks agilely. A creature that eats big animals needs powerful claws and teeth for grappling and clawing, while a creature that eats small animals may need only small teeth and no claws. Creatures living in environments where there may be fierce competition from other animals might require armor plating for protection. Whatever the creature, the understanding of morphology is decided by form following function. Try to think about these things as you read forward and conceive beasts of your own.

William O'Connor

Wargriffin
Digital
20" × 14" (51cm × 36cm)

6

DRAWING TOOLS

What materials you use to create your own mythological creatures are entirely up to you. My hope is that *Dracopedia: The Bestiary* can be used as a reference by artists of all disciplines. For my own purposes and for the demonstrations, all of the images in this bestiary are produced using pencil sketches, then colored digitally on a computer using editing software such as Adobe Photoshop®.

Sketchbooks
Here are some of the sketchbooks and drawing materials used to create the artwork in this bestiary. I believe the sketchbook is the artist's best tool. This is where the real creativity happens.

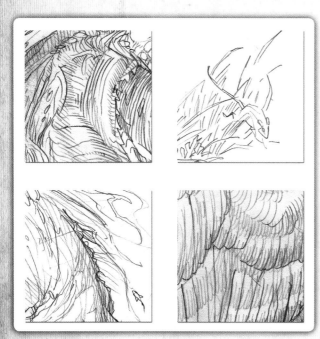

Experiment With Lines and Mark-Making
These are some examples of the kinds of marks and lines that can be made with a pencil. Experiment with different pencil weights to find a hardness that suits you. They usually range from 9B (softest) to 9H (hardest). I like HB, which is right in the middle. The softer the lead, the darker the marks the pencil can make.

Any Medium Will Do
Any medium will work to create the creatures of your bestiary. Experiment with a range of materials to find which types work best for you, such as colored pencils, markers, pens, paints and chalk.

REFERENCE

When creating animals, nothing is more important than having good reference—you can never have too much of it. The Internet, natural history books and animal models are invaluable sources to the fantasy artist. If you have a zoo or a natural history museum near you, there is never a substitute for working from life.

Animal Photographs
The Internet is also a great place to search for animal images. Organize your digital files by subject into easily accessible folders.

Books
Books about animals, both real and imaginary, are a great resource. Hit the library or build a collection from used book shops, garage sales or discounted online sellers.

3-D Animal Models
Here are a few animal models I purchased at toy shops or had sculpted with clay. When lit, they are a great reference for understanding form and anatomy.

ONLINE BONUS MATERIAL

Visit **impact-books.com/bestiary** for a free step-by-step feature of this cast bronze Dragon Turtle sculpture by fantasy sculptor and fellow artist Christina Yoder.

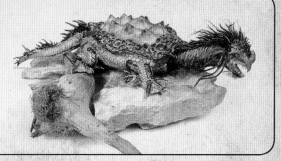

DIGITAL TOOLS

I prefer to paint digitally because it's easy and efficient. All of the paintings in this book are digitally painted in Adobe Photoshop using a Wacom tablet. Digital painting is no different from traditional painting and is less expensive over the long run than traditional mediums. They both require practice and experimentation to get results. I've been painting for almost thirty years, so don't expect overnight results. Patience is an artist's most important skill.

My Brush Menu and Custom Brushes
I like to keep my brushes in a pull-down so they are not in my way while I'm working. I also like to minimize the number of windows I have open. Use the Tab button to hide your tools while working.

Photoshop provides myriad brush shapes that you can use as is or alter. Shown here are some of my custom brush sets. Experiment with a variety of brush dynamics in your painting. You will quickly discover your favorites.

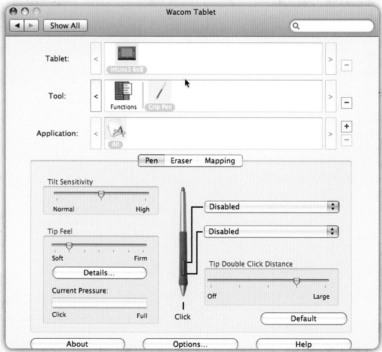

Tablet Preferences
This screenshot shows the preferences for my pen tablet—I have most of the function buttons turned off. This allows me to hold the brush more comfortably.

Color Chart

This chart shows the interrelationship of colors. You will find these terms used throughout the demonstrations. Hue is an object's appearance on the ultraviolet spectrum and is commonly synonymous with color. Tint is any color plus white; shade is any color plus black—the value of a form. Value is the measure of an object's darkness or lightness. Tone is the variation of a color within a painting. Tone is similar to shading, but in reference to color (for example, a tonal painting uses variation of one color to establish forms).

Color Picker

When digitally coloring, the interrelationships of colors can be easily manipulated with near infinite variety.

Color Palette

My Photoshop palette is extensive and well organized, allowing me to quickly grab colors as I paint and not have to spend too much time mixing colors. I organize my custom swatches horizontally from light to dark.

ANIMAL ANATOMY

Scan these animal templates into
your computer or trace directly
onto paper to use in your artwork.
Use your imagination to mix
and match these simple designs
for a variety of morphology
combinations.

Anatomy of a Canine

Anatomy of an Equine

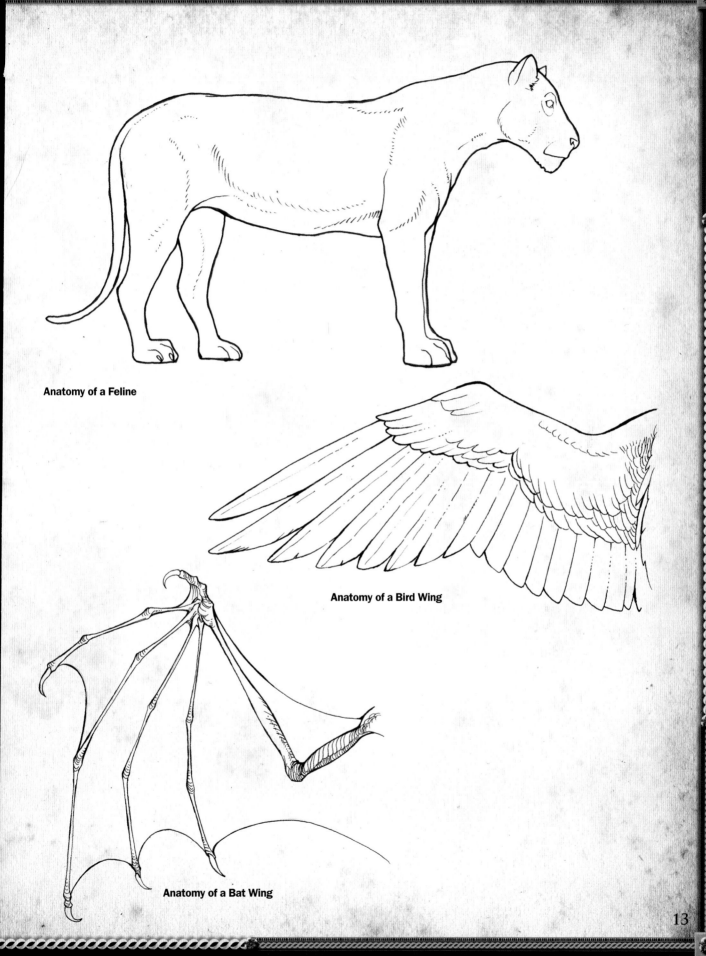

Anatomy of a Feline

Anatomy of a Bird Wing

Anatomy of a Bat Wing

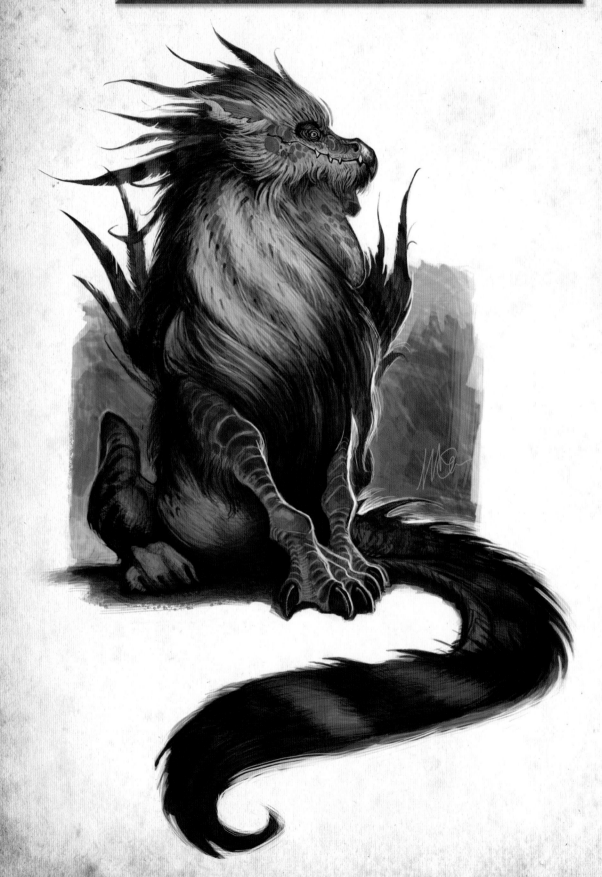

HISTORY

The *alphyn* combines the features of dragons, wolves and lions, and was commonly used in medieval heraldry. Depicted in medieval bestiaries as a dragon-lion or dire-wolf, the alphyn is one of the more esoteric mythological creatures in the bestiary. Perhaps related to the drake (*Draco drakus*), this beast has been depicted in many different forms as a predatory animal that uses speed and strength to hunt its prey. The alphyn might live in an open savannah or grasslands like its *panthera* cousins—lions, tigers and leopards.

The alphyn is commonly depicted with the forelegs of a dragon and the elegant flowing mane and tail of a lion. Though thought to have gone extinct thousands of years ago in response to conflict with other apex predators such as drakes and lions, the alphyn lived on in the bestiaries of the Middle Ages as one of the most beautiful of cryptids.

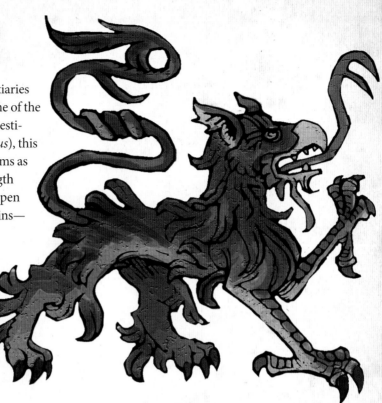

Woodcut of Alphyn, Circa 15th Century Germany

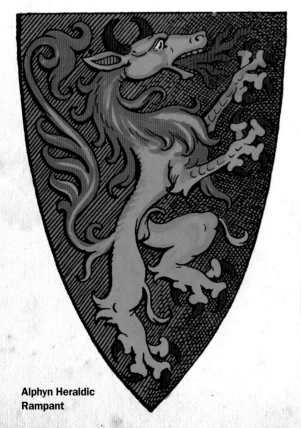

Alphyn Heraldic Rampant

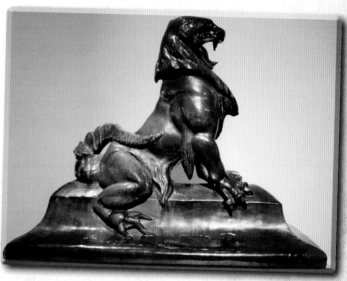

Lizard (1887) by French sculptor Emmanuel Frémiet, Collection of Metropolitan Museum of Art in New York City

15

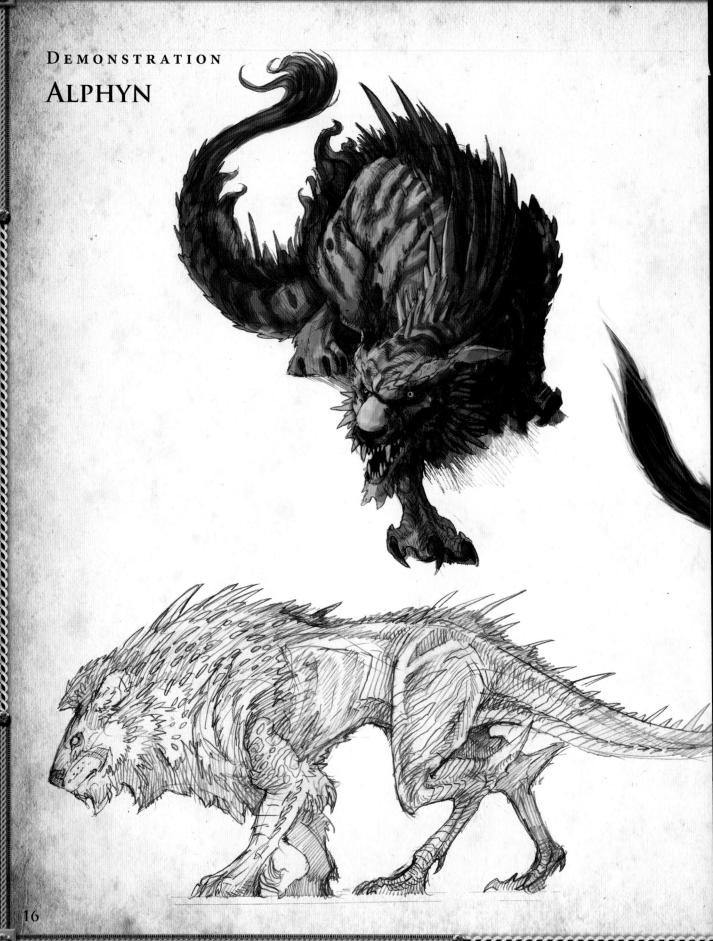

DEMONSTRATION
ALPHYN

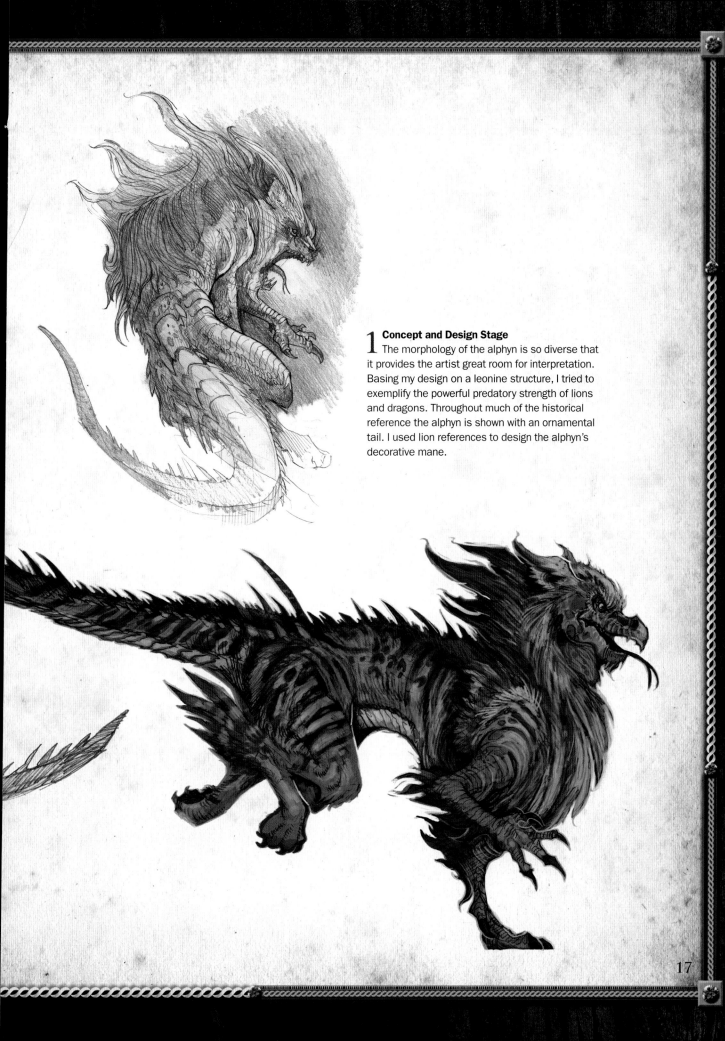

1 Concept and Design Stage

The morphology of the alphyn is so diverse that it provides the artist great room for interpretation. Basing my design on a leonine structure, I tried to exemplify the powerful predatory strength of lions and dragons. Throughout much of the historical reference the alphyn is shown with an ornamental tail. I used lion references to design the alphyn's decorative mane.

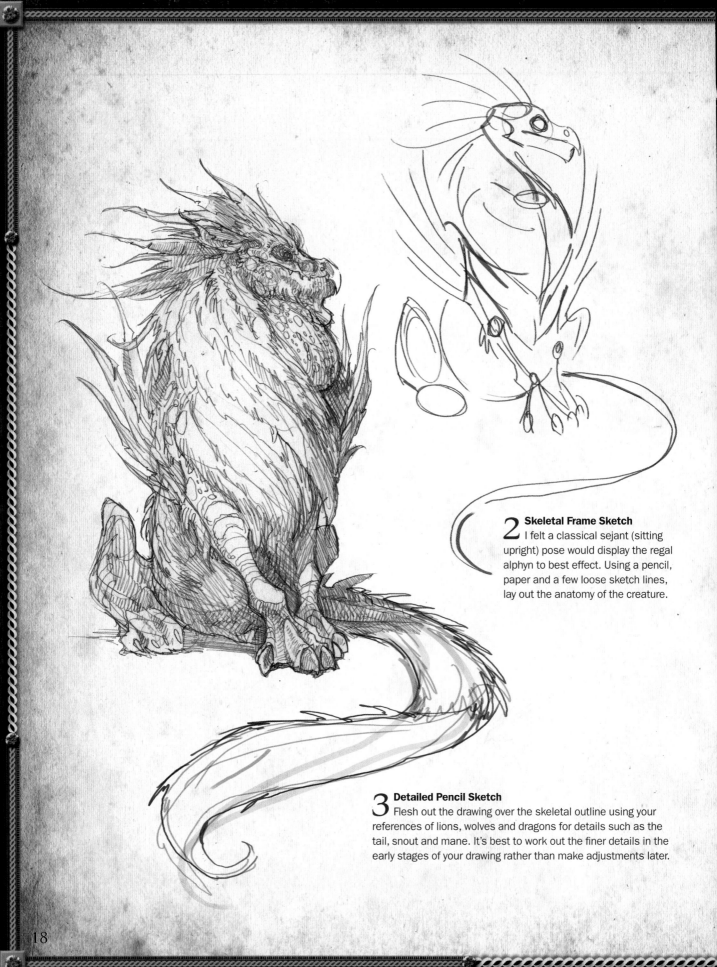

2 Skeletal Frame Sketch

I felt a classical sejant (sitting upright) pose would display the regal alphyn to best effect. Using a pencil, paper and a few loose sketch lines, lay out the anatomy of the creature.

3 Detailed Pencil Sketch

Flesh out the drawing over the skeletal outline using your references of lions, wolves and dragons for details such as the tail, snout and mane. It's best to work out the finer details in the early stages of your drawing rather than make adjustments later.

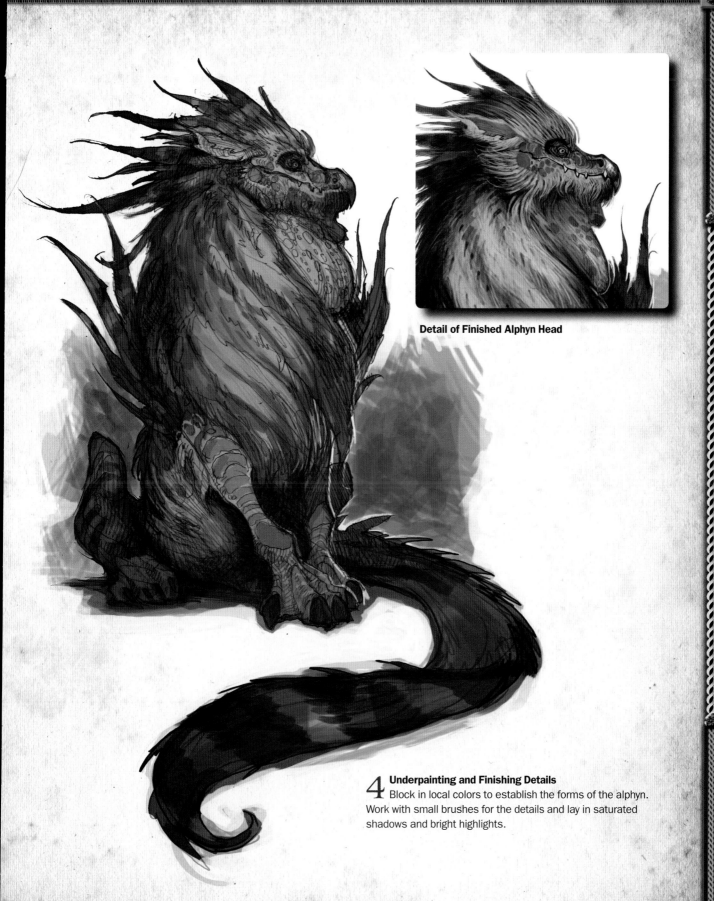

Detail of Finished Alphyn Head

4 **Underpainting and Finishing Details**
Block in local colors to establish the forms of the alphyn.
Work with small brushes for the details and lay in saturated
shadows and bright highlights.

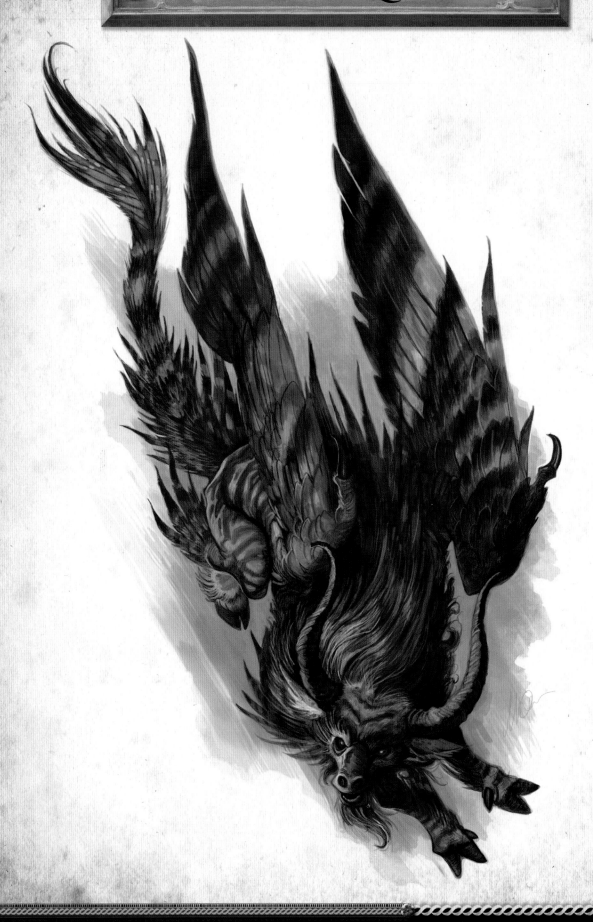

HISTORY

One of the rarest and most resplendent creatures of folklore and legend is the *buraq*, also referred to as a lamassu. Historical depictions of the buraq range widely in appearance. According to Persian legend and theology, the buraq was a celestial steed used by the prophets to travel great distances with extraordinary speed (see also *pegasus* and *hippogriff*). Sometimes depicted as a horse or a bull with a long peacock tail, brightly colored wings and the beautiful face of a woman with flowing dark hair and a crown, this singular animal would have been a sight to behold. The buraq is often confused with the *shedu*; both creatures were derived from Persian mythology.

European Heraldic Buraq

The buraq is similar to the Bull of Heaven, another divine bovine of Persian mythology. In the *Epic of Gilgamesh*, the gods angered by King Gilgamesh sent the terrible Bull of Heaven to terrorize him, but the bull was slain by Gilgamesh and his companion Enkidu. The gods then fatally punished Enkidu as retribution for killing the bull.

In the Christian faith the imagery of the winged bull played a large part in the iconography of the early church. It was the icon used to illustrate the apostle Luke.

The buraq still holds importance in the Middle East as the namesake of Buraq Air Transport headquartered in Libya. Like the pegasus in the West, the buraq represents divine transport to heaven for nobility.

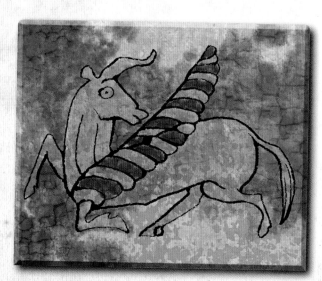

Mesopotamian Buraq, Circa 5th Century B.C.

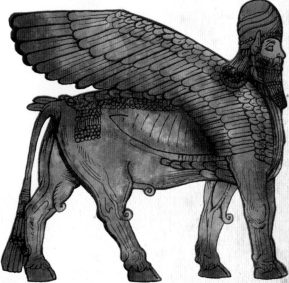

Buraq Depicted in a Persian Sculpture

DEMONSTRATION
BURAQ

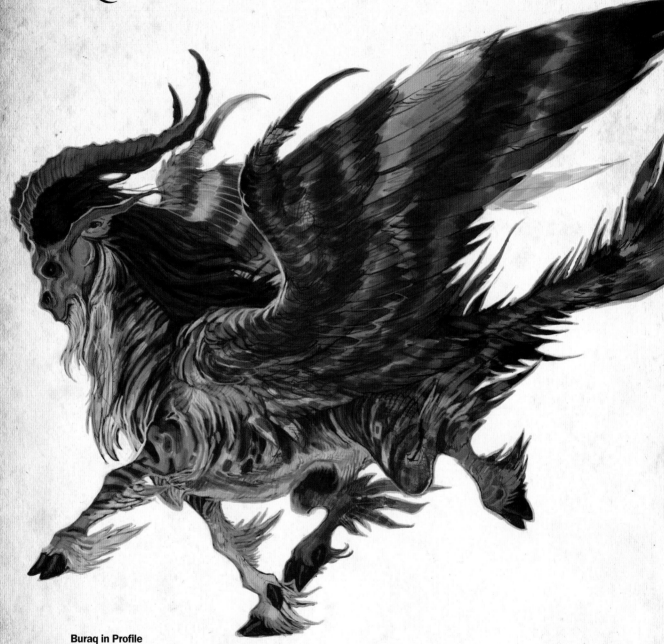

Buraq in Profile

1 Concept and Design Stage

Conceptualizing the morphology of an animal such as the buraq is unique. My first intention was to remove the human face. The long, flowing mane and the crown interpreted as a magnificent set of horns was my solution to these difficult characteristics. I opted for a goat-like face to blend with the horns and make anthropomorphizing the beast a bit easier. Creating long elegant plumage of bright colors with bold markings rounded out the concept. I obtained significant reference working from goats, horses, peacocks and bulls.

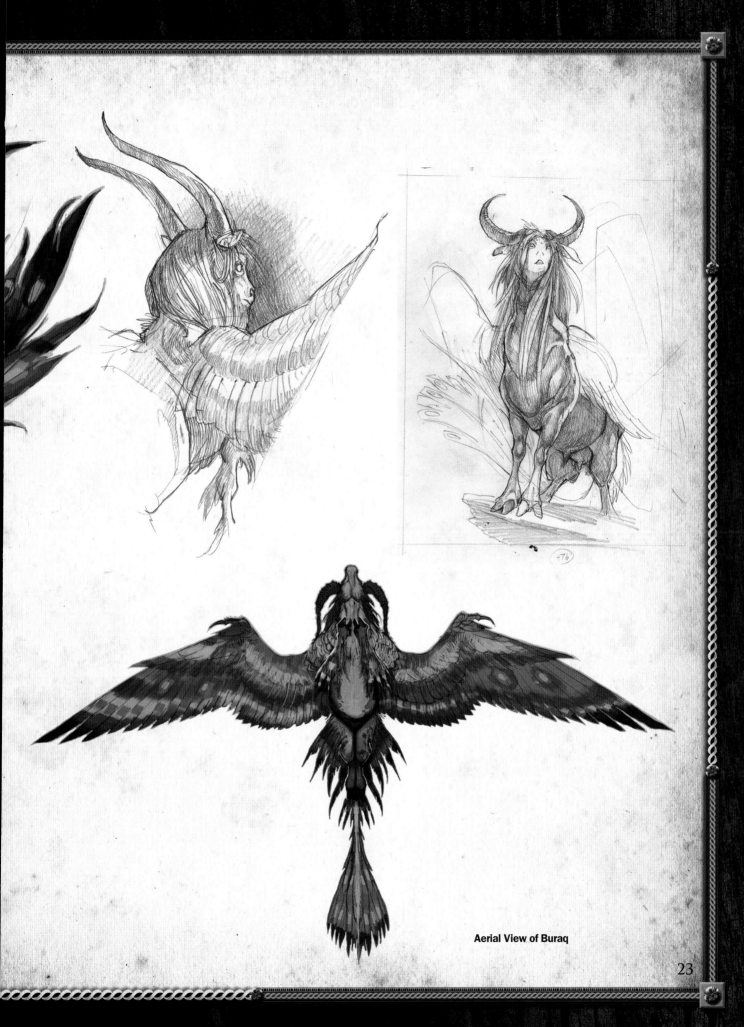

Aerial View of Buraq

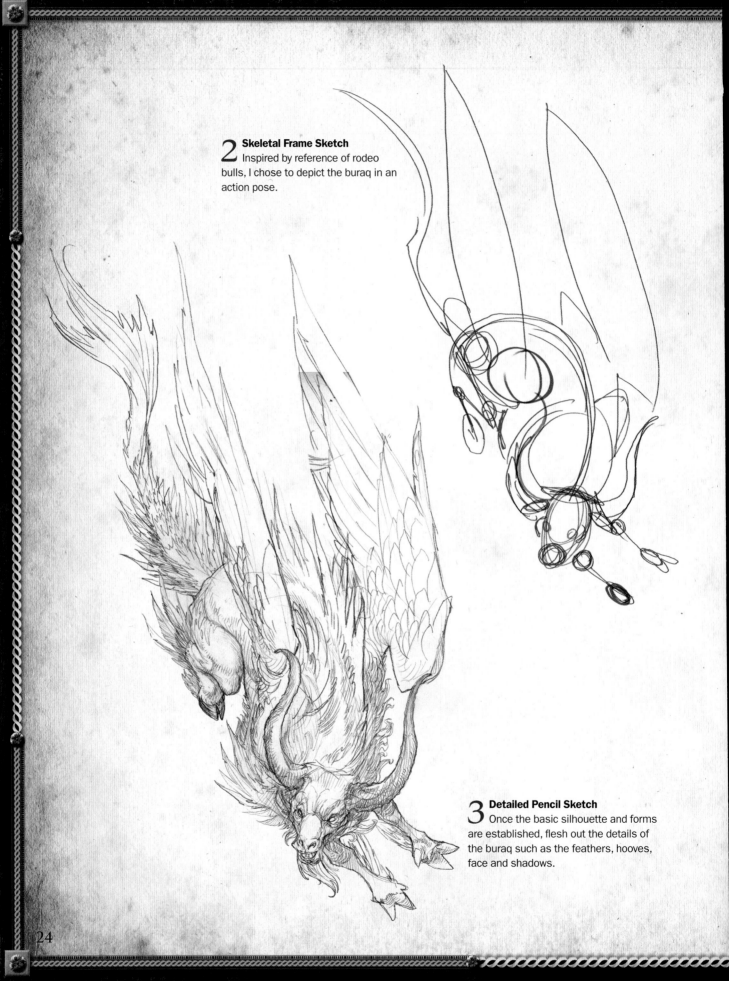

2 Skeletal Frame Sketch
Inspired by reference of rodeo bulls, I chose to depict the buraq in an action pose.

3 Detailed Pencil Sketch
Once the basic silhouette and forms are established, flesh out the details of the buraq such as the feathers, hooves, face and shadows.

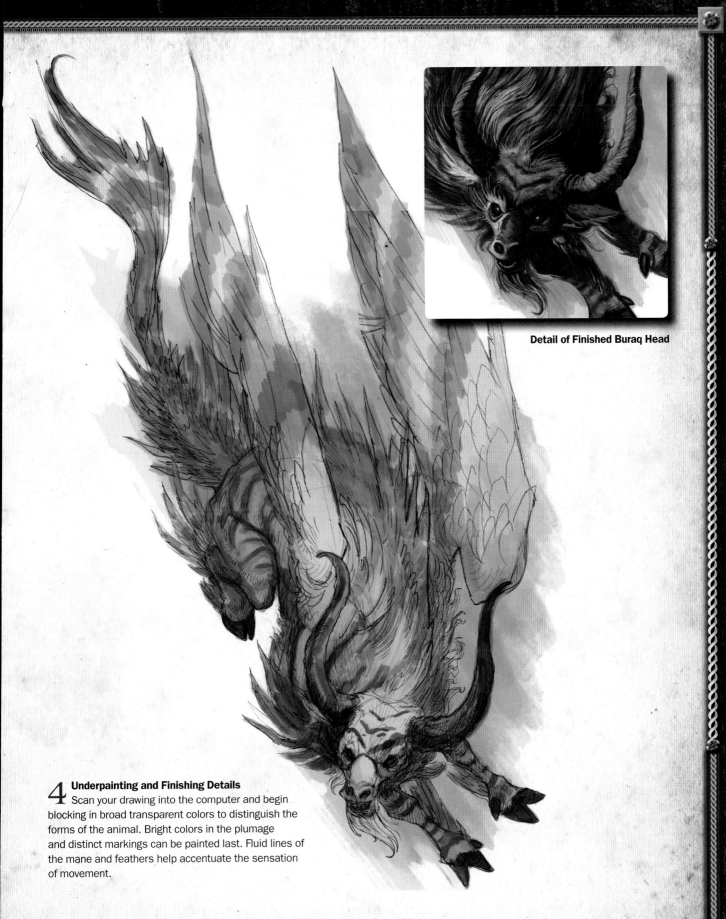

Detail of Finished Buraq Head

4 **Underpainting and Finishing Details**
Scan your drawing into the computer and begin blocking in broad transparent colors to distinguish the forms of the animal. Bright colors in the plumage and distinct markings can be painted last. Fluid lines of the mane and feathers help accentuate the sensation of movement.

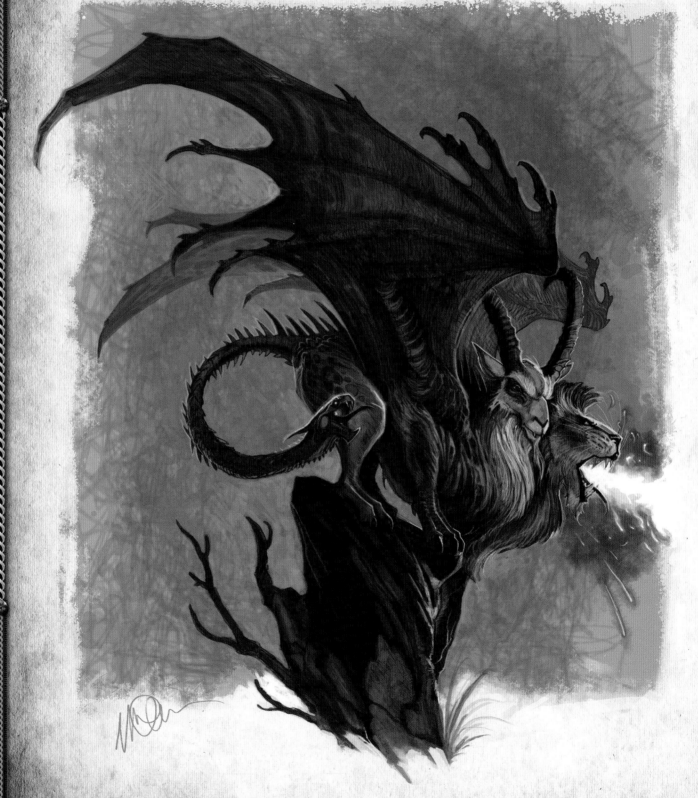

HISTORY

Since the time of antiquity the fire-breathing *chimera* (*Chimaera*) has existed in legend and lore. In ancient Greek mythology the chimera was related to the Hydra and the Cerberus and eventually came to represent any fantastical creature comprised of the features of various animals including goats, lions and snakes. Traditionally the classic chimera has two heads—a goat's and a lion's—and features the tail of a serpent. Mentioned in the Greek poem *Theogony* and Homer's *Iliad*, the chimera is one of the great classical monsters. According to Greek mythology, the chimera was the offspring of Typhon and Echidna, and was eventually destroyed by the heroic Bellerophon riding on Pegasus.

In modern biology *chimerism* is a genetic mutation where an organism (such as an animal or plant) contains cells, tissues or DNA of more than one origin formed by processes such as fusion or mutation. This scientific occurrence is indeed named after the classical monster.

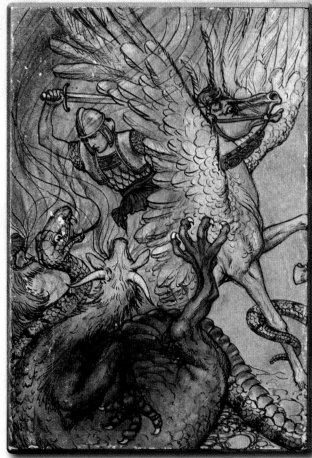

Bellerophon vs. Chimera (1913) by Milo Winter

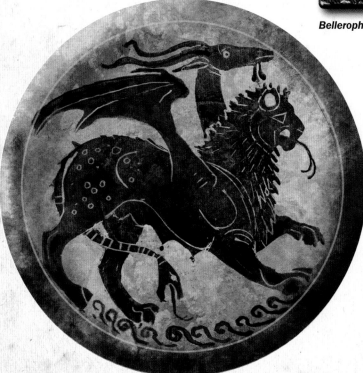

Depiction of a Chimera on Greek Pottery, Circa 500 B.C.

CHIMERA

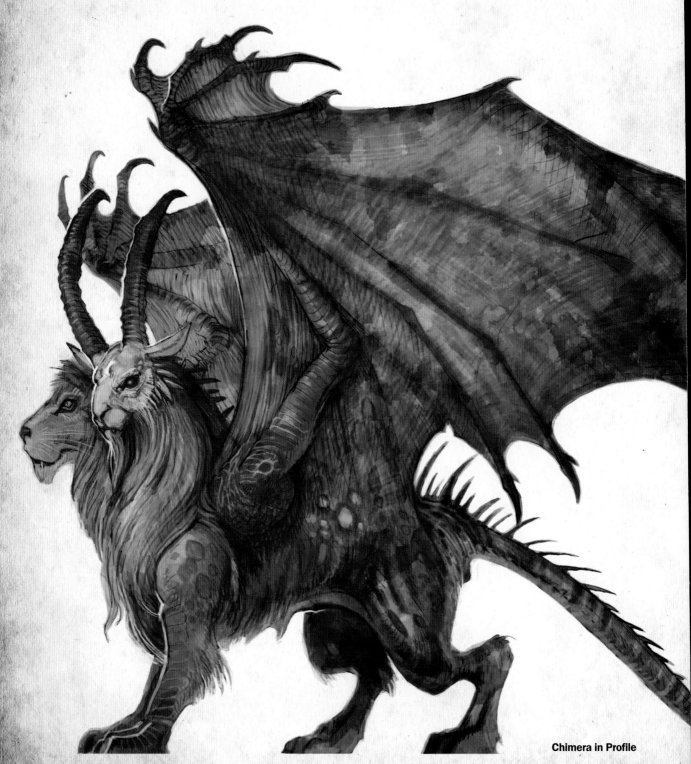

Chimera in Profile

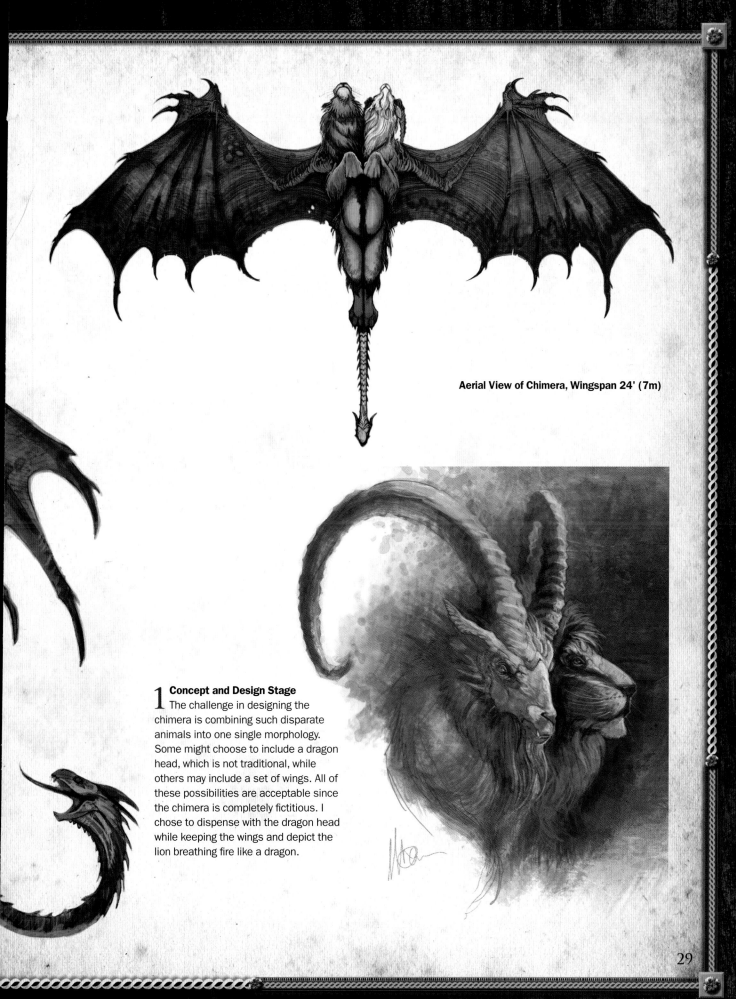

Aerial View of Chimera, Wingspan 24' (7m)

1 Concept and Design Stage
The challenge in designing the chimera is combining such disparate animals into one single morphology. Some might choose to include a dragon head, which is not traditional, while others may include a set of wings. All of these possibilities are acceptable since the chimera is completely fictitious. I chose to dispense with the dragon head while keeping the wings and depict the lion breathing fire like a dragon.

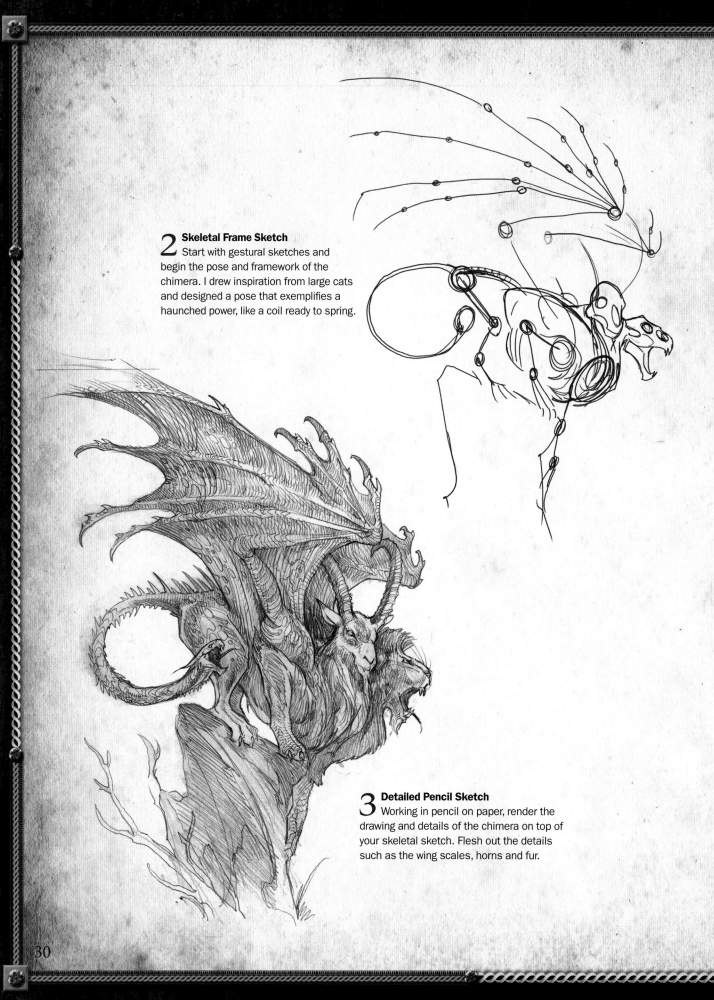

2 Skeletal Frame Sketch
Start with gestural sketches and begin the pose and framework of the chimera. I drew inspiration from large cats and designed a pose that exemplifies a haunched power, like a coil ready to spring.

3 Detailed Pencil Sketch
Working in pencil on paper, render the drawing and details of the chimera on top of your skeletal sketch. Flesh out the details such as the wing scales, horns and fur.

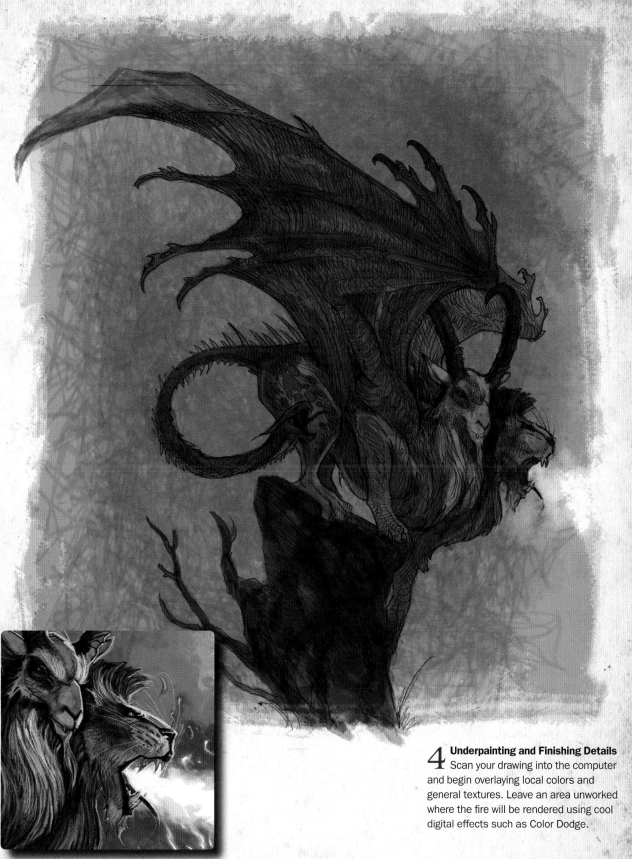

Detail of Finished Chimera Head

4 Underpainting and Finishing Details
Scan your drawing into the computer and begin overlaying local colors and general textures. Leave an area unworked where the fire will be rendered using cool digital effects such as Color Dodge.

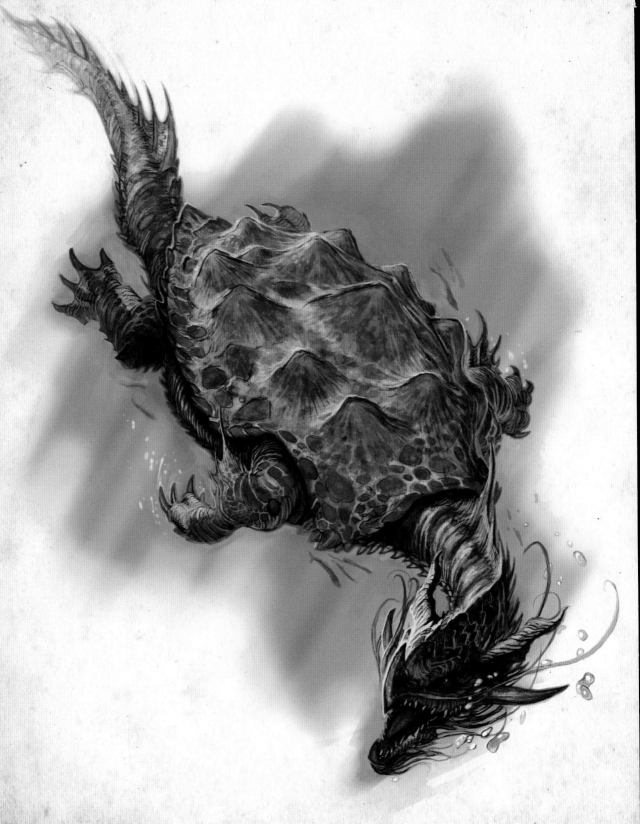

HISTORY

The *dragon turtle*, a creature of magnificent power and fortune, originated from Chinese culture. Despite its name it is in fact not a dragon. Just as the whale shark is not a whale, the dragon turtle is a reptile closely related to the turtle. Able to reach titanic sizes of more than 100 feet (30m) in length, the dragon turtle was a terrible threat to the sea creatures within its range in the southern Pacific Ocean.

At the beginning of its life, a dragon turtle is hatched from one of hundreds of eggs no bigger than a baseball and weighing only a few pounds. Like its marine turtle cousins, the young dragon turtle must survive its youth before growing to its maximum size. The bulk and weight of the dragon turtle limits the animal's ability to move and hunt; therefore, like the snapping turtle (*Chelydra serpentina*), the dragon turtle's environment is the shallow shorelines of seas and rivers. The dragon turtle seeks out unique hunting opportunities, snatching prey such as horses, cows, seals and even whales that come near its serpentine head and snatching beak.

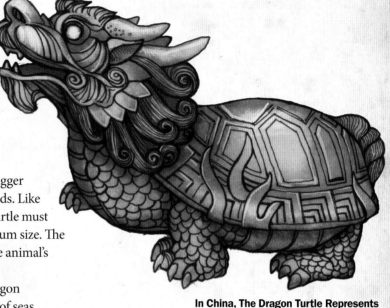

In China, The Dragon Turtle Represents Good Fortune in Business

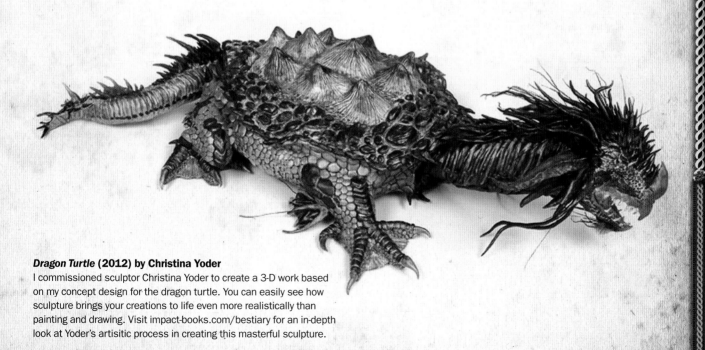

Dragon Turtle (2012) by Christina Yoder
I commissioned sculptor Christina Yoder to create a 3-D work based on my concept design for the dragon turtle. You can easily see how sculpture brings your creations to life even more realistically than painting and drawing. Visit impact-books.com/bestiary for an in-depth look at Yoder's artisitic process in creating this masterful sculpture.

33

1 **Concept and Design Stage**
I found sea turtles and snapping turtles to be excellent references for designing this creature.

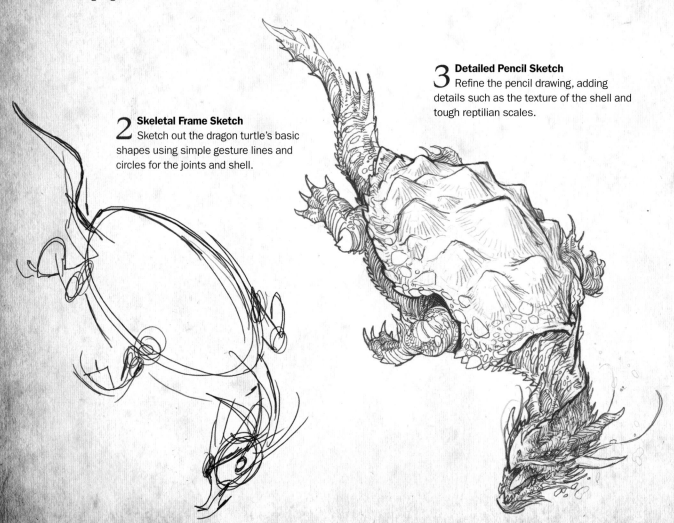

2 **Skeletal Frame Sketch**
Sketch out the dragon turtle's basic shapes using simple gesture lines and circles for the joints and shell.

3 **Detailed Pencil Sketch**
Refine the pencil drawing, adding details such as the texture of the shell and tough reptilian scales.

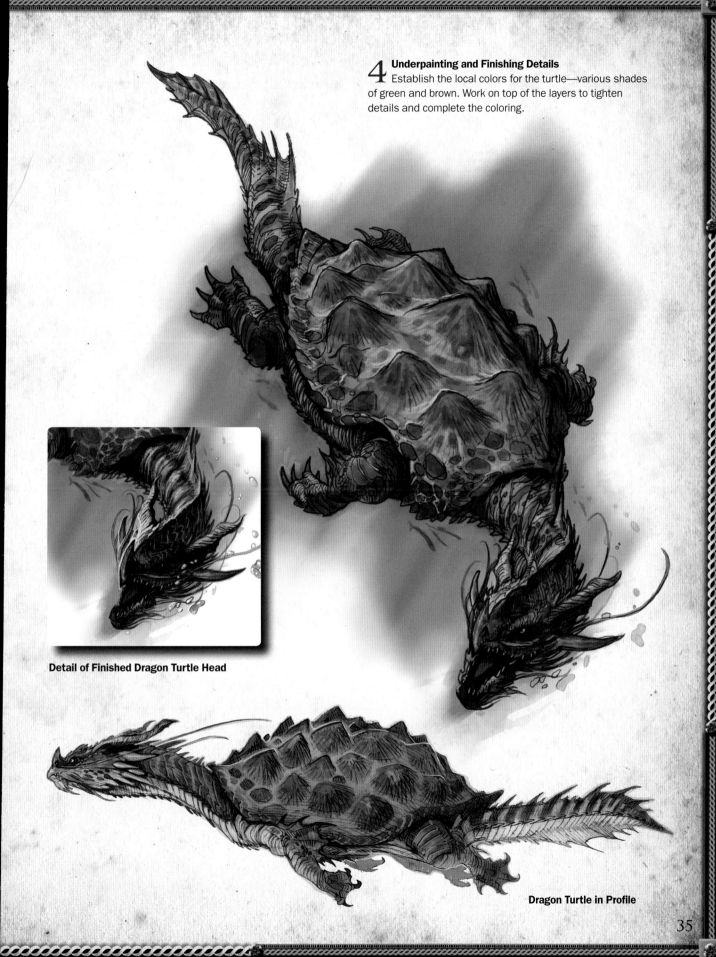

4 Underpainting and Finishing Details
Establish the local colors for the turtle—various shades of green and brown. Work on top of the layers to tighten details and complete the coloring.

Detail of Finished Dragon Turtle Head

Dragon Turtle in Profile

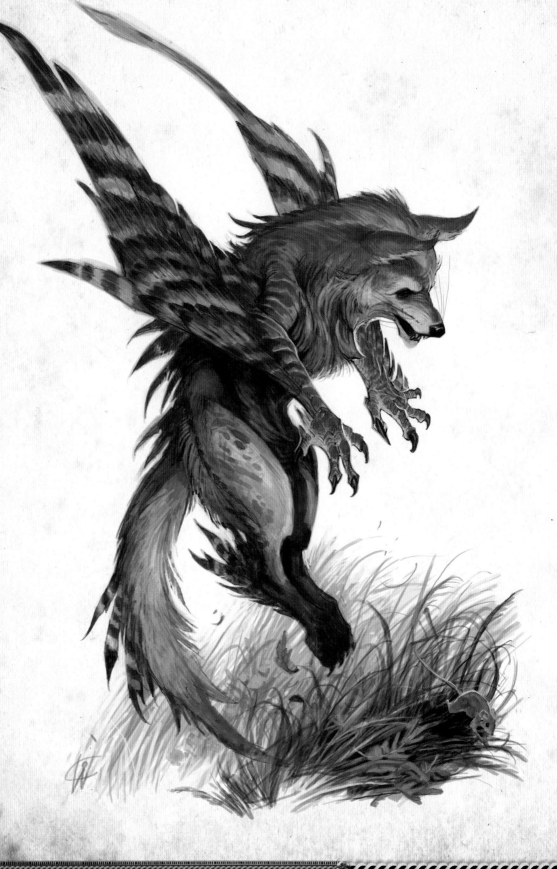

HISTORY

The *enfield* was an extremely rare animal depicted in medieval Europe as a combination of a raptor and a fox. Since the appearance of the enfield was uncommon and restricted to northwestern Europe, it is believed that this animal had a very limited range before going extinct sometime around the sixteenth century.

The enfield covered about the same range as a red fox and had a similar habitat and omnivorous diet of berries, grasses and small animals. Fox hunting and encroachment by other predators strained the populations of the already rare creature, and it is assumed it died out from limited resources. The enfield remains highly regarded for its agility, precise hunting skills and extreme beauty. Humans are known to have kept them as pets in menageries.

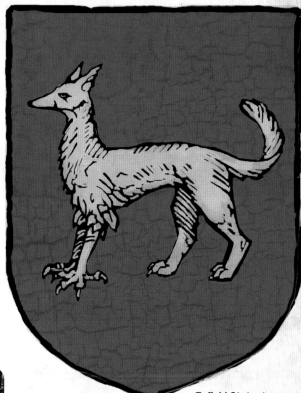

**Enfield Statant on a
Medieval Coat of Arms**

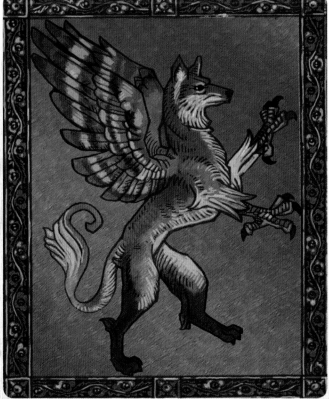

Italian Tapestry Depicting an Enfield, Circa 16th Century

DEMONSTRATION

ENFIELD

1 Concept and Design Stage
The enfield is a pairing of two extremely graceful and beautiful animals, allowing the artist great freedom in determining how to depicted it. Medieval bestiaries and heraldry records depict the enfield both with and without wings. To bridge this gap in reference, I chose to design proto-wings on the enfield inspired by many insects, birds and feathered dinosaurs. The wings of the enfield make it even more agile than its cousin the red fox (*Vulpes vulpes*), allowing it to glide and soar above its prey, swooping in for the kill.

With this design in mind I wanted to display the enfield's extraordinary leaping abilities to best effect, without suggesting that it is in full flight, effectively an *enfield rampant*. The fox has a hunting technique of leaping and coming down from above on its prey, so using online reference of this behavior I extrapolated this balletic movement with accuracy. Placing a small rodent in the corner created a sense of scale in the composition.

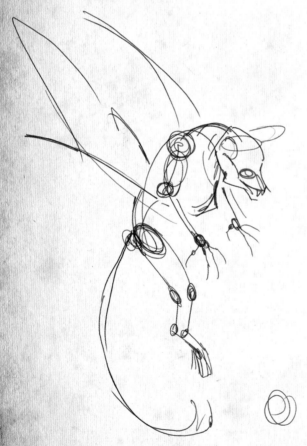

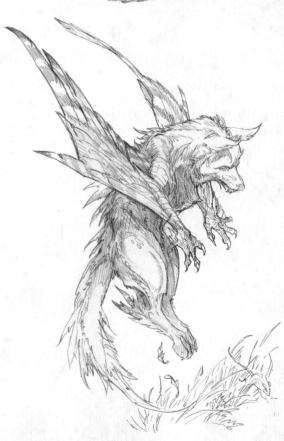

2 Skeletal Frame Sketch
Use simple lines and circles to rough in the wings, body, tail, joints and location of the small rodent.

3 Detailed Pencil Sketch
Sketch over your frame drawing and rough in the details of the wings, fur, tail and grass. Add a couple of leaves and extend his claws to give the impression of him swooping in on his prey.

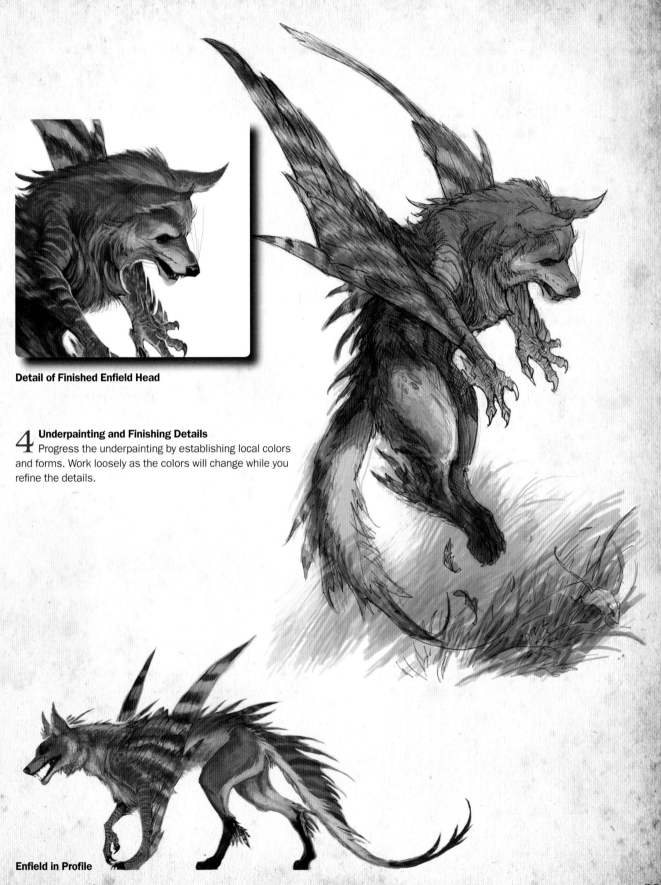

Detail of Finished Enfield Head

4 Underpainting and Finishing Details

Progress the underpainting by establishing local colors and forms. Work loosely as the colors will change while you refine the details.

Enfield in Profile

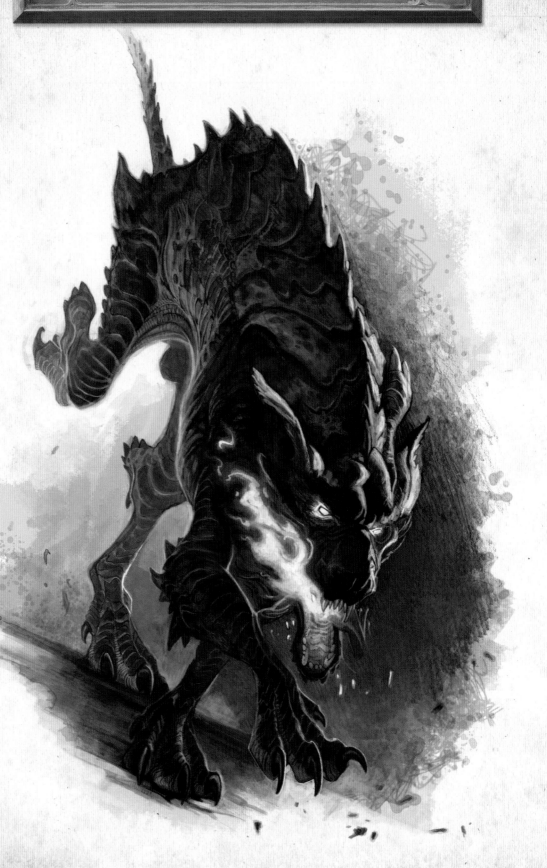

HISTORY

Throughout many cultures and mythos the concept of a demon hound has existed. Sometimes called a *warg* or a *hellhound*, the *freybug* has possessed the human psyche for millennia. The primal fear that humans have toward wild dogs is a perennial horror. In Greek mythology it was Cerebus, the dog who guards the entrance to Hades. In other literature, Arthur Conan Doyle's giant hound in the *Hound of the Baskervilles*, Ray Bradbury's Mechanical Hound in *Fahrenheit 451*, and J.R.R. Tolkien's Warg wolves in *The Lord of the Rings*.

Ever since man first domesticated the dog, stories have been told in every society of the wild packs of ravenous beasts that roam the darkness. In later centuries the wild hound was a scourge to farmers, and ever present in times of war or plague, it fed on the dead much like ravens. The freybug is an English folktale of a spectral black hound that prowled the moors and dragged away travelers.

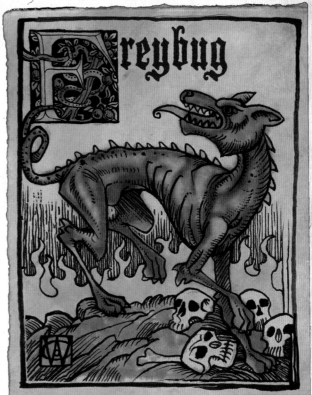

Freybug Depicted in a Medieval Bestiary

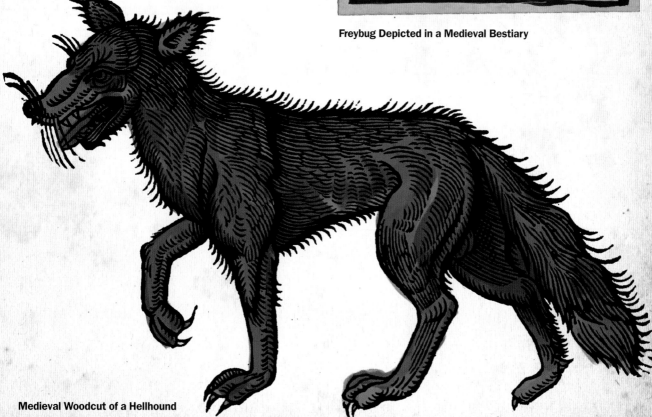

Medieval Woodcut of a Hellhound

41

FREYBUG

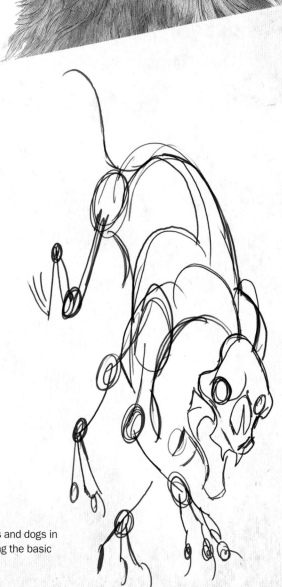

1 Concept and Design Stage

The idea of a demonic wolf has existed for centuries. The human predisposition to fear wild hounds is preternatural. For the concept artist there is a great deal of latitude in designing a freybug or hellhound. Adorn the freybug with spikes, horns and plating to make it more intimidating. I chose to accentuate the aspects of the wolf that are most fearful, the freybug's strength, speed and agility. The freybug's hunting prowess is best depicted by creating a running posture.

2 Skeletal Frame Sketch

Establish the pose using reference of wolves and dogs in action. Use simple circles for the joints connecting the basic shapes with gestural lines.

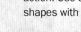

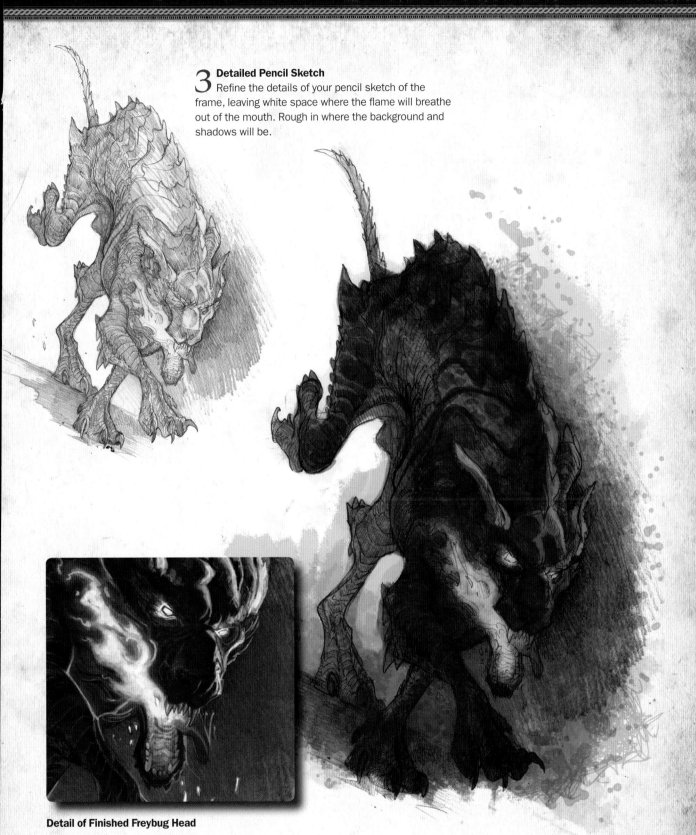

3 Detailed Pencil Sketch

Refine the details of your pencil sketch of the frame, leaving white space where the flame will breathe out of the mouth. Rough in where the background and shadows will be.

Detail of Finished Freybug Head

4 Underpainting and Finishing Details

Establish the local colors and use cool digital effects to make the flames glow. Slowly layer in more details and refine the color to make your beast come alive.

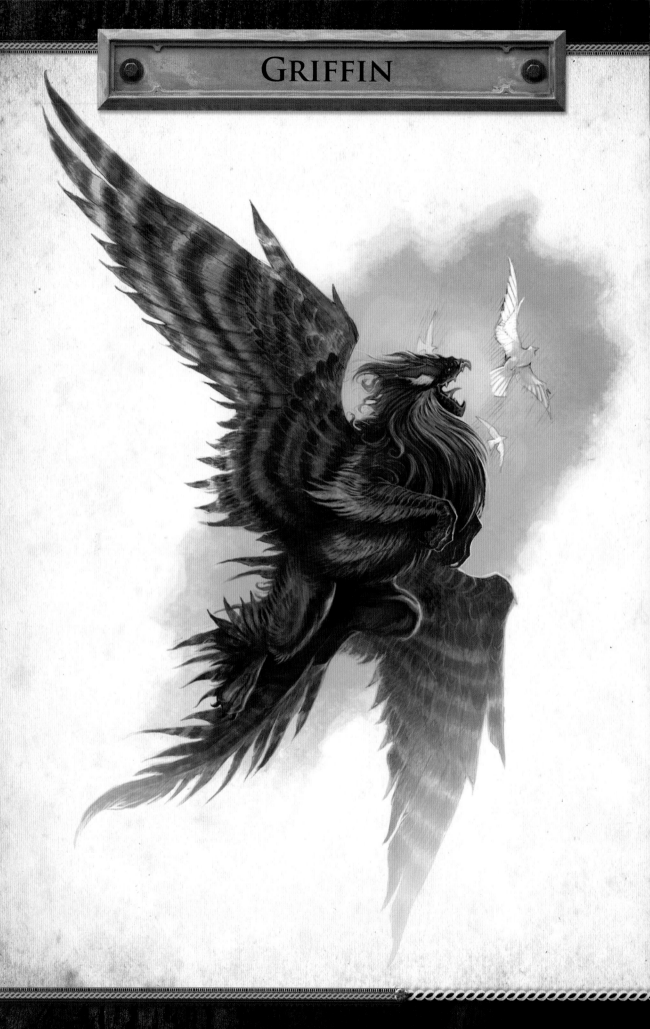

44

HISTORY

The *griffin* is by far one of the most common mythical creatures. It possesses the hind quarters of a lion and the wings and head of an eagle. In classical mythology, medieval bestiaries, heraldry and even contemporary fiction, the griffin is one of history's favorite creatures, perhaps second only to the dragon. Various cultures from the Greeks, Romans, Arabians, Egyptians and throughout medieval Europe, have depicted the griffin in its own way.

A large predatory animal such as the griffin is likely to have come from a mountainous environment where it would be able to hunt fish and game. Although the griffin is depicted as early as the Sythian and Greek legends, it did not become commonplace until the Middle Ages. This leads one to believe that this predatory relative to the hippogriff and the shedu may have been particular to Western Europe, especially the Pyrenees and the Alps. After the Renaissance the griffin seems to have gone extinct around the seventeenth century, possibly due to hunting or competition from other European animals such as the wyvern. In North America, the mythos of the powerful eagle god is pervasive among native tribes who speculate that the European griffin may have had an American cousin.

In Heraldry, Griffins Commonly Depict Courage, Strength and Nobility

Griffin Decoration by Albrëcht Dürer, Circa 15th Century

Medieval Stone Relief Depictions of Griffins

45

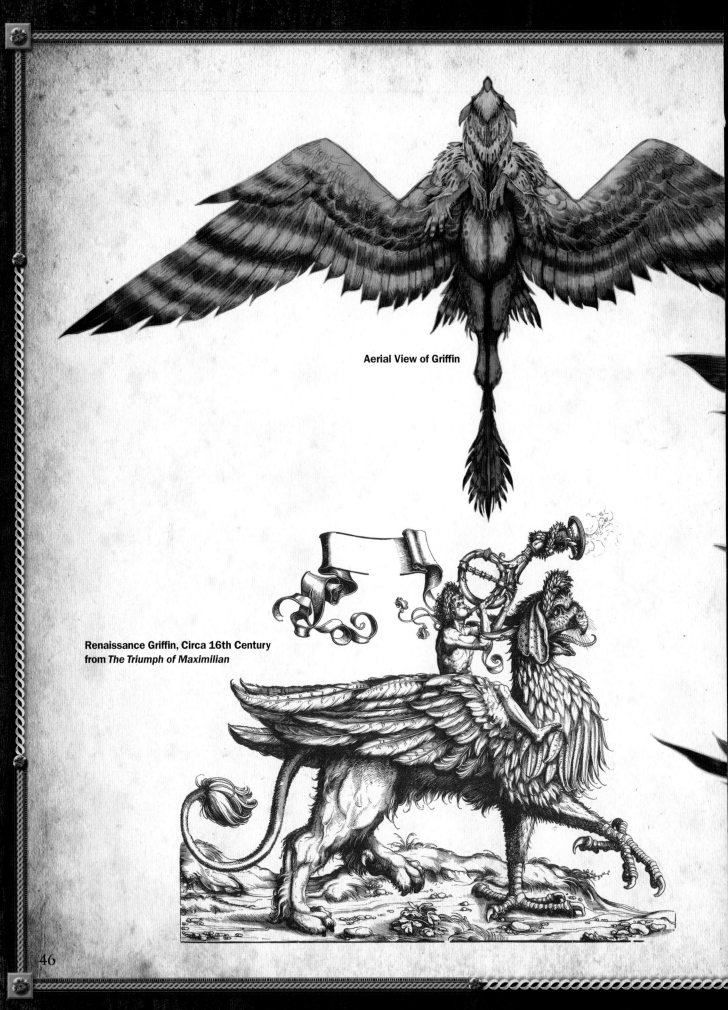

Aerial View of Griffin

Renaissance Griffin, Circa 16th Century
from The Triumph of Maximilian

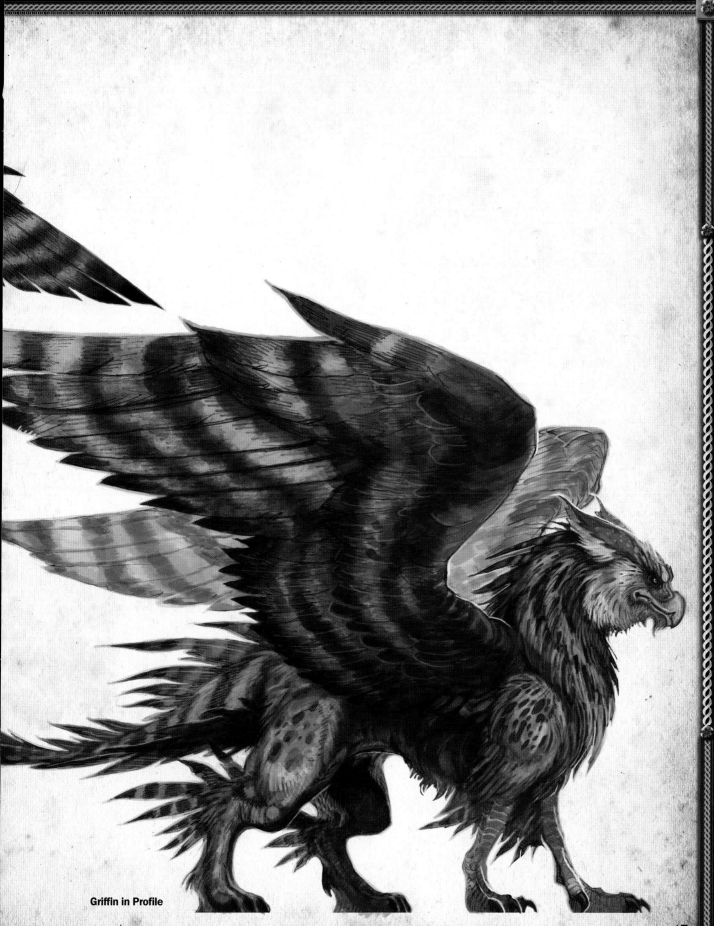

Griffin in Profile

Demonstration
GRIFFIN

1 Concept and Design Stage
The griffin is one of the most illustrated legendary beasts from the ancient to the contemporary, and there is a plethora of great reference to choose from. When approaching the design of this classical creature, I wanted to give the animal a natural and realistic form while keeping with the traditional representations. To make the griffin more aerodynamically believable, I changed the traditional lion's tail to a more avian tail for better flight dynamics. My goal was to show the graceful silhouette of the Falconiformes in flight—the diurnal birds of prey such as eagles, raptors and hawks.

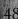

John Tenniel's Illustration from Lewis Carroll's
Alice's Adventures in Wonderland

49

2 Skeletal Frame Sketch

Use simple circles and lines to sketch out the action pose of a large falcon in flight. Study the anatomy of wings to help get the perspective right.

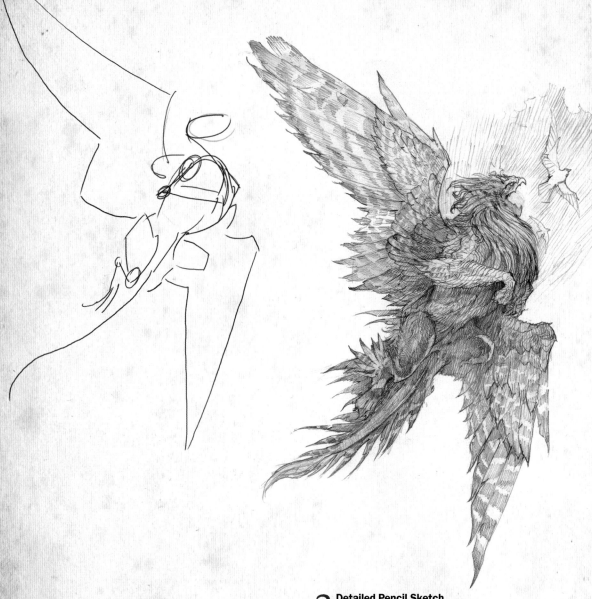

3 Detailed Pencil Sketch

Add details in pencil such as the design of the plumage and texture of the lion's legs. Loosely sketch another bird in the background to improve the believability of a bird in flight.

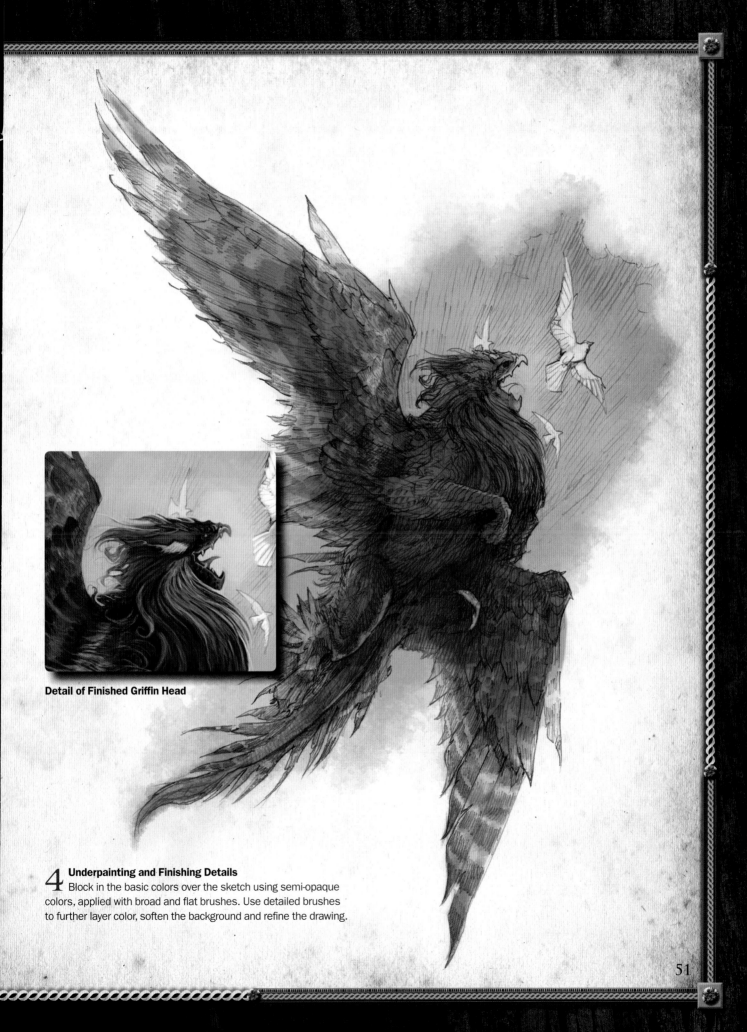

Detail of Finished Griffin Head

4 Underpainting and Finishing Details
Block in the basic colors over the sketch using semi-opaque colors, applied with broad and flat brushes. Use detailed brushes to further layer color, soften the background and refine the drawing.

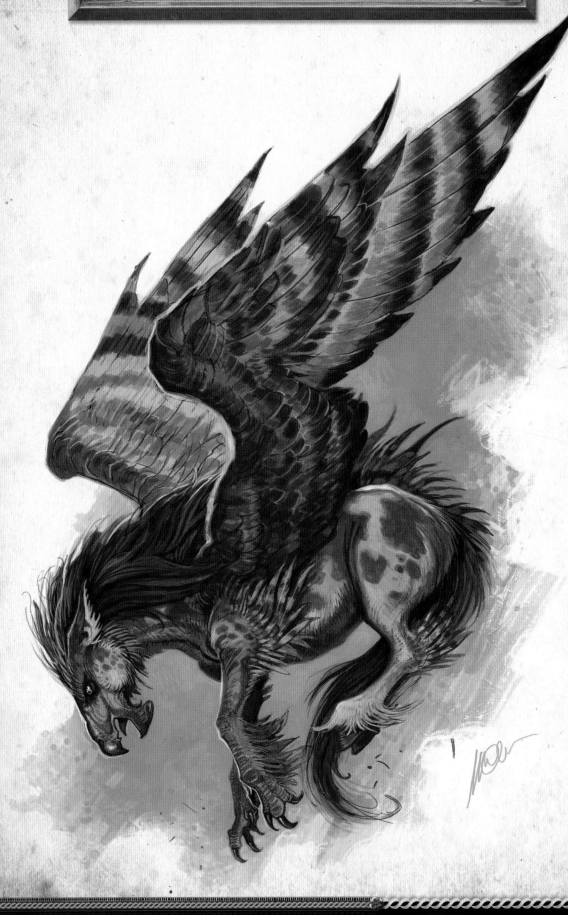

HISTORY

Powerful and wild, noble and strong, the *hippogriff* is one of the most majestic and famous creatures in the bestiary. It is a combination of a horse (*hippos* means horse in Greek) and a griffin, and is also related to the pegasus and buraq.

The hippogriff first rose to popularity during the Middle Ages, captured in the chivalric tales of the medieval romances. The hippogriff embodies the duality of the perfect knight, savage and powerful in battle, but gentle and loyal to its noble charges.

In *Orlando Furioso*, Ludovico Ariosto's 1516 epic poem and fantasy masterpiece composed during the Italian Renaissance, the hippogriff is placed center stage, becoming the flying steed of the paladins of Charlemagne. "No empty fiction-wrought magic lore, but natural was the steed the wizard called. For him a filly to griffin bore, named hippogryph. In wings and beak and crest, formed like his father and in the feet like the mare, his mother, in all the rest. Such on Riphaean hills, though rarely found are bred, beyond the frozen ocean's bound."

Rarely seen in art and literature for centuries, the hippogriff experienced a popular renaissance in the 1999 novel *Harry Potter and the Prisoner of Azkaban* by J.K. Rowling introducing a hippogriff named Buckbeak.

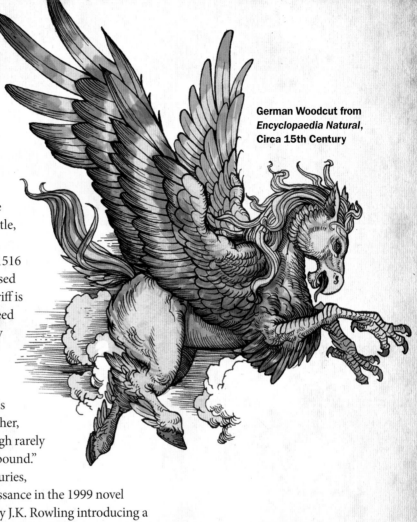

German Woodcut from *Encyclopaedia Natural*, Circa 15th Century

Hippogriff depicted in *Orlando Furioso* (1877) by Gustave Doré

53

DEMONSTRATION
HIPPOGRIFF

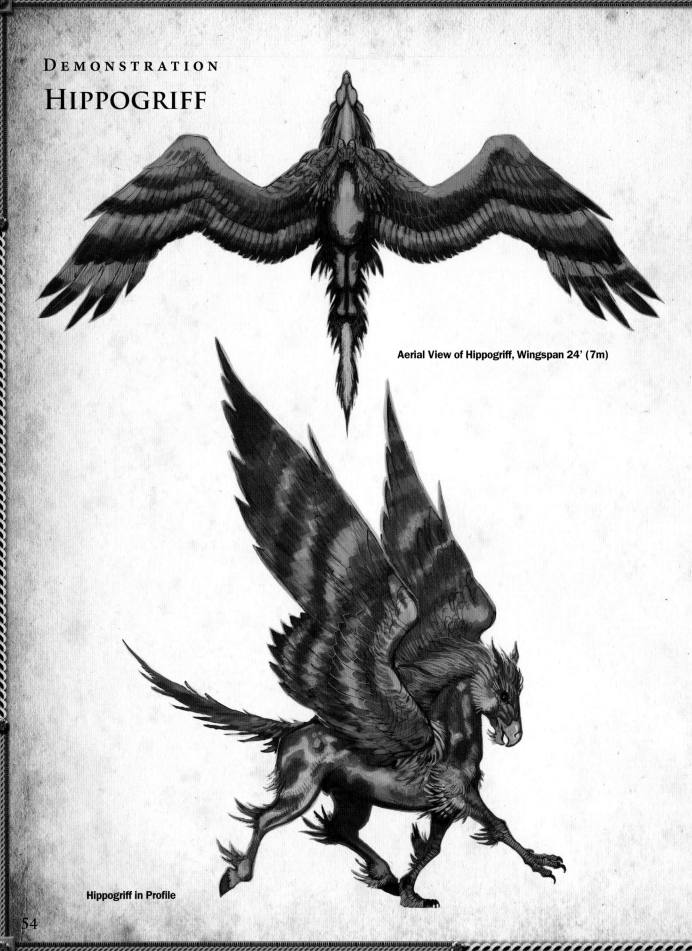

Aerial View of Hippogriff, Wingspan 24' (7m)

Hippogriff in Profile

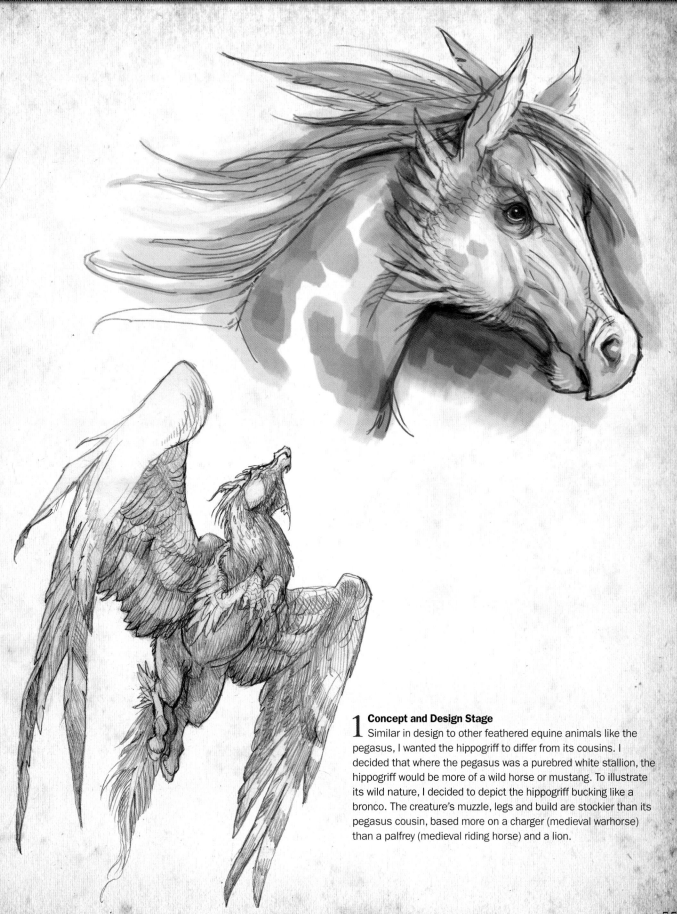

1 Concept and Design Stage

Similar in design to other feathered equine animals like the pegasus, I wanted the hippogriff to differ from its cousins. I decided that where the pegasus was a purebred white stallion, the hippogriff would be more of a wild horse or mustang. To illustrate its wild nature, I decided to depict the hippogriff bucking like a bronco. The creature's muzzle, legs and build are stockier than its pegasus cousin, based more on a charger (medieval warhorse) than a palfrey (medieval riding horse) and a lion.

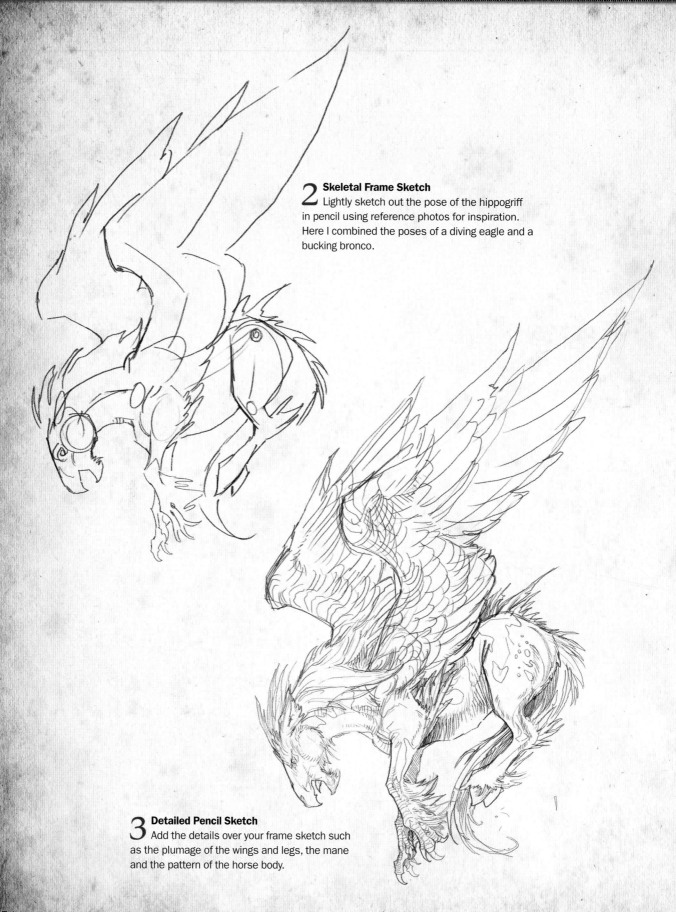

2 Skeletal Frame Sketch
Lightly sketch out the pose of the hippogriff in pencil using reference photos for inspiration. Here I combined the poses of a diving eagle and a bucking bronco.

3 Detailed Pencil Sketch
Add the details over your frame sketch such as the plumage of the wings and legs, the mane and the pattern of the horse body.

4 Underpainting and Finishing Details
Block in the basic colors of the hippogriff using inspiration from photographs of wild mustangs. Work loosely and experiment with a variety of marking and color designs until you are satisfied with the results. Render the final painting using fine details and brighter colors to complete the hair and intricate markings on the hippogriff.

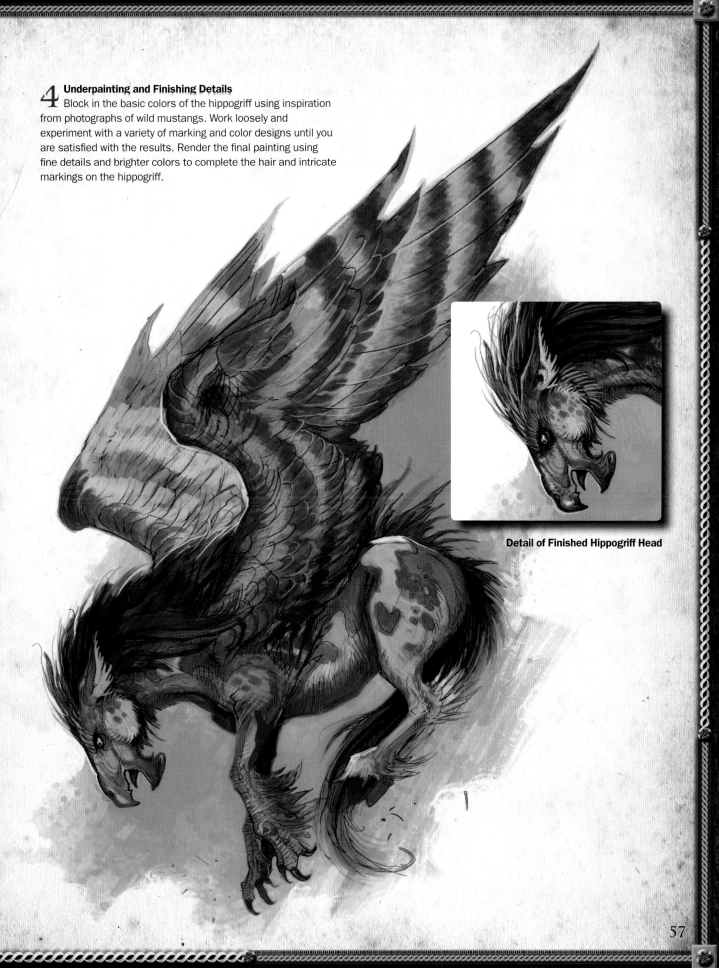

Detail of Finished Hippogriff Head

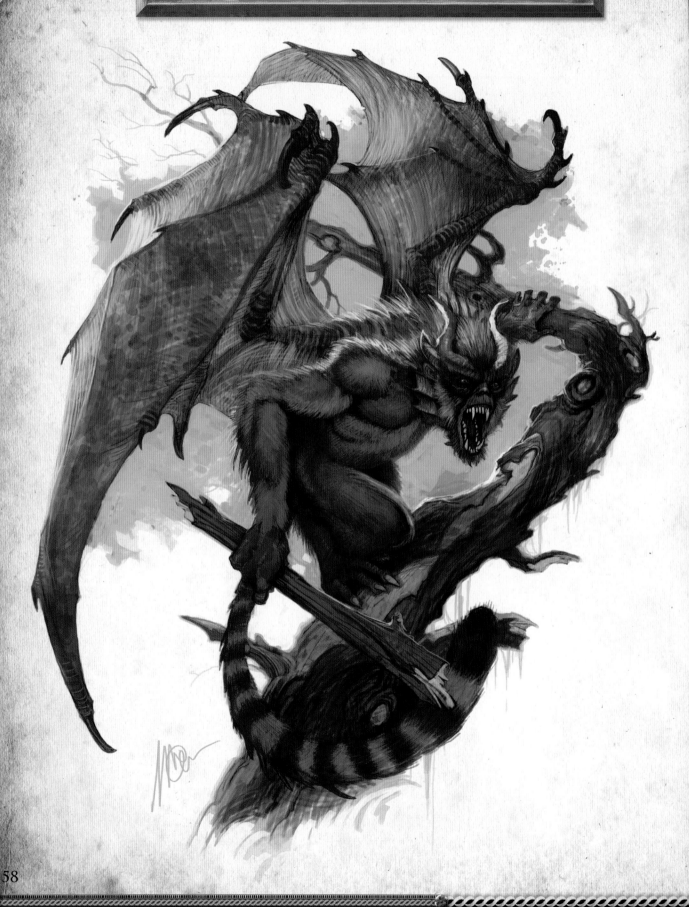

HISTORY

The flying monkeys of Africa are a rumored species that has intrigued cryptozoologists for years. Through the Middle Ages *imps* were described in Germanic folklore as small demons related to fairies who played pranks on humans. Beginning in the sixteenth century, Western explorers of Africa and South America heard rumors and stories of flying creatures, reminding them of small demons. Tales of the imp from indigenous jungle tribes spoke of a trickster demon who stole small objects from the villages. Similar to the medieval description of a mischievous demon, the winged primate and the demonic gremlin may have evolved parallel to one another.

Sightings of the imp became more frequent as expeditions traveled deeper into the African interior. During the nineteenth and twentieth centuries, reports of the newly discovered great ape captured the public's fascination. There has been great human interest in discovering the imp alive, but to this day, scientific evidence of the animal has remained elusive.

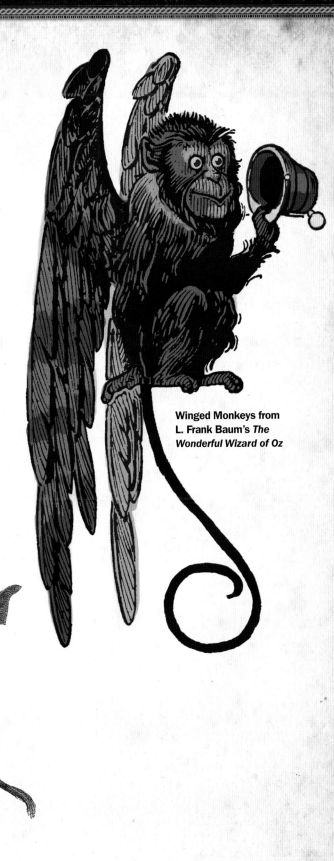

Winged Monkeys from L. Frank Baum's *The Wonderful Wizard of Oz*

Artist's Rendering of Imp Found in a 19th-Century Natural History Encyclopedia

DEMONSTRATION

IMP

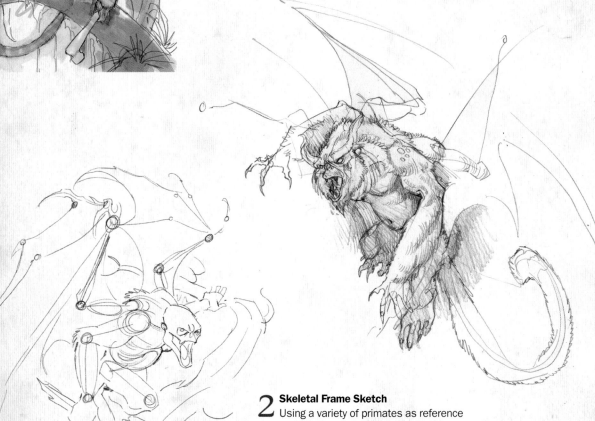

1 Concept and Design Stage
A flying monkey involves a very intuitive design, and it is surprising that this morphology has not evolved in nature considering an ape's ability to leap through trees searching for food and escaping predators. For this design I wanted to use the mythology of the demonic imp with bat wings as a jumping off point combined with the aesthetic of well documented animals such as the ape. Horns added to the demon imagery and the subtle use of tools suggest the intelligence of the creature.

2 Skeletal Frame Sketch
Using a variety of primates as reference such as monkeys and ring-tailed lemurs, I began roughing out the basic anatomical structure.

3 Detailed Pencil Sketch

Using your photo reference, build on top of the frame sketch to render the details of the imp in pencil.

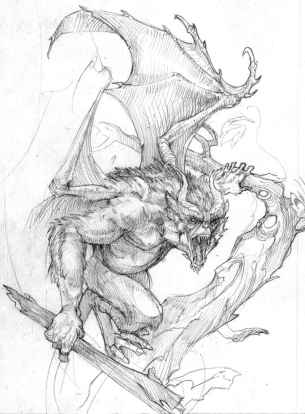

4 Underpainting and Finishing Details

After importing the pencil sketch into the computer, re-size the drawing to compose the large wings. Block in broad color forms for the markings and coloration of the imp's wings, tail and body, and the tree.

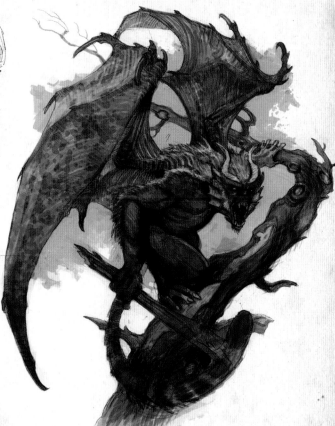

Imp in Profile

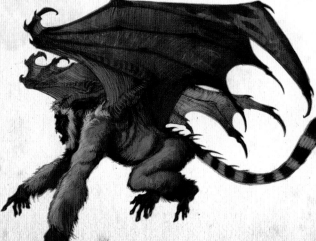

JOROGUMO

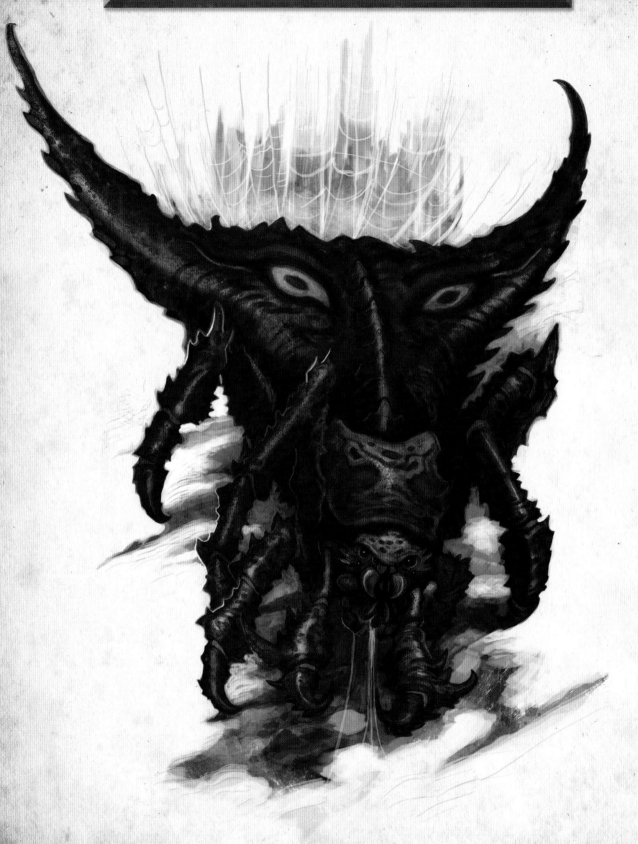

HISTORY

Arachnophobia, the fear of spiders, is a human trait that spans all cultures. Poisonous alien-like creatures lurking in dark woven webs, the image of a giant spider is the stuff of nightmares. Derived from Japanese folklore the *jorogumo* is a giant, monstrous spider able to transform herself into a beautiful woman in order to lure men into her cave.

The jorogumo is also the name of the golden orb web spider classified as *Nephila clavata*. This colorful and poisonous spider weaves intricate webs that have fascinated humans for millennia. Such intricate webs suggest some kind of intelligence, leading to the legends of spider people.

The legend of spiders in mythology is universal. In classical Greece spiders were believed to weave the fates of men. In the American Indian creation myth the spider god Iktomi was depicted as a trickster spinning webs to ensnare victims. The mythos of the spider continues in modern culture. In J.R.R. Tolkien's *Lord of the Rings*, the spider Shelob is a harrowing ancient scourge. And in *Dungeons & Dragons*, the creatures known as driders are fearsome denizens of the underworld.

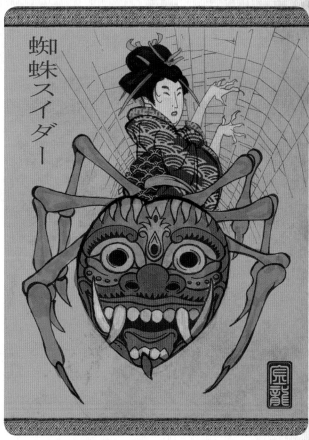

Japanese Depiction of the Jorogumo, Circa 16th Century

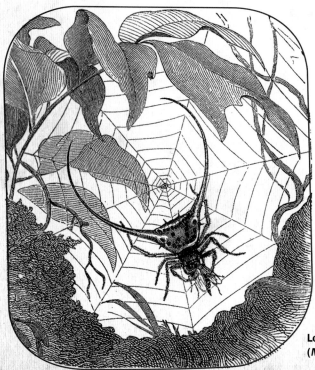

Long-Horned Orb Weaver Spider
(*Macracantha Arcuata*)

63

DEMONSTRATION
JOROGUMO

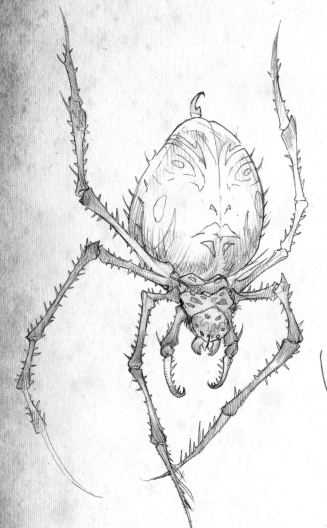

1 Concept and Design Stage

Concepting a creature like the jorogumo is a challenge because it combines the elements of a giant spider creature with a beautiful woman, obviously a combination that could never exist in nature. The origin of my design was a massive arachnid whose carapace markings (its outershell) could be perceived as the face of a woman. With an abdomen the size of a human head, the jorogumo would have a leg span of over 3 feet (1m), and its legs must be large and strong enough to support its weight. I referred to images of arthropods like crabs, scorpions and beetles to glean ideas for large exoskeletons.

2 Skeletal Frame Sketch

Using an HB pencil, rough out the pose of the giant spider with simple lines and circles.

3 Detailed Pencil Sketch

Render the details of the jorogumo such as the crab-like legs and claws, and rough in the woman's face on the outer shell. When you are satisfied, scan the drawing into your computer to begin the coloring stage.

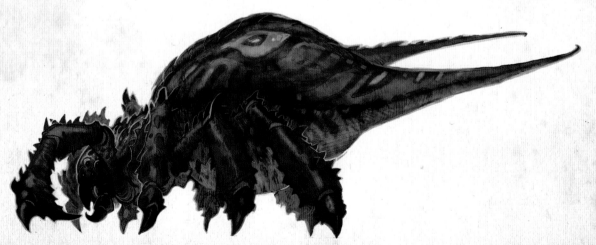

4 Underpainting and Finishing Details

Using broad, loose brushstrokes in a transparent layer, block in the basic forms of color. Render the details with opaque paint and fine brushes. Apply bright colors to create an iridescent effect common to many insects.

Jorogumo in Profile

KRAKEN

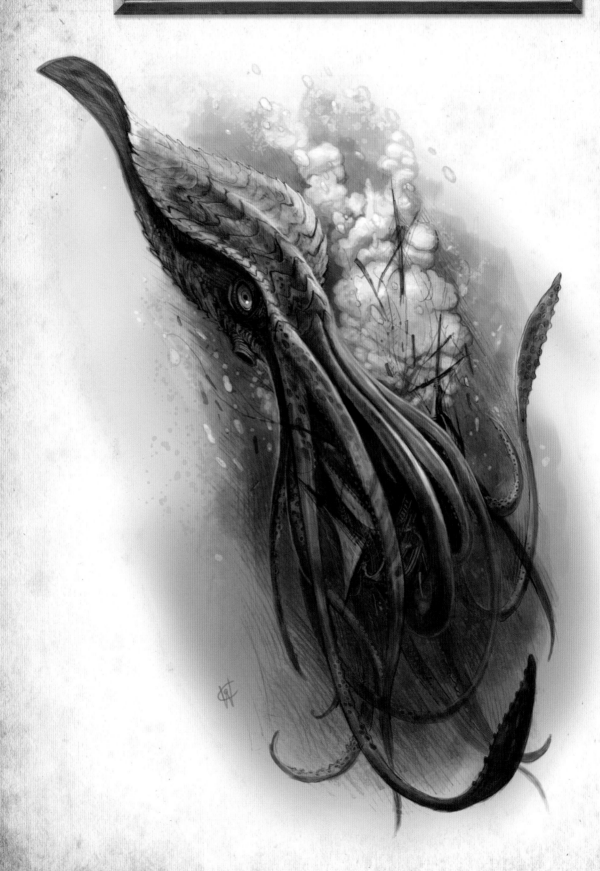

KRAKEN

HISTORY

The *kraken* has been a scourge of the seas ever since man first set sail. This titanic sea creature over 200 feet (61m) long was able to attack and destroy vessels up to the size of a galleon. The kraken is believed to be related to the genus *Architeuthis* in the family *Architeuthidae* consisting of the species of giant squid. At one time, it is possible that giant squid were able to achieve such massive dimensions feeding upon huge fish, sea orcs and ocean dinosaurs. Later in its history the kraken would have fed on whales that filled the seas.

The kraken is most famously depicted in Jules Verne's classic *20,000 Leagues Under the Sea*. By the late nineteenth century, new mechanized ocean vessels were becoming strong enough to survive an attack by the kraken. More recently, the whaling industry has destroyed much of the kraken's food supply resulting in smaller specimens of giant squid and the possible extinction of the kraken. The use of large transatlantic ships since the twentieth century has further reduced encounters between man and kraken, relegating this monster to the realm of sea lore.

PL. 17

ARCHITEUTHIS

Encyclopaedia Mythicum **Illustration of the Kraken, Circa 18th Century**

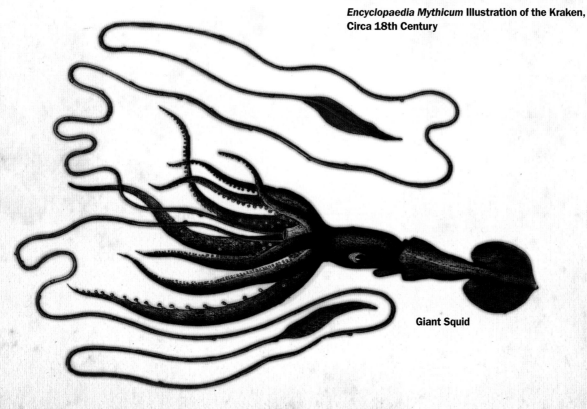

Giant Squid

KRAKEN

1 Concept and Design Stage
The kraken or titanic squid is a creature able to destroy large sailing vessels and grow to over 200 feet (61m) long. In order to grow to such huge proportions it would have to survive attacks by sperm whales during its childhood. Armored plating was added in my concept design to account for this defensive adaptation.

Profile of Kraken, Length of 200' (61m)

Captain Nemo vs. The Kraken
Digital
16" × 12" (41cm × 30cm)

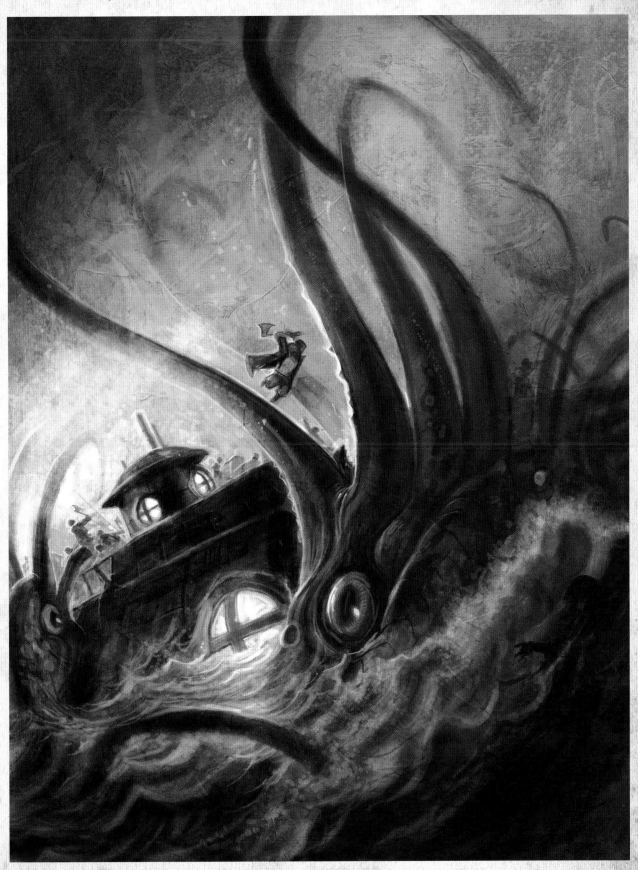

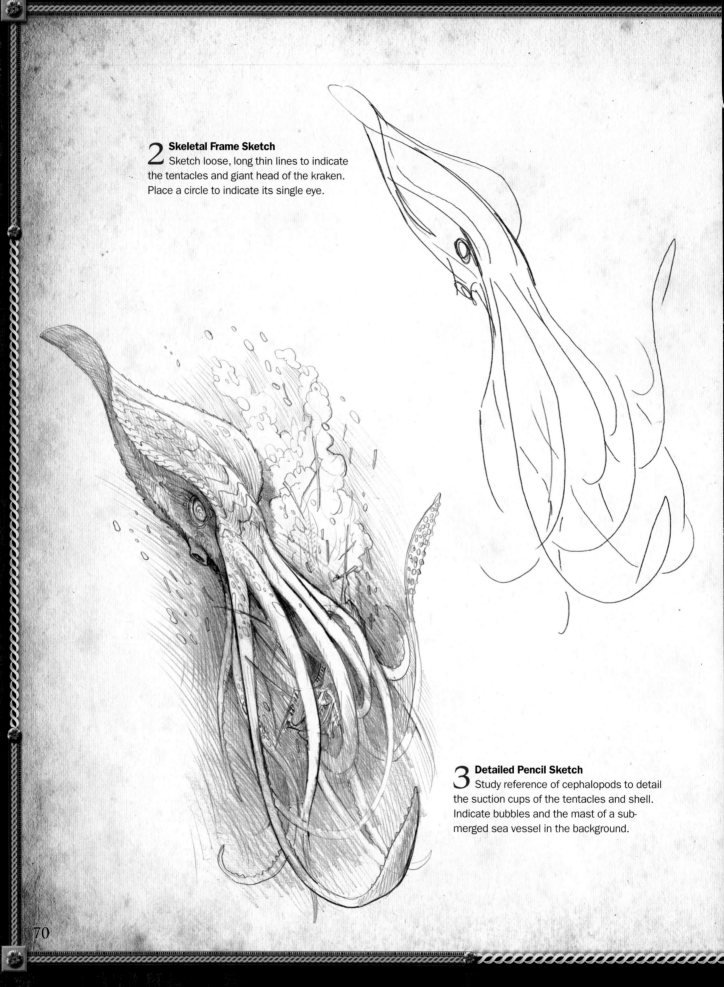

2 Skeletal Frame Sketch
Sketch loose, long thin lines to indicate the tentacles and giant head of the kraken. Place a circle to indicate its single eye.

3 Detailed Pencil Sketch
Study reference of cephalopods to detail the suction cups of the tentacles and shell. Indicate bubbles and the mast of a submerged sea vessel in the background.

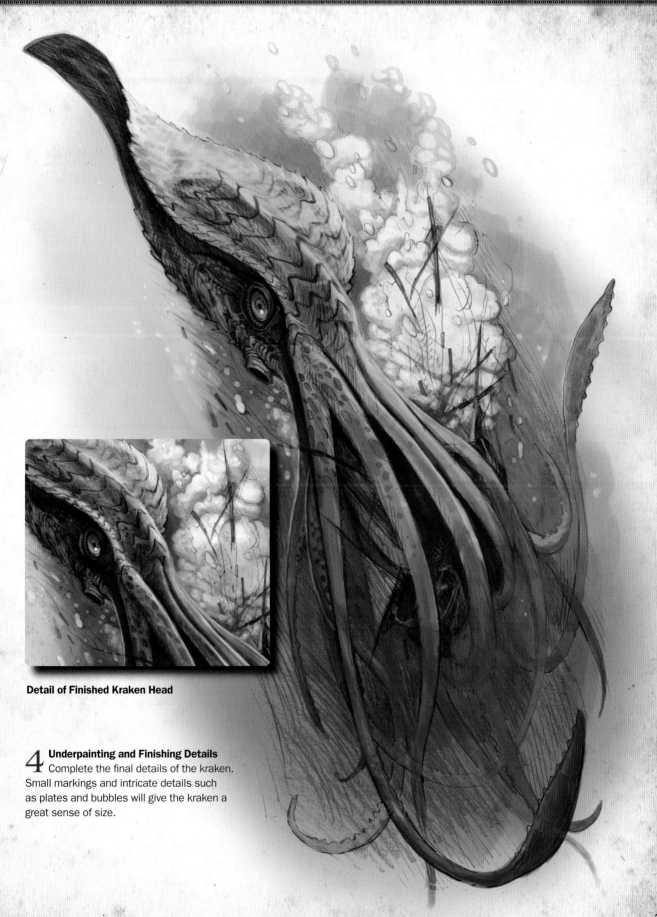

Detail of Finished Kraken Head

4 **Underpainting and Finishing Details**
Complete the final details of the kraken. Small markings and intricate details such as plates and bubbles will give the kraken a great sense of size.

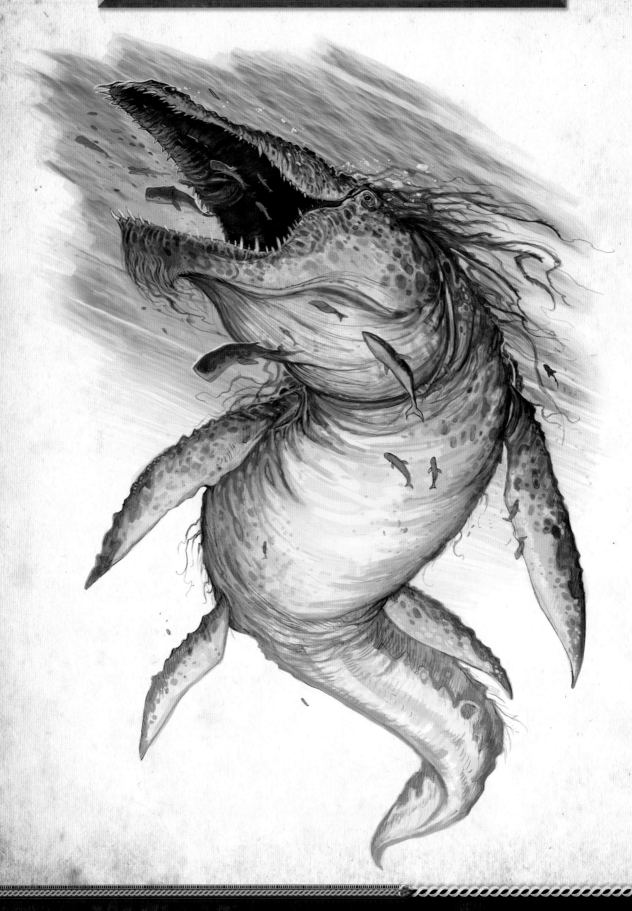

HISTORY

Depictions of giant whales of ancient times can be found in many cultures. Of all the animals described in the bestiary, none comes close in sheer size to the enigmatic *leviathan*. The word *leviathan* itself has come to be synonymous with gigantism. Although never documented as a specific species, cryptozoologists believe the leviathan to be related to plesiosaurs, or the ancient-toothed cetacean family of *Basilosauridae* or the recently unearthed *Livyatan melvillei*. Such an animal may have grown to gigantic proportions in order to survive in a predatory environment against other giant sea creatures during past epochs such as the Pleistocene era.

The most legendary depiction of a leviathan is found in the Bible, Job 41: 12–34: *"I will not fail to speak of Leviathan's limbs, its strength and its graceful form. Who can strip off its outer coat? Who can penetrate its double coat of armor?*

Who dares open the doors of its mouth, ringed about with fearsome teeth? Its back has rows of shields tightly sealed together; each is so close to the next that no air can pass between ... Smoke pours from its nostrils as from a boiling pot over burning reeds. Its breath sets coals ablaze, and flames dart from its mouth. Strength resides in its neck; dismay goes before it. The folds of its flesh are tightly joined; they are firm and immovable. Its chest is hard as rock, hard as a lower millstone. When it rises up, the mighty are terrified; they retreat before its thrashing ... It makes the depths churn like a boiling caldron and stirs up the sea like a pot of ointment. It leaves a glistening wake behind it; one would think the deep had white hair. Nothing on earth is its equal—a creature without fear. It looks down on all that are haughty; it is king over all that are proud."

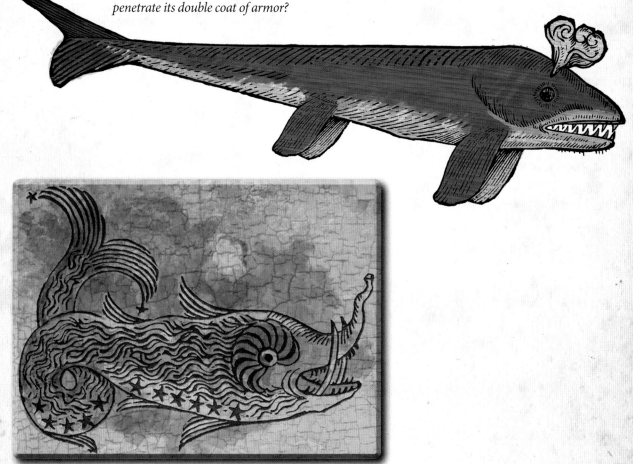

Historical Depictions of the Leviathan from Antique Bestiaries

DEMONSTRATION

LEVIATHAN

1 Concept and Design Stage
When designing an animal as big as a leviathan, it is important to understand its environment. Many animals live in the leviathan's environment, but in this case I conceived an animal that *is* the environment. Like a living island or coral reef, a whole ecology developed around the creature.

My initial idea was to portray the leviathan as a prehistoric whale with characteristics of a plesiosaur dinosaur, such as its four large flippers. My goal was to create a beast that had been living for thousands of years. Living in the deepest ocean depths and surfacing rarely helped form a whole ecosystem around the beast similar to how remora fish survive in close proximity to sharks.

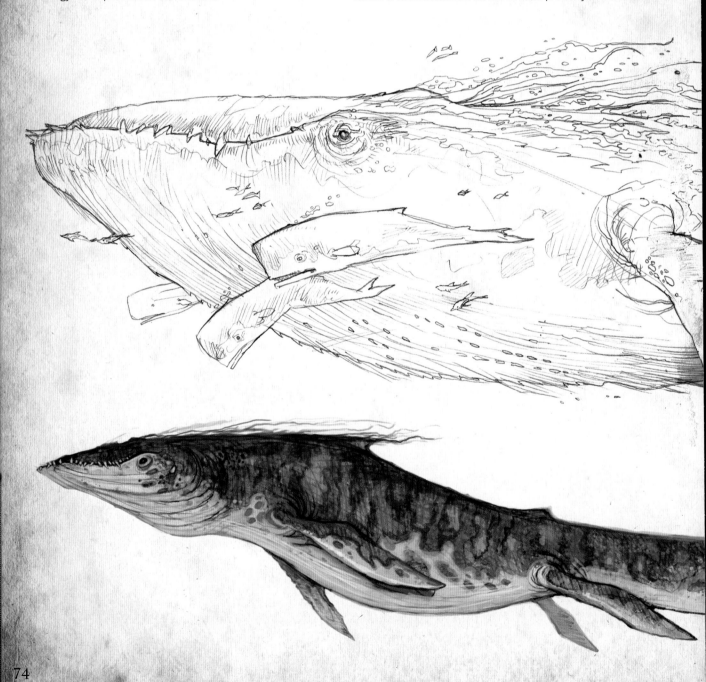

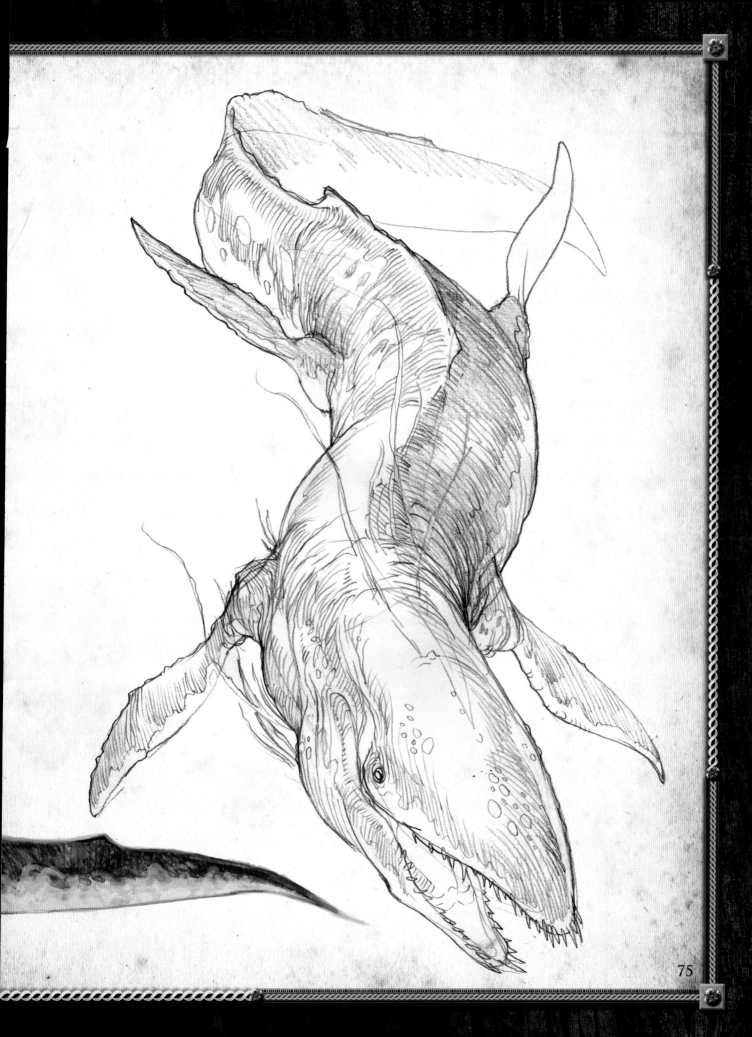

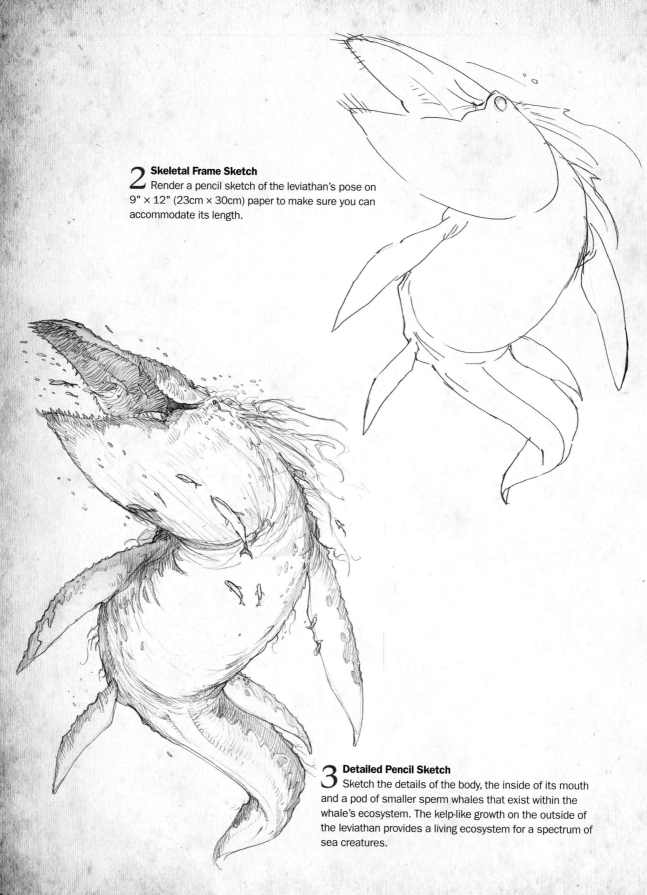

2 Skeletal Frame Sketch
Render a pencil sketch of the leviathan's pose on 9" × 12" (23cm × 30cm) paper to make sure you can accommodate its length.

3 Detailed Pencil Sketch
Sketch the details of the body, the inside of its mouth and a pod of smaller sperm whales that exist within the whale's ecosystem. The kelp-like growth on the outside of the leviathan provides a living ecosystem for a spectrum of sea creatures.

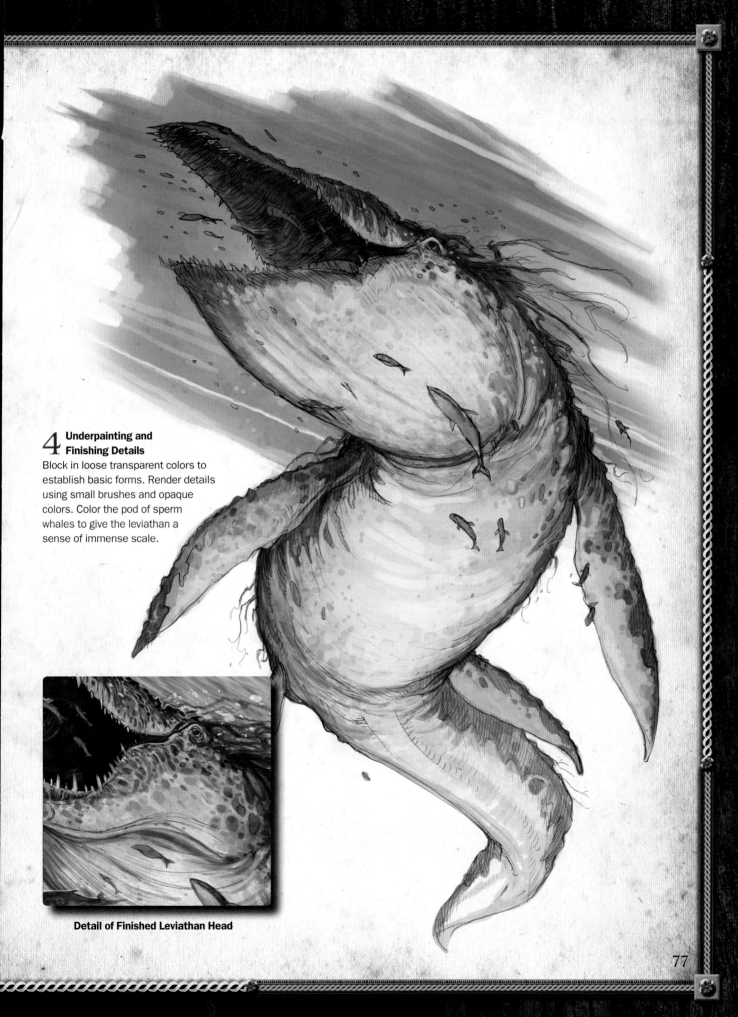

4 Underpainting and Finishing Details

Block in loose transparent colors to establish basic forms. Render details using small brushes and opaque colors. Color the pod of sperm whales to give the leviathan a sense of immense scale.

Detail of Finished Leviathan Head

MANTICORE

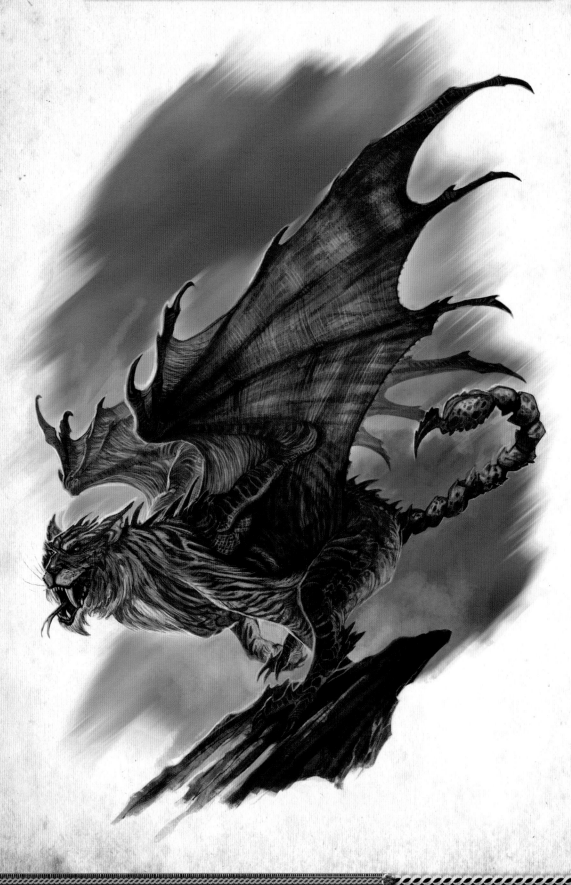

HISTORY

The *manticore* is one of the most ferocious and bizarre creatures described throughout classical medieval bestiaries. Similar to its cousin the sphinx, the manticore traditionally has the body of a lion, the head of a man, bat wings and the spiked tail of a scorpion—a lethal and fear-inducing combination. Originating in Persian mythology (modern Iraq) and documented by Greek naturalists, the manticore is described as having a keen appetite for humans and a howl like that of a trumpet.

The manticore's morphology no doubt evolved out of necessity from the rugged terrain it occupied in Persia and the Middle East. It needed as many weapons as possible to both hunt a scarce food source and defend itself against predators. Preying on animals such as mountain goats and pigs, the manticore would find itself in human villages lured by the livestock. It is thought that the manticore began to feed on humans, developing a taste for such meat, thus establishing the lore of the man-eating manticore. Like many of its mythological cousins in the region, the manticore likely went extinct at the height of the Roman Empire due to hunting and competition.

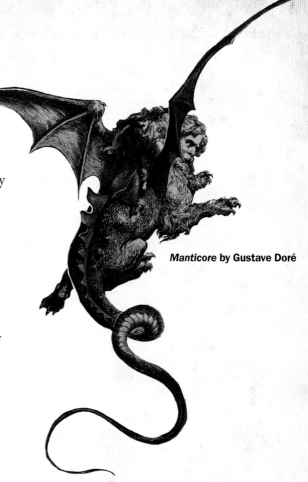

Manticore **by Gustave Doré**

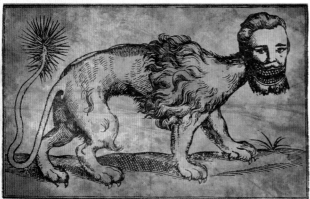

19th Century Illustration of a Manticore

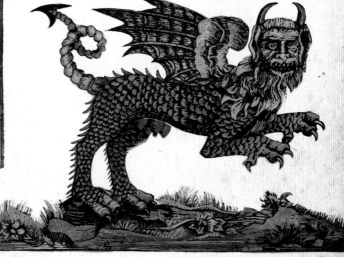

Manticore from Medieval Bestiary

Demonstration
Manticore

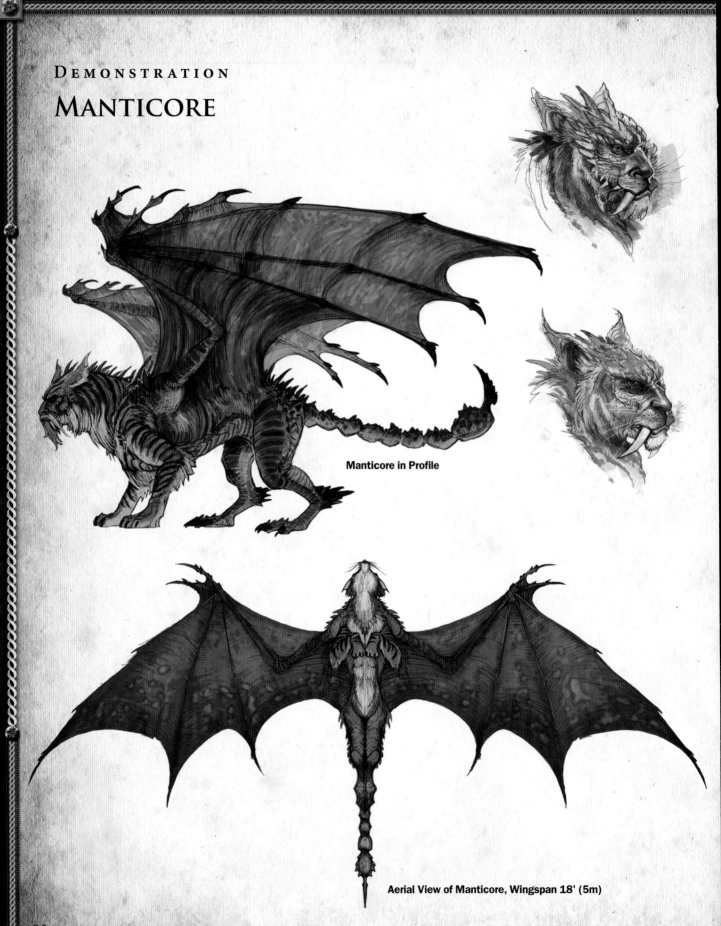

Manticore in Profile

Aerial View of Manticore, Wingspan 18' (5m)

1 Concept and Design Stage

The standard depiction of the manticore is the body of a lion with a vicious spiked tail and the face of a man. Winged variants are common in contemporary depictions, which is the direction I went. I decided that the manticore would be based primarily on the features of a tiger so as not to confuse it with the shedu or chimera. I also chose to feature a scorpion-like tail.

From the start I wanted to portray the feline grace and speed that is common to the great cats, so I started with a kinetic, action-based pose for my creature. The concept goals I focused on were speed and ferocity.

One of the classical elements of the manticore is that it has the head of a man. To keep the design natural, I wanted to avoid simply attaching a human head to a lion's body. I aimed to design a tiger's features in a slightly human fashion to avoid ending up with what looks like a person dressed up in a cat costume.

The mutation of the tiger's face was minimal, just a slight flattening of the muzzle and bridging of the nose. This allowed the creation of a mouth and lips capable of human speech. I chose to give the creature human eyes, an important aspect of the manticore. The spark of intelligence behind them is crucial.

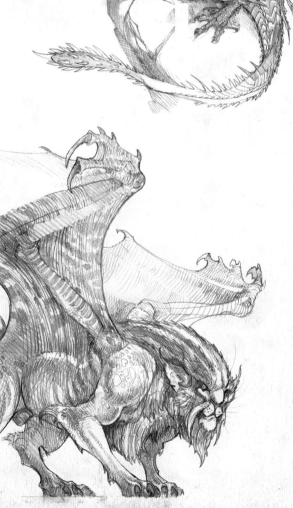

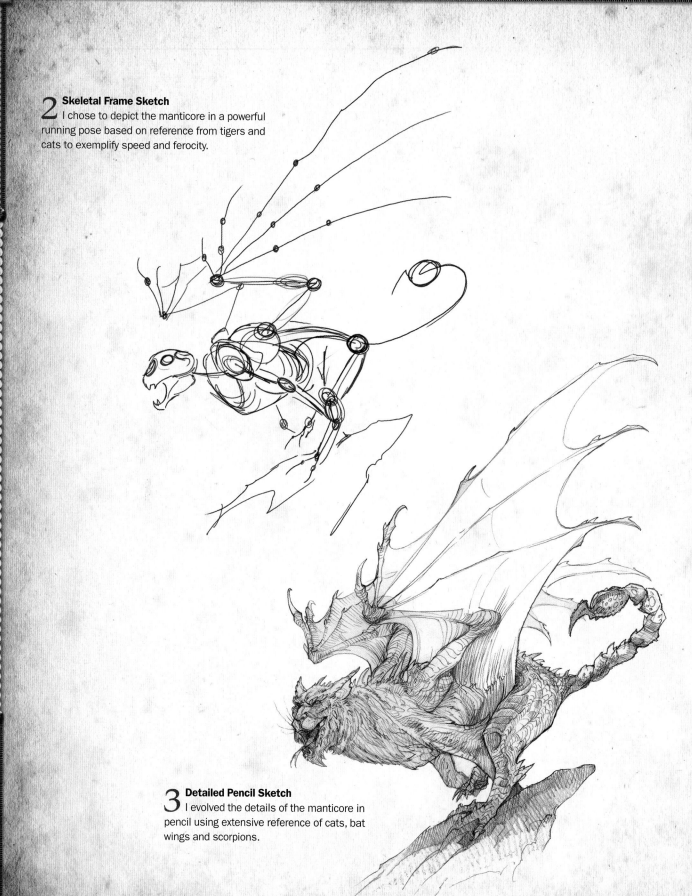

2 Skeletal Frame Sketch
I chose to depict the manticore in a powerful running pose based on reference from tigers and cats to exemplify speed and ferocity.

3 Detailed Pencil Sketch
I evolved the details of the manticore in pencil using extensive reference of cats, bat wings and scorpions.

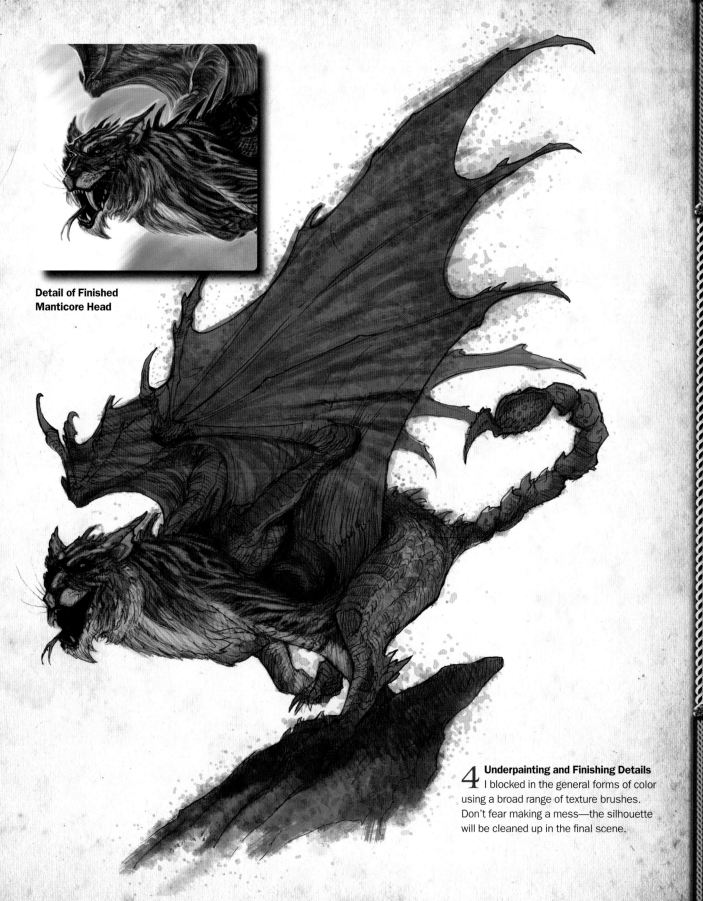

Detail of Finished Manticore Head

4 **Underpainting and Finishing Details**
I blocked in the general forms of color using a broad range of texture brushes. Don't fear making a mess—the silhouette will be cleaned up in the final scene.

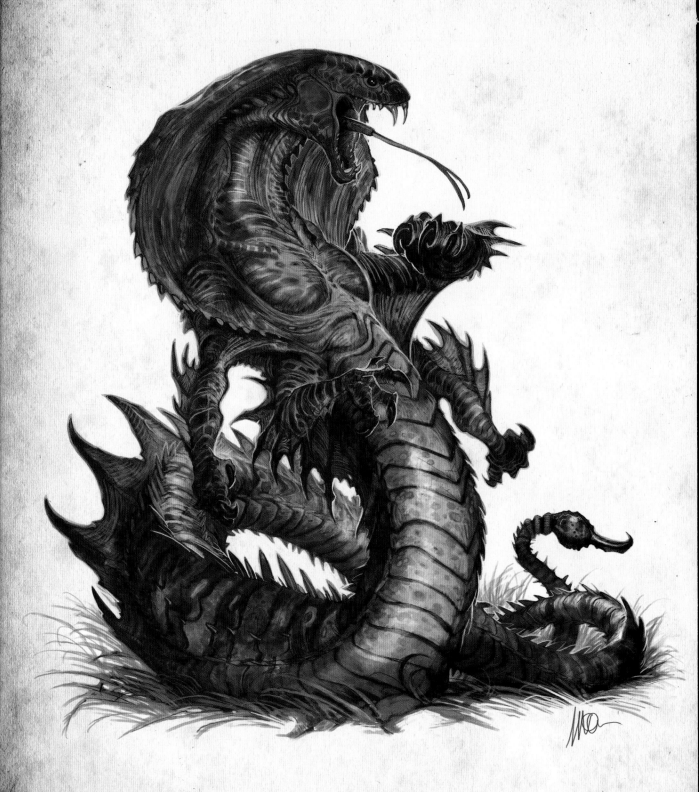

HISTORY

Archaic serpents possessing human qualities have provoked the imaginations of storytellers in all cultures. In Hindu and Buddhist mythology the *naga* developed as a cryptoid growing to immense size. Possibly influenced by the encounters these cultures had with large snakes such as anacondas or boas as well as the powerful king cobra, the legend of the naga was born. Like most snakes, the naga could coil around and strangle its victims. Its venomous teeth, stinger tail and razor-sharp claws made it a formidable predator hunting in the jungles and swamps of India and Asia.

Eastern Naga Rendering

King Cobra (*Ophiophagus Hannah*)

Medieval Rendering of the Garden of Eden Serpent

DEMONSTRATION
NAGA

1 Concept and Design Stage
While designing the naga I wanted to incorporate aspects of human morphology while keeping the animal decidedly serpentine. I referred to mostly cobra reference as they are renowned for their ferocity and lethality. It was challenging to figure out how to attach the arms, which required the development of pectoral muscles and clavicle, scapula and sternum bones to support the new anatomy.

2 Skeletal Frame Sketch
Create the line drawing of the naga with simple lines. Refer often to snake references in all motions, including coiled and preparing to strike, to understand its anatomy.

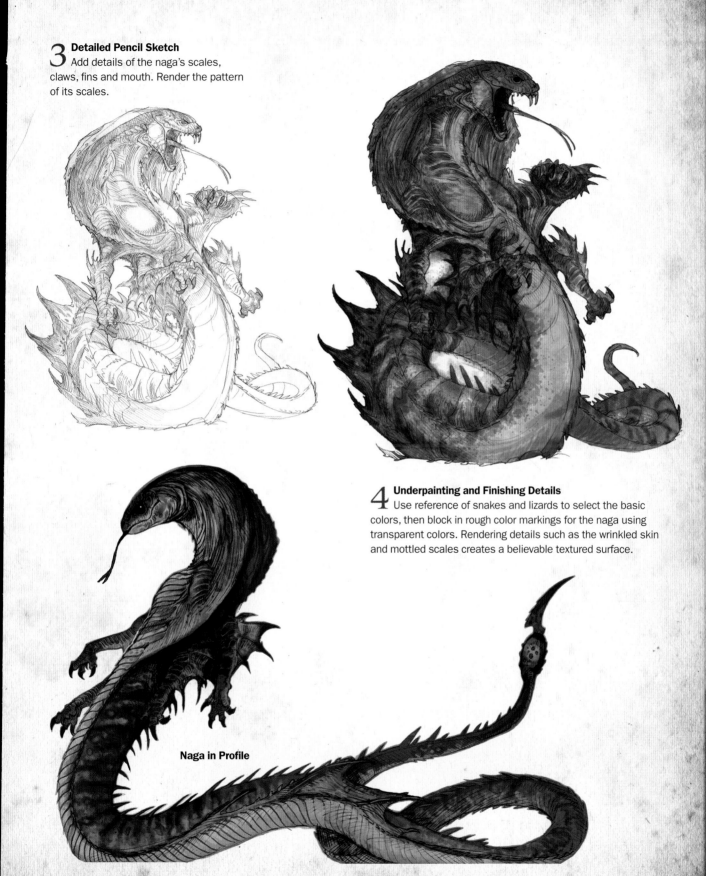

3 Detailed Pencil Sketch
Add details of the naga's scales, claws, fins and mouth. Render the pattern of its scales.

4 Underpainting and Finishing Details
Use reference of snakes and lizards to select the basic colors, then block in rough color markings for the naga using transparent colors. Rendering details such as the wrinkled skin and mottled scales creates a believable textured surface.

Naga in Profile

87

OWLURSUS

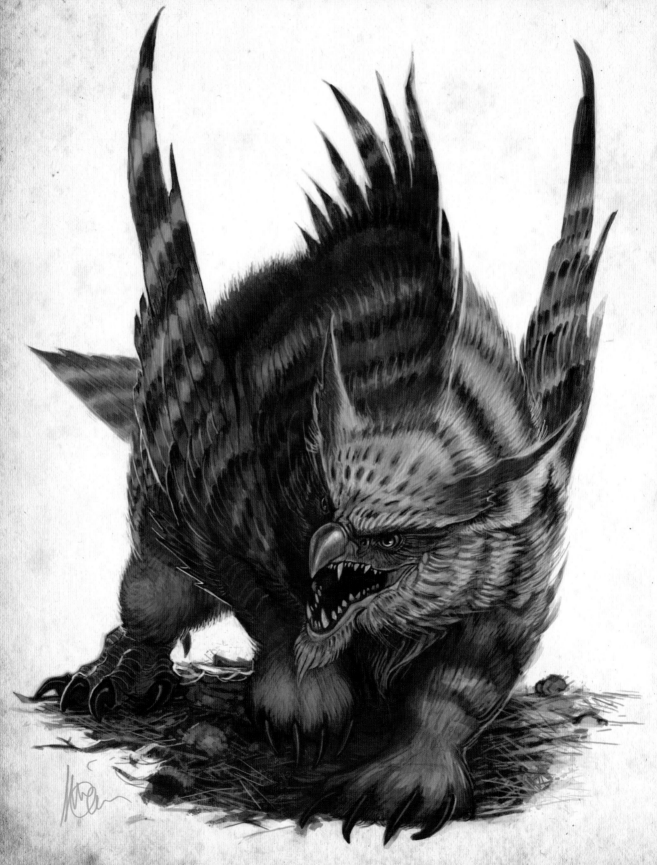

HISTORY

The *owlursus*, owlbear or raptorbear is one of the most fabulous fabled animals of legend. Although there have been limited instances of winged bears in Western heraldry, the owlursus is most common in Native American legend. Throughout North America tales of bears, bear spirits and bear monsters fill almost every tribal culture. The combination of the owl and the bear is a powerful totem symbolizing strength and wisdom.

In the mythology of the Salish tribe the legend of the Katshituashkee tells the story of a young couple in love but from different tribes. A curse was cast upon them to keep them separated forever: the man was turned into a bear and the woman an owl so that they could never live together. It is believed that they loved one another despite the curse, and their child became the owlursus.

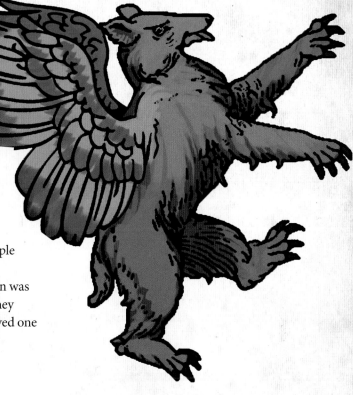

European Heraldic Winged Bear

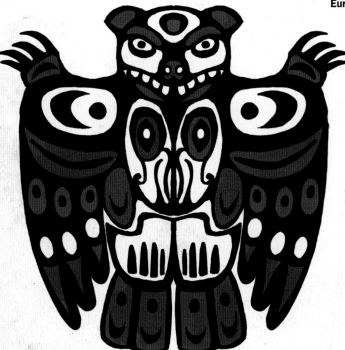

Reconstruction of the Owlbear Spirit Totem Inspired From American Indian Legend

89

DEMONSTRATION
OWLURSUS

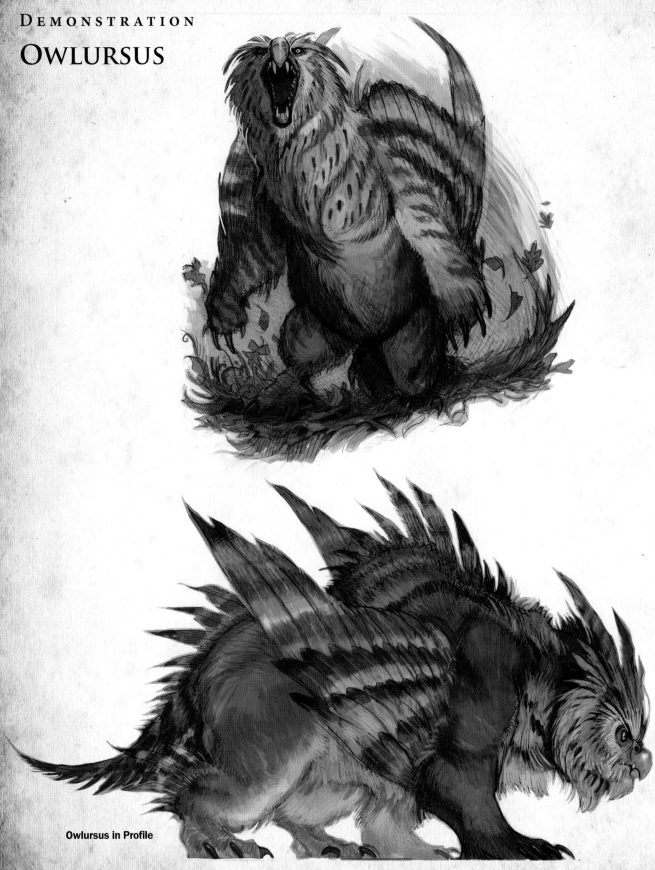

Owlursus in Profile

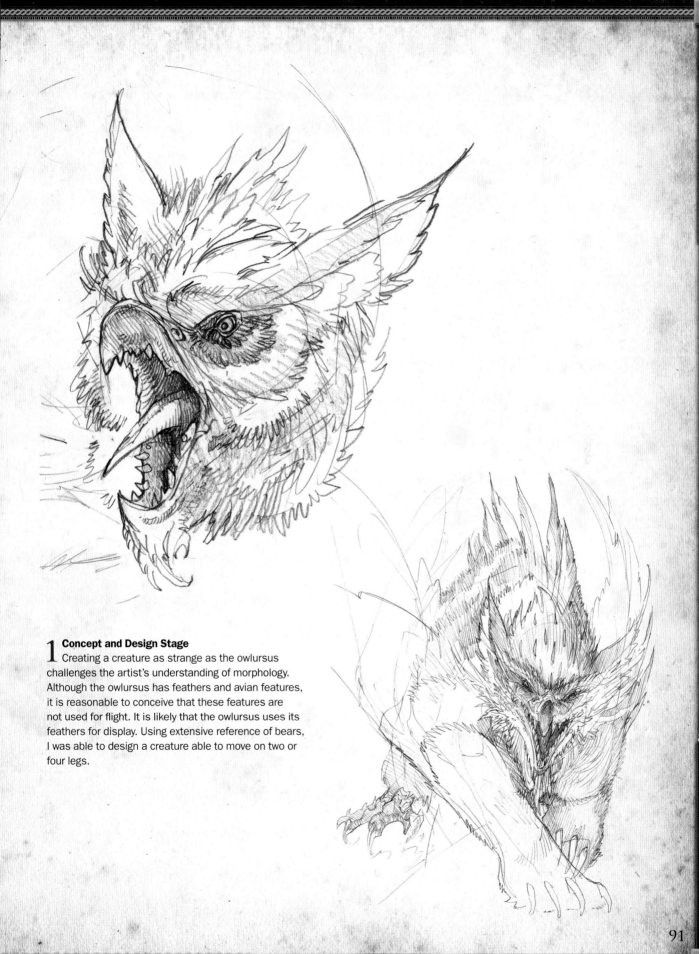

1 Concept and Design Stage

Creating a creature as strange as the owlursus
challenges the artist's understanding of morphology.
Although the owlursus has feathers and avian features,
it is reasonable to conceive that these features are
not used for flight. It is likely that the owlursus uses its
feathers for display. Using extensive reference of bears,
I was able to design a creature able to move on two or
four legs.

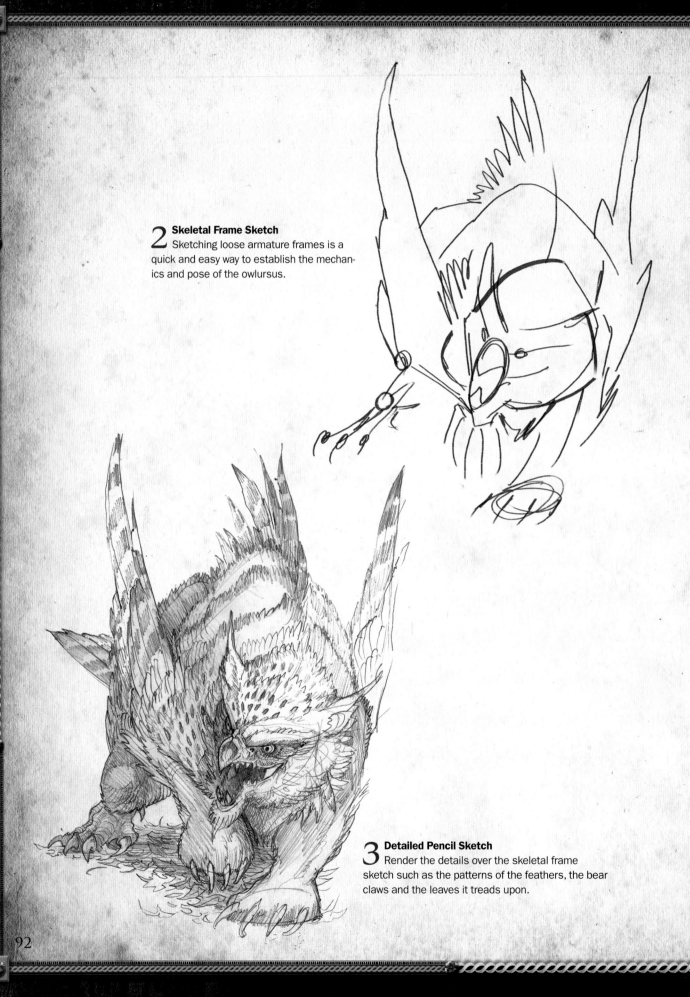

2 Skeletal Frame Sketch
Sketching loose armature frames is a quick and easy way to establish the mechanics and pose of the owlursus.

3 Detailed Pencil Sketch
Render the details over the skeletal frame sketch such as the patterns of the feathers, the bear claws and the leaves it treads upon.

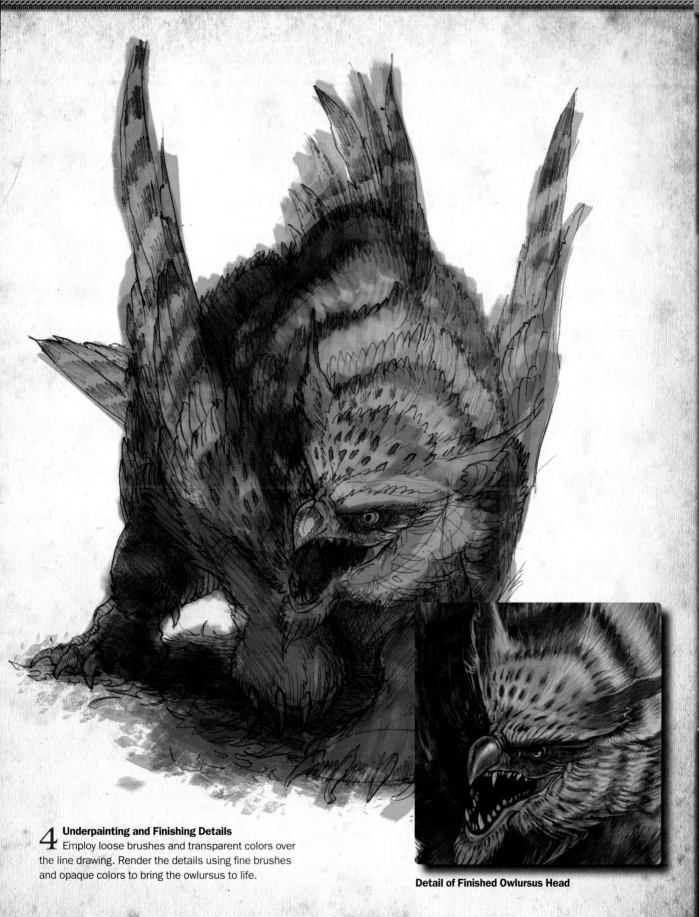

4 Underpainting and Finishing Details
Employ loose brushes and transparent colors over the line drawing. Render the details using fine brushes and opaque colors to bring the owlursus to life.

Detail of Finished Owlursus Head

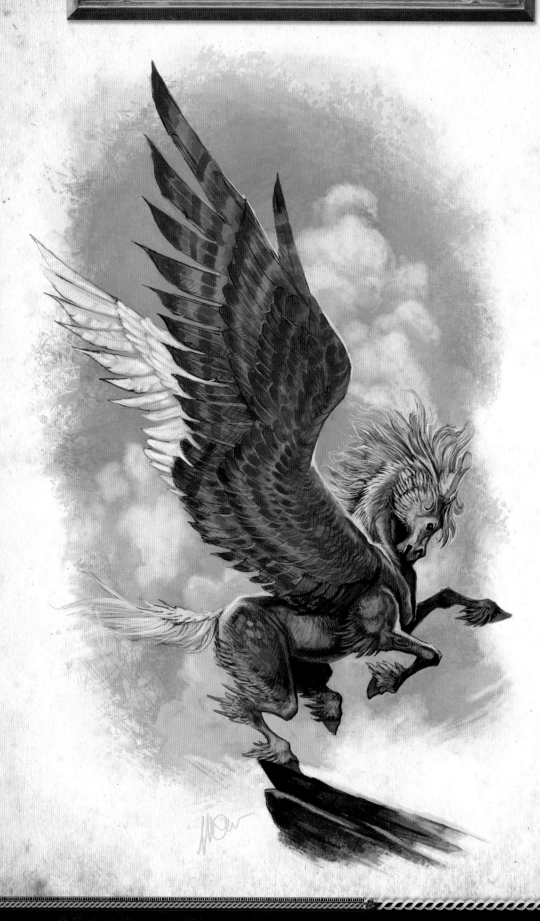

HISTORY

The graceful and beautiful *pegasus* has captured the imaginations of artists and storytellers since antiquity. In Greek mythology Pegasus was the name of only one of a team of flying horses including Zephyr, but has come to identify all flying horses. Pegasus was ridden by the hero Bellerophon to slay the chimera, and Perseus to destroy the kraken. During the Renaissance, the pegasus was associated with artists and poets as the messenger of the muses. The pegasus has always been a symbol of speed, courage and divine power throughout history. Today its likeness appears in logos and advertisements to imply such characteristics.

Related to other winged creatures such as the hippogriff and the griffin, the pegasus was known as the faithful steed of brave knights and daring heroes. The divine power and grace of its riders was reflected by the creature.

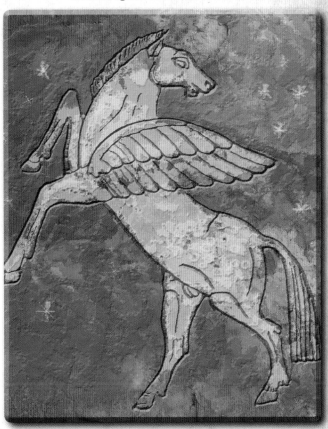

Pegasus Emblazoned on a Medieval Coat of Arms

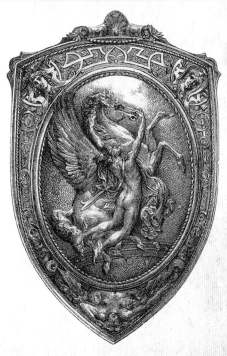

Italian Renaissance Shield of Pegasus and Perseus

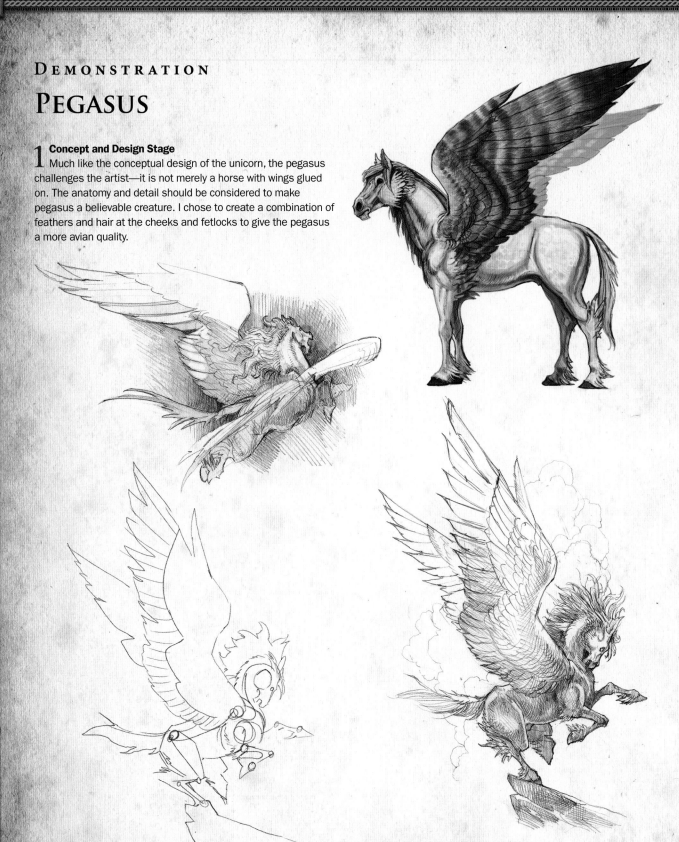

DEMONSTRATION
PEGASUS

1 Concept and Design Stage
Much like the conceptual design of the unicorn, the pegasus challenges the artist—it is not merely a horse with wings glued on. The anatomy and detail should be considered to make pegasus a believable creature. I chose to create a combination of feathers and hair at the cheeks and fetlocks to give the pegasus a more avian quality.

2 Skeletal Frame Sketch
Sketch the line drawing using reference form horses and eagles.

3 Detailed Pencil Sketch
Create a horse and bird hybrid by combining feathers and horse hair in the mane and fetlocks.

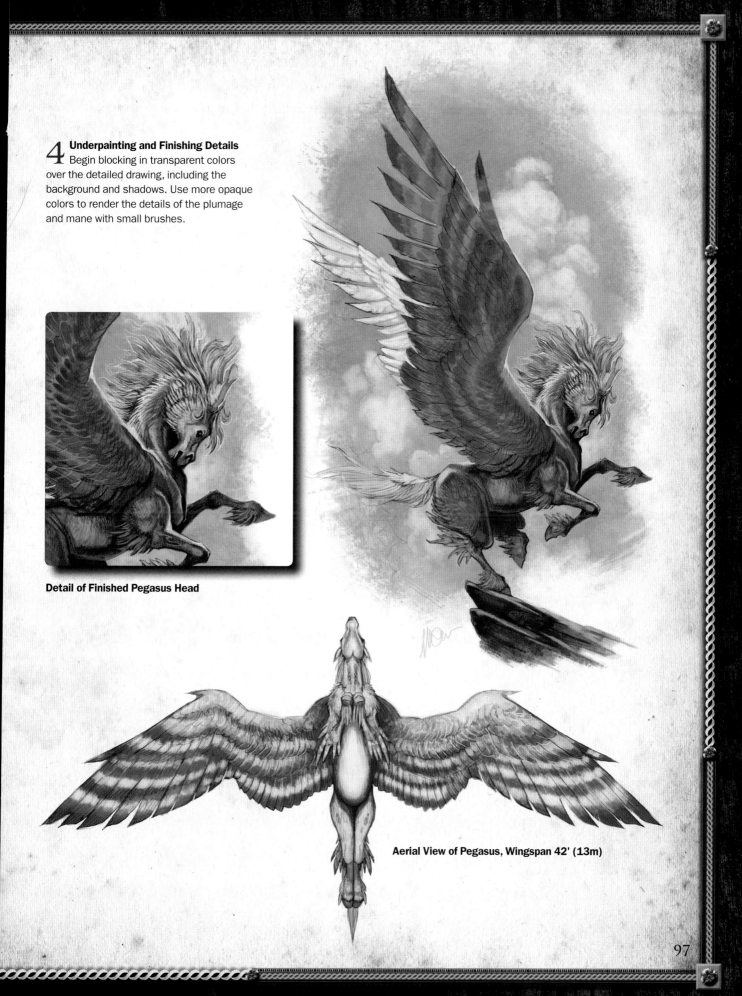

4 Underpainting and Finishing Details
Begin blocking in transparent colors over the detailed drawing, including the background and shadows. Use more opaque colors to render the details of the plumage and mane with small brushes.

Detail of Finished Pegasus Head

Aerial View of Pegasus, Wingspan 42' (13m)

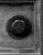

HISTORY

Enigmatic and mysterious, one of the most bizarre legendary creatures is the *questing beast*. Famous for its appearance in Thomas Malory's *Le Morte d'Arthur*, the questing beast has been debated by Arthurian academics for centuries. Described as having the head and tail of a serpent combined with the body of a leopard and the legs of a stag, the questing beast appeared to King Arthur beside a river as he slept. This seems to imply that the beast's appearance was perhaps a vision, giving the animal a mystical quality combining a dragon and a stag, two animals with deep symbolic meaning, possessing both the ferocity of a serpent and the natural majesty of a stag.

The origin of the questing beast's name refers to the noise emitted by the creature's belly. The sound has been described as a pack of dogs "questing" after prey.

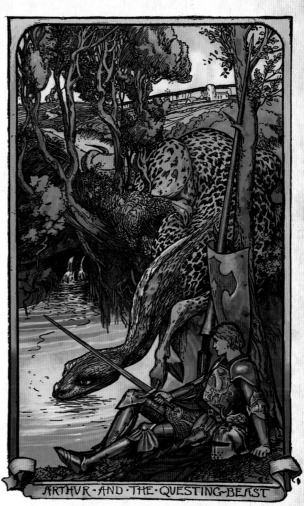

Arthur and the Questing Beast by Walter Crane

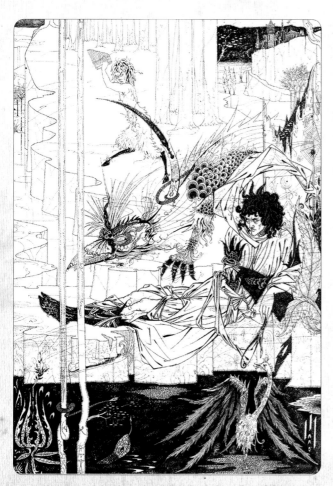

Arthur and the Questing Beast by Aubrey Beardsley

QUESTING BEAST

1 Concept and Design Stage

The questing beast presents a unique challenge to the concept artist. While the head is obviously draconic or serpentine, the body is similar to a stag's. It is apparent from this description that the questing beast is a woodland carnivore, like a deer, able to agilely leap through dense underbrush. Its reptilian head enables it to hunt birds, fish and small mammals from along the river bank. The eponymous questing noise that emanates from its belly was also a quality I wanted to communicate in my drawing.

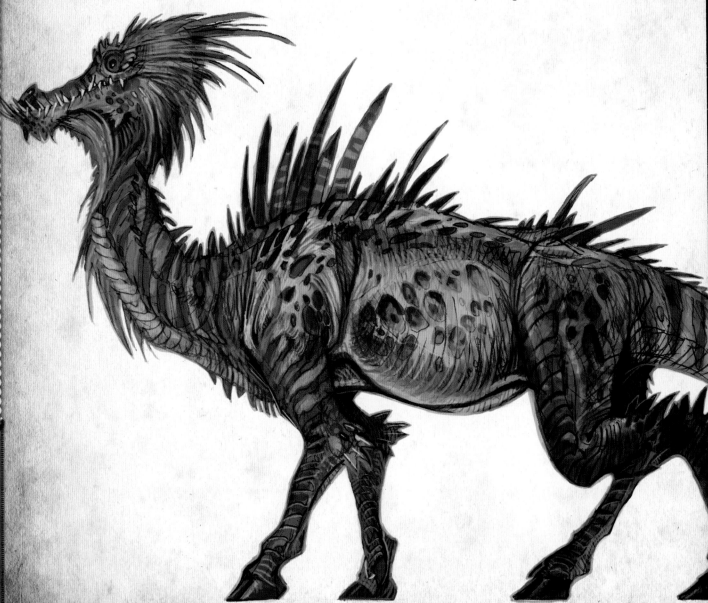

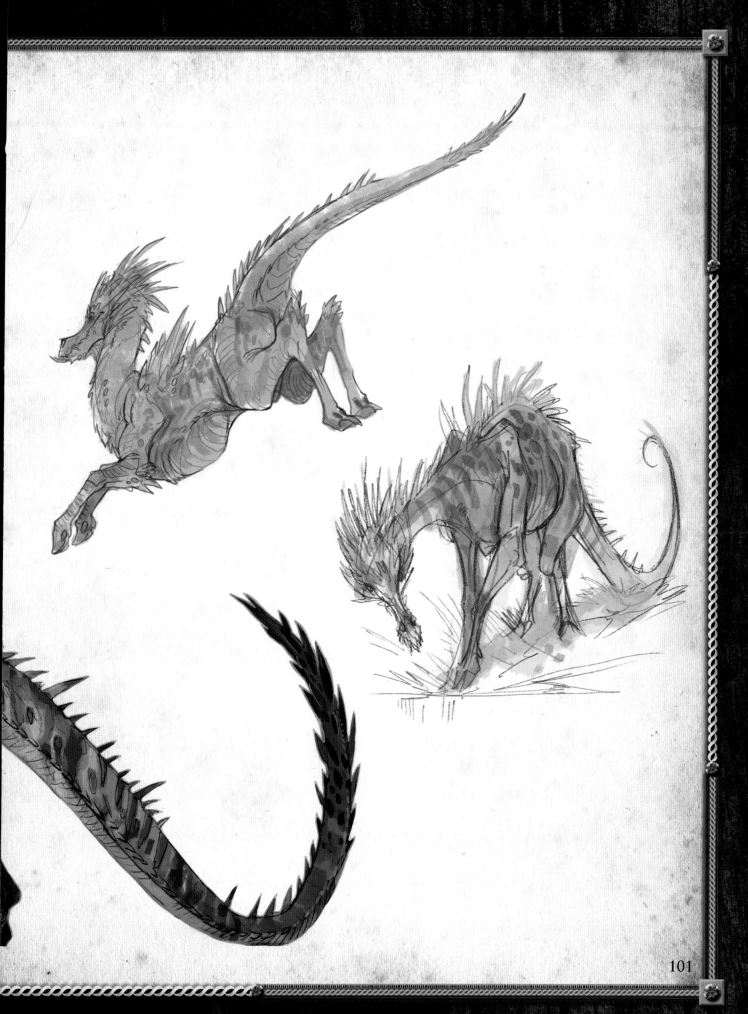

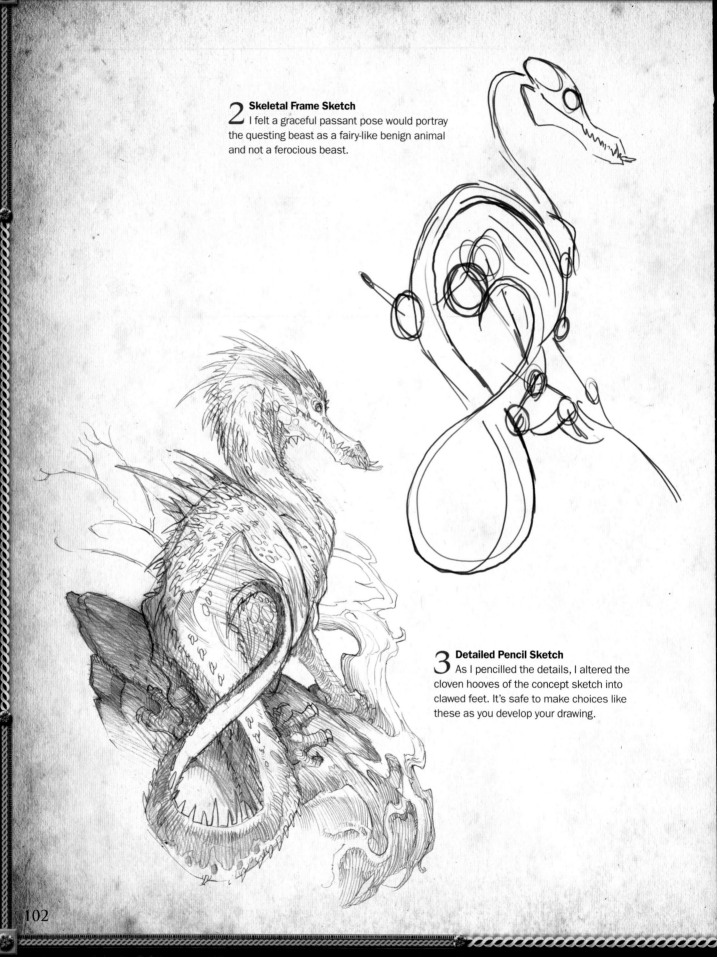

2 Skeletal Frame Sketch
I felt a graceful passant pose would portray the questing beast as a fairy-like benign animal and not a ferocious beast.

3 Detailed Pencil Sketch
As I pencilled the details, I altered the cloven hooves of the concept sketch into clawed feet. It's safe to make choices like these as you develop your drawing.

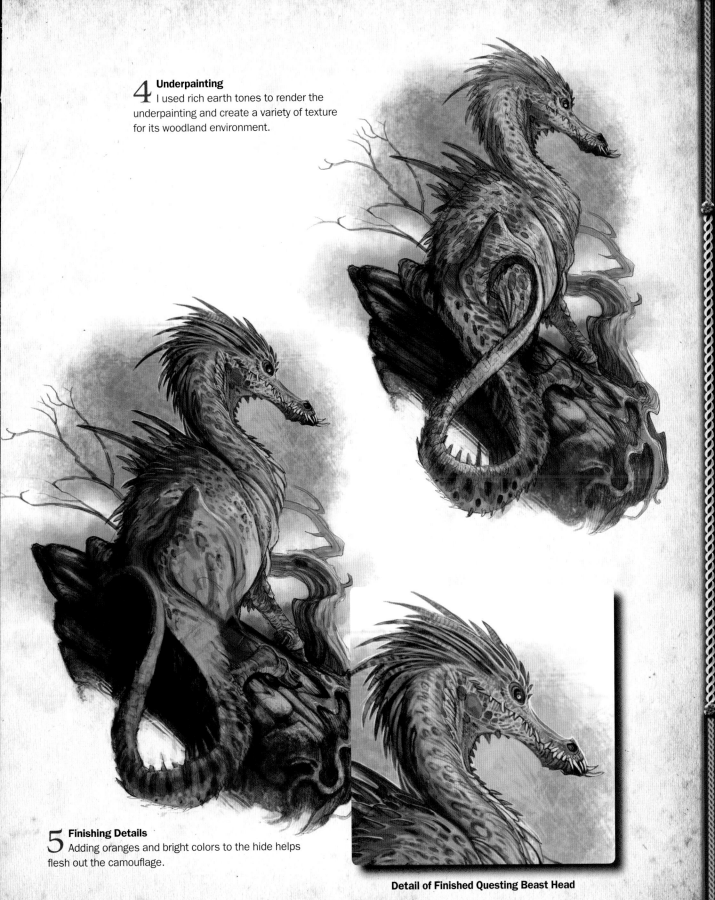

4 Underpainting
I used rich earth tones to render the underpainting and create a variety of texture for its woodland environment.

5 Finishing Details
Adding oranges and bright colors to the hide helps flesh out the camouflage.

Detail of Finished Questing Beast Head

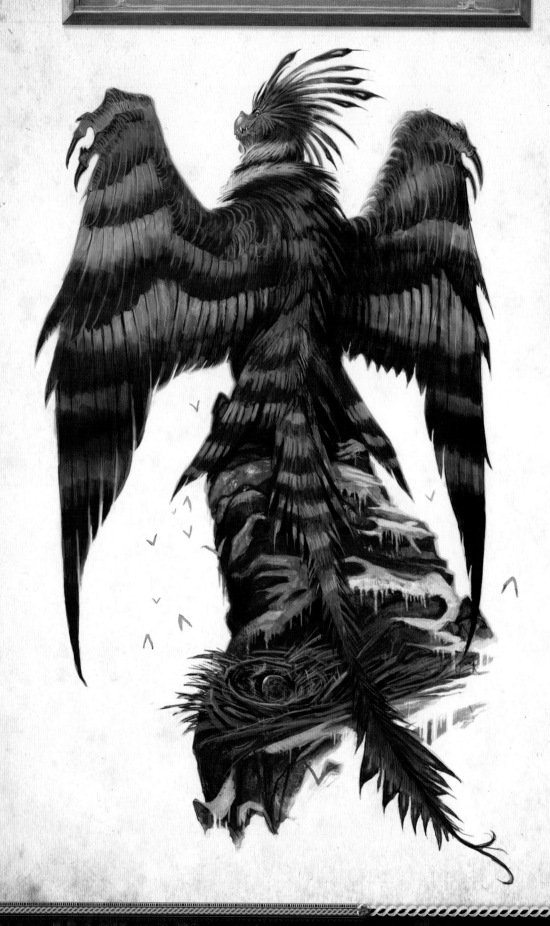

HISTORY

The enthralling image of the titanic *roc* has mesmerized artists and writers for centuries. Depictions of giant birds are common throughout several different legends, most famously the Arabian tales, North American Indian folklore and *The Lord of the Rings* by J.R.R. Tolkien.

Native to the Middle East and the Indian subcontinent, the roc is described in several legends and accounts by early explorers like Marco Polo as being large enough to carry off elephants and destroy ships. Cryptozoologists believe that a creature the size of a roc may be a living fossil from dinosaurs or perhaps a feathered species of dragon. The microraptor (*Microraptor zhaoianus*) or the prehistoric terror bird (*Titanis walleri*) may be the roc's distant relatives. In the American Pacific Northwest, recent accounts of giant raptors similar to the legendary thunderbird are likewise believed to be sightings of descendants of the mythical roc.

Mythical Depiction of the Roc Inspired by the Ancient Folklore *Arabian Nights*

Biblical Depiction of the Roc Inspired by Dante's *The Divine Comedy*

105

Demonstration
Roc

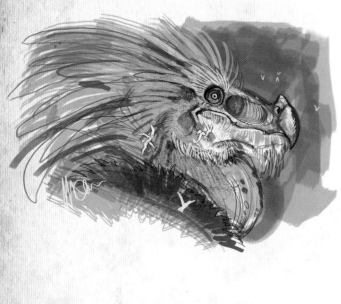

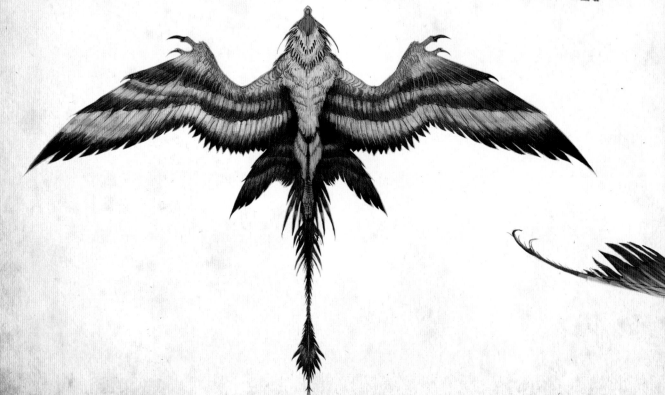

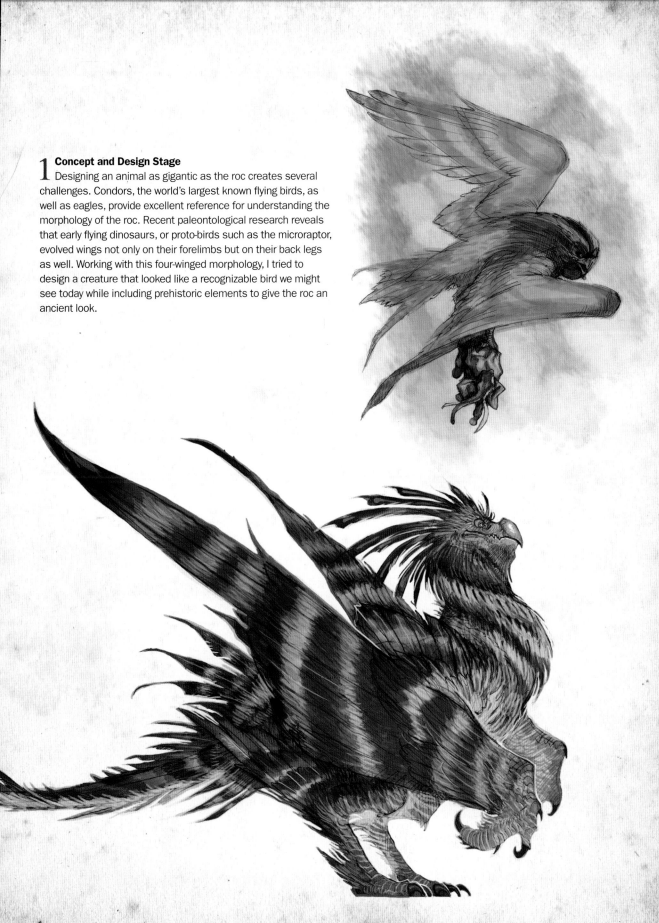

1 Concept and Design Stage

Designing an animal as gigantic as the roc creates several challenges. Condors, the world's largest known flying birds, as well as eagles, provide excellent reference for understanding the morphology of the roc. Recent paleontological research reveals that early flying dinosaurs, or proto-birds such as the microraptor, evolved wings not only on their forelimbs but on their back legs as well. Working with this four-winged morphology, I tried to design a creature that looked like a recognizable bird we might see today while including prehistoric elements to give the roc an ancient look.

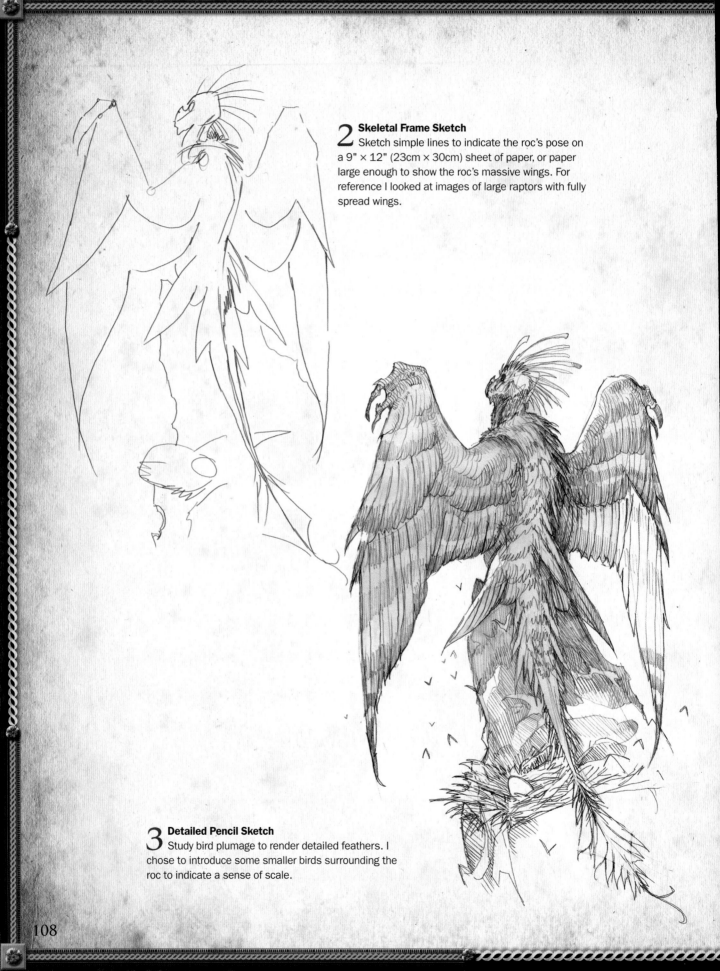

2 Skeletal Frame Sketch
Sketch simple lines to indicate the roc's pose on a 9" × 12" (23cm × 30cm) sheet of paper, or paper large enough to show the roc's massive wings. For reference I looked at images of large raptors with fully spread wings.

3 Detailed Pencil Sketch
Study bird plumage to render detailed feathers. I chose to introduce some smaller birds surrounding the roc to indicate a sense of scale.

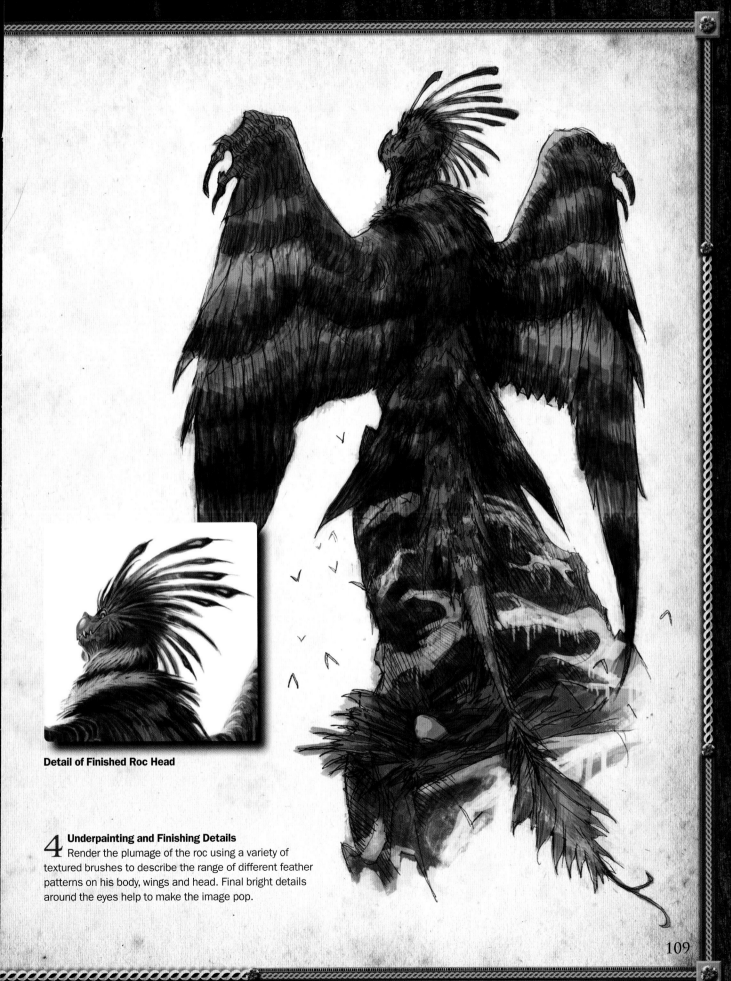

Detail of Finished Roc Head

4 Underpainting and Finishing Details
Render the plumage of the roc using a variety of textured brushes to describe the range of different feather patterns on his body, wings and head. Final bright details around the eyes help to make the image pop.

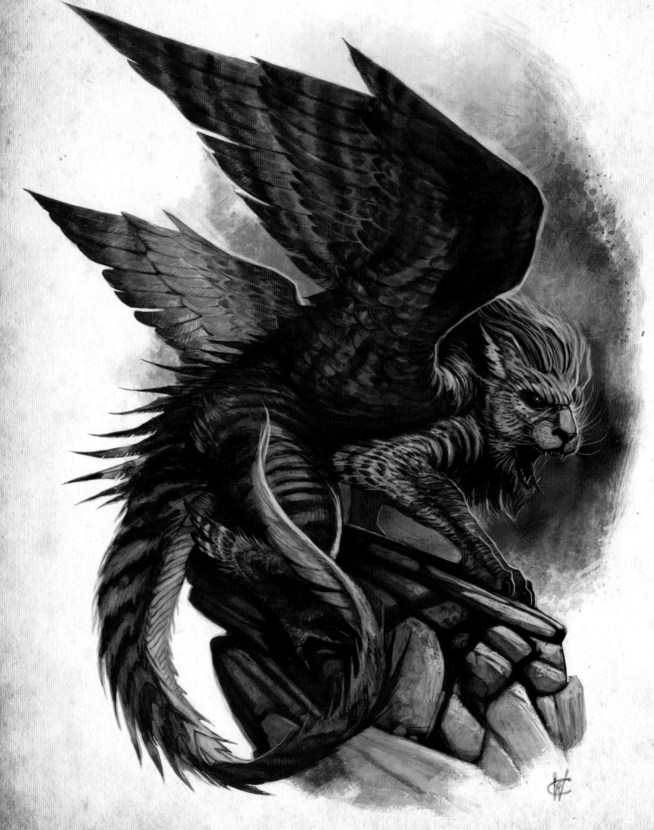

HISTORY

Related closely to the griffin, the *shedu* is a winged lion that has represented royalty and majestic power since the times of ancient Persia. The shedu is believed to have originated in Persian territory, though a living specimen has ever been discovered.

In some cultures, the shedu and the llamasu are thought of as the same creature, though the latter is more closely related to the buraq. In Christian lore, the winged lion came to represent St. Mark the Evangelist. The Republic of Venice used the shedu on their coat of arms because of St. Mark's Basilica in the city.

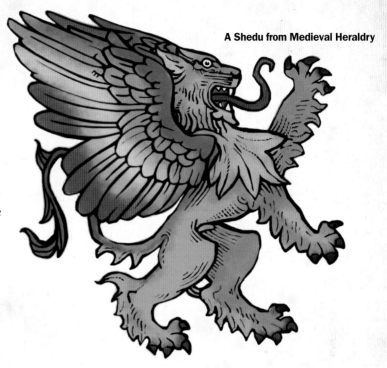

A Shedu from Medieval Heraldry

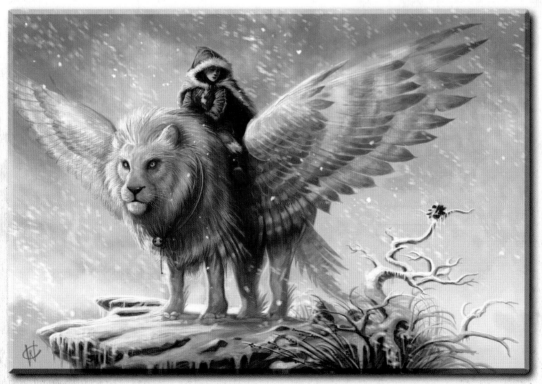

White Shedu
Digital
11" × 17" (28cm × 43cm)

SHEDU

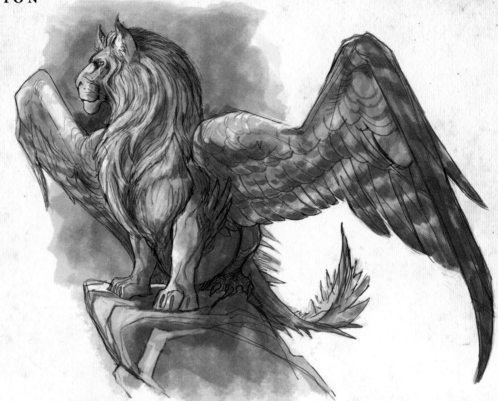

1 Concept and Design Stage

The similarity of the shedu to the griffin is important in that its leonine body design must be winged in order for this beast to obtain flight. It is important for the tail to be rendered realistically to convey controlled flight. The shedu is essentially the inverse of the griffin in that the front of the beast is a lion whilst the hindquarters are avian. To enhance this avian quality I designed more raptor-like hind legs combined with a feathered, almost draconic tail. To ensure design continuity I incorporated both feathers and fur throughout its anatomy.

2 Skeletal Frame Sketch

I sketched my shedu in a crouched position to give the impression that he just landed or is ready to take flight again.

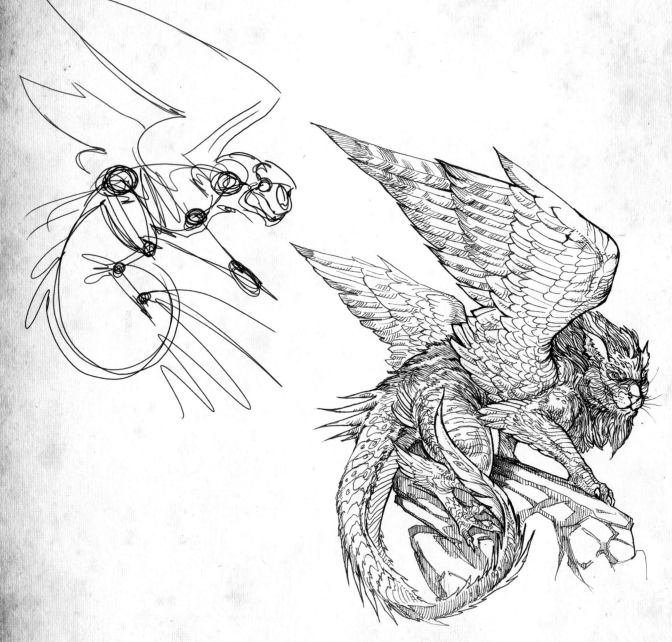

3 Detailed Pencil Sketch

Feathered creatures allow the artist great creative license in concepting unique designs. Research exotic birds for unending ideas for plumage styles and colors.

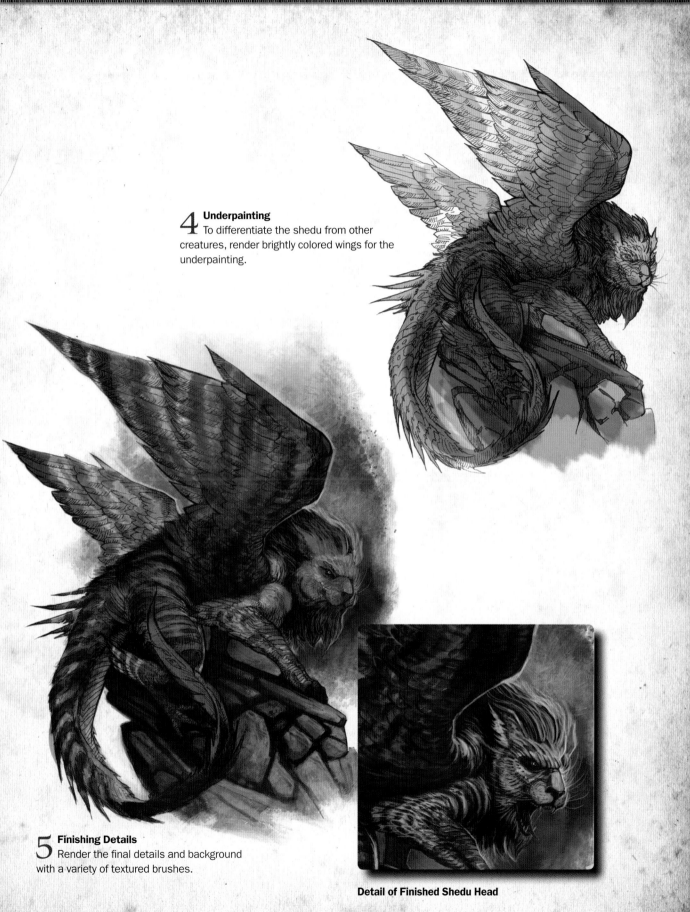

4 **Underpainting**
To differentiate the shedu from other creatures, render brightly colored wings for the underpainting.

5 **Finishing Details**
Render the final details and background with a variety of textured brushes.

Detail of Finished Shedu Head

TARASQUE

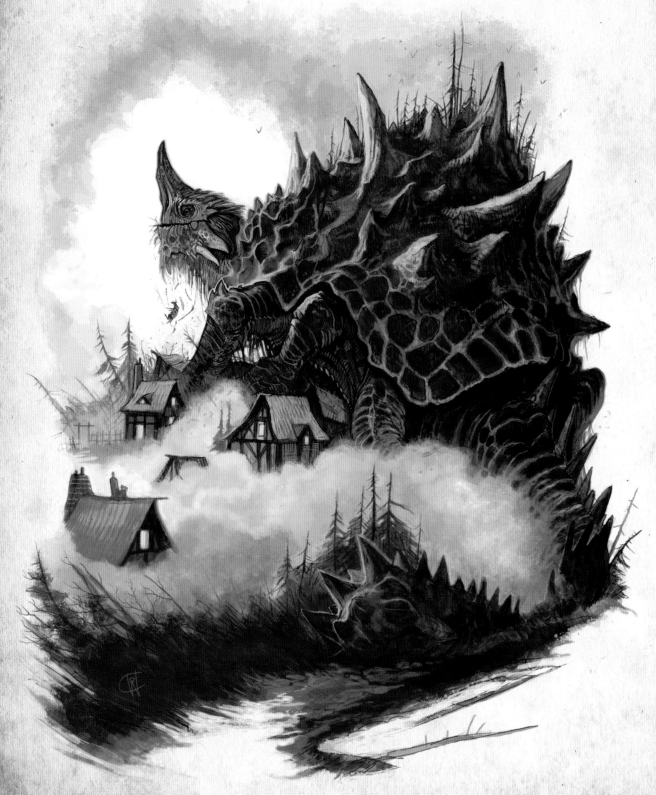

HISTORY

The *tarasque* is considered by some to be the most powerful of all the legendary creatures. In 2005 UNESCO, a division of the United Nations, included the tarasque on the list of Masterpieces of the Oral and Intangible Heritage of Humanity.

The legend of St. Martha and the Tarasque is related in the medieval omnibus of the Golden Legend. The tarasque was a horrible beast that emerged from the waters of the Rhone River in Provence, France. It had a turtle's shell, the head of a beast, six legs and a stingered tail. The creature ravaged the landscape, destroying everything in its path. The king sent out his knights to slay the tarasque with swords and spears and even catapults, but nothing would damage the beast. At last St. Martha went out to the tarasque and tamed the horrible animal, saving the countryside. The town she saved was renamed Tarascon, and every year the citizens put on a parade that reenacts the legend of St. Martha and the Tarasque.

No one is certain of the biological nature of the tarasque. Some suggest that the gargantuan beast was a species of dragon, while others insist that because of its six legs and turtle shell, it was a form of basilisk that somehow migrated or was imported into southern France across the Mediterranean from northern Africa. Other legends insist the tarasque came from Galatia, which is situated in modern-day Turkey. Whatever the truth, the legend of the tarasque is deeply rooted in French culture and inspires wonderful storytelling that even today inspires contemporary monster movies.

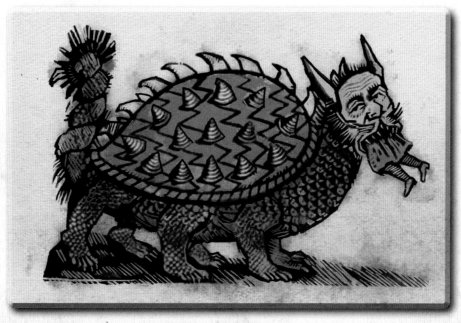

Medieval Woodcut of the Tarasque

DEMONSTRATION
TARASQUE

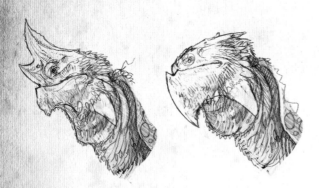

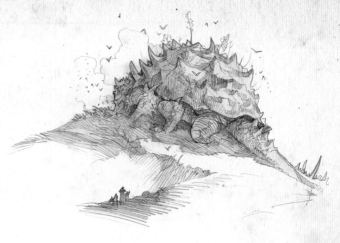

1 Concept and Design Stage

The town of Tarascon provides a lot of historical reference to work with when designing a tarasque. My first priority in concepting my design was to try to convey the animal's titanic size. I envisioned a gargantuan ankylosaur—a huge, heavily armored creature. A beast so big it swept like a vacuum through the countryside eating everything in sight with its huge steam-shovel-shaped mouth. It would move so slowly that groves of trees grew on its back. To further this aesthetic I developed a plow-shaped head for furrowing through everything in its path. My tarasque would have no teeth, since it would simply crush and swallow its food whole.

2 Skeletal Frame Sketch

Sketch a large shell to begin the line drawing. I envisioned a tarasque so many centuries old that its spikes and armor have grown a patina of moss and algae. Pits and dents and broken spikes on its armor tell the tale of kings and knights hurling arrows, spears and catapult stones in a futile attempt to halt the leviathanic beast. Much like a whale, its giant body is capable of supporting a huge ecosystem of crows and rats that live and travel on the huge animal. The tarasque was the original Godzilla.

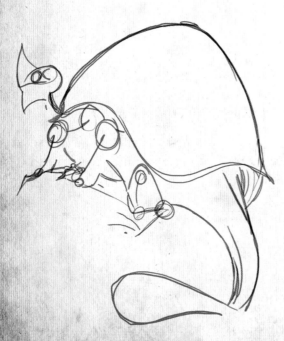

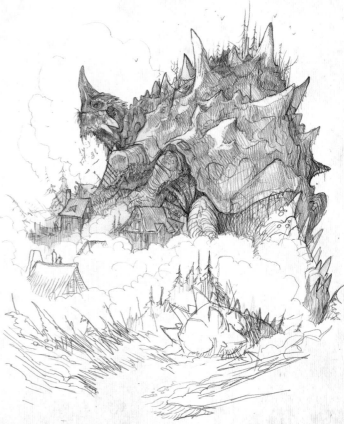

3 Detailed Pencil Sketch

Grazing through the countryside, the unstoppable tarasque consumes everything in its path, including whole villages.

4 Underpainting
I chose semi-transparent colors to establish the base colors of the tarasque's body and the land with the goal of creating camouflage.

5 Finishing Details
Complete the details and coloring of the tarasque with muted earthtones. Camouflage patterns are unnecessary since nothing can harm such a large and heavily armored creature. Mating markings of display are also unneeded since it is believed that the tarasque is a unique creature.

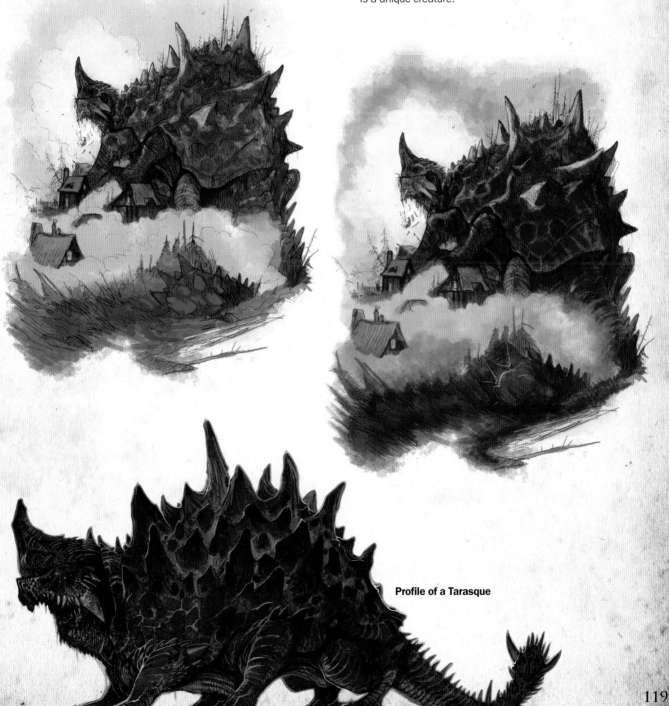

Profile of a Tarasque

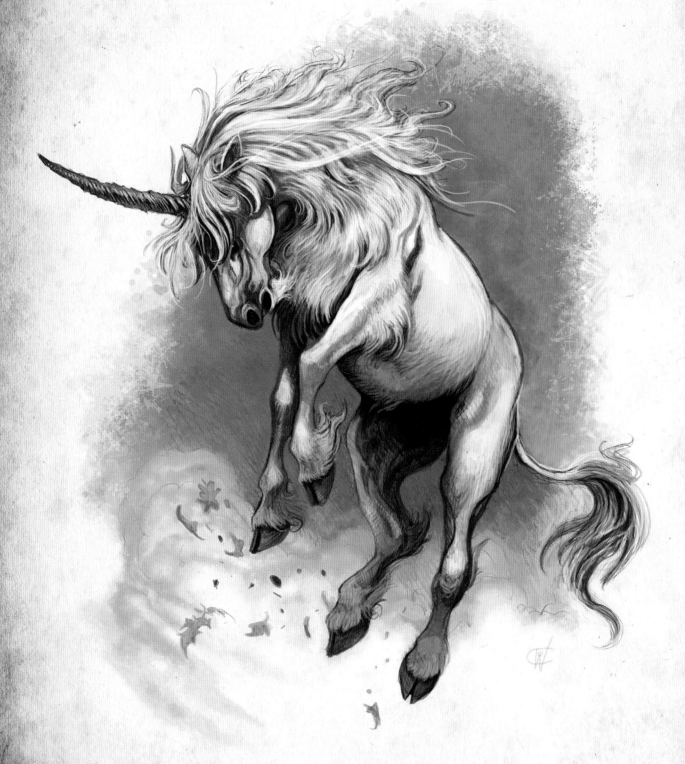

HISTORY

No other creature captures the imagination of the medieval bestiary better than the *unicorn*. What is described as a horned horse is in fact a beast of immense power and beauty. Almost always described as a pure white stallion with a majestic horn, in medieval Europe the unicorn was an important symbol of Christ—a pure and powerful creature that was betrayed, captured and sacrificed. It is believed the unicorn was a Christian adaptation of the Celtic white stag, which represented the power of nature and was an avatar of the gods.

Known to live in the forests of Europe, the unicorn was so formidable a beast with its slashing horn that hunters with spears and hounds could not bring it down. Though an herbivore, the unicorn was feared to be as dangerous a woodland creature as the wild boar. It was believed that the power of the unicorn was contained within its horn, which was prized for its medicinal qualities. The unicorn's weakness, however, was that the purity and goodness of a maiden could tame it like a puppy. Hunters used maidens as bait to lure and trap unicorns to be slain. According to medieval bestiaries and illustrations, the unicorn is about the size of a pony or deer, not a full-sized horse. A second distinction from the horse is its cloven, goatlike hooves and distinctive goatee and tail. It is possible that the unicorn was a wild woodland species of the *Caprinae* family. Contemporary historians have suggested that rare narwhal horns from the north gave rise to the legend of the unicorn. The United Kingdom to this day employs the symbols of the lion and the unicorn on its coat of arms.

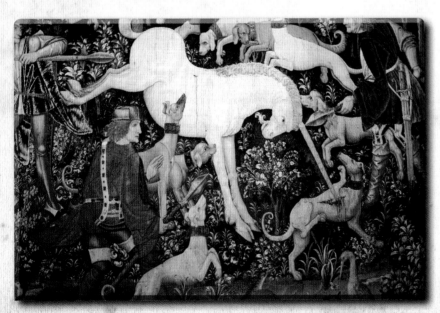

Detail From *The Hunt of the Unicorn* Tapestries (Circa 1500), Collection of Metropolitan Museum of Art in New York City

UNICORN

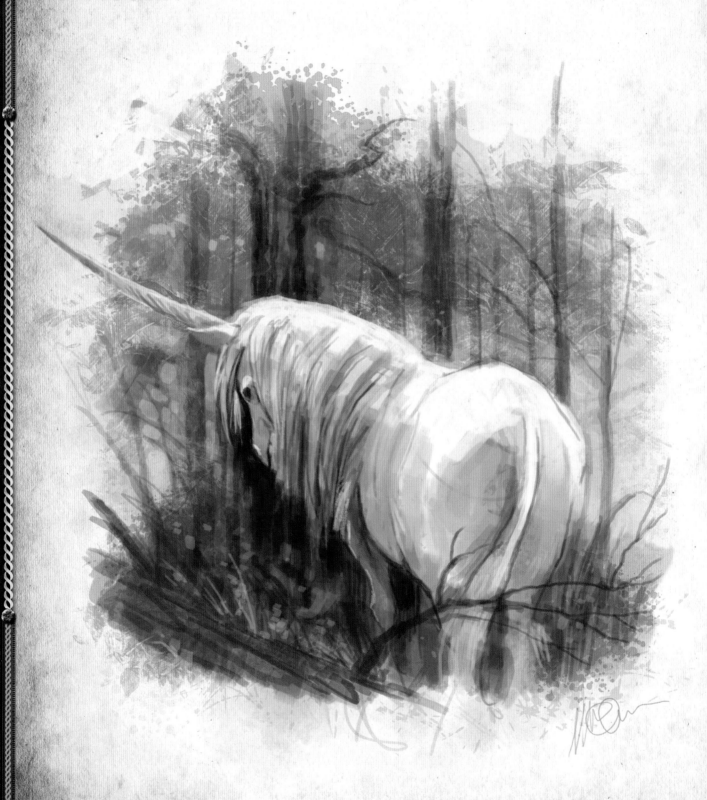

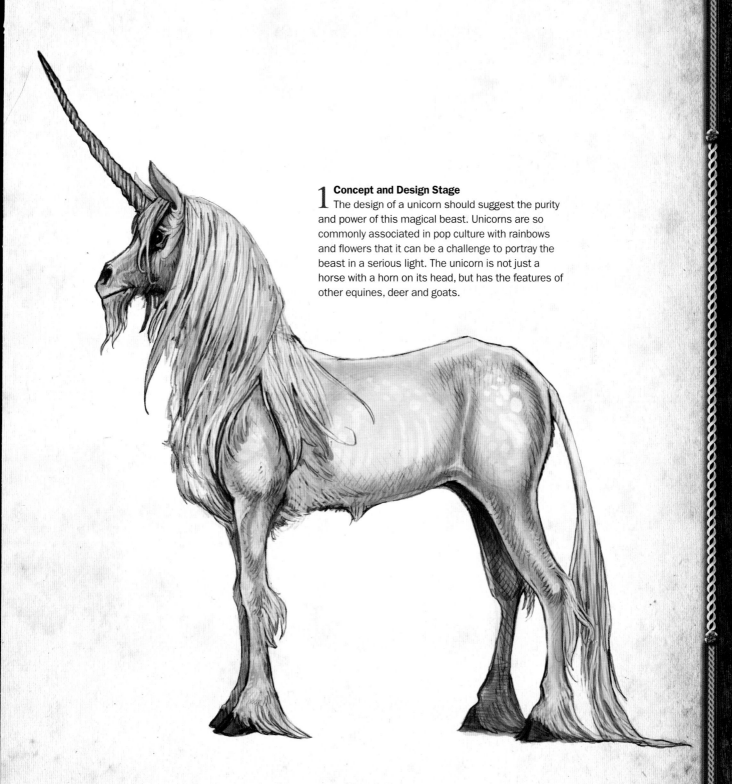

1 Concept and Design Stage
The design of a unicorn should suggest the purity and power of this magical beast. Unicorns are so commonly associated in pop culture with rainbows and flowers that it can be a challenge to portray the beast in a serious light. The unicorn is not just a horse with a horn on its head, but has the features of other equines, deer and goats.

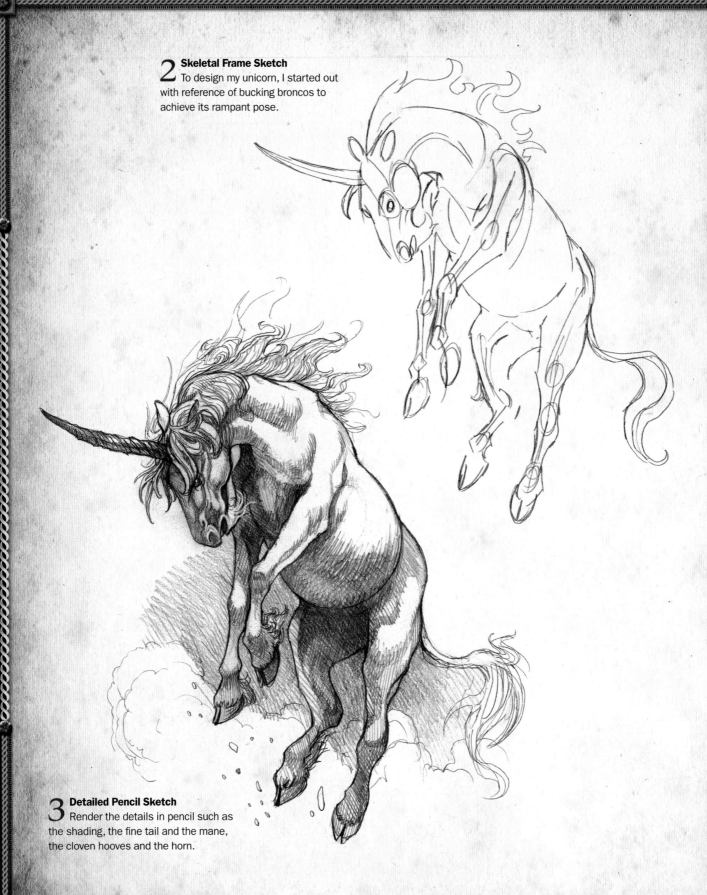

2 Skeletal Frame Sketch
To design my unicorn, I started out with reference of bucking broncos to achieve its rampant pose.

3 Detailed Pencil Sketch
Render the details in pencil such as the shading, the fine tail and the mane, the cloven hooves and the horn.

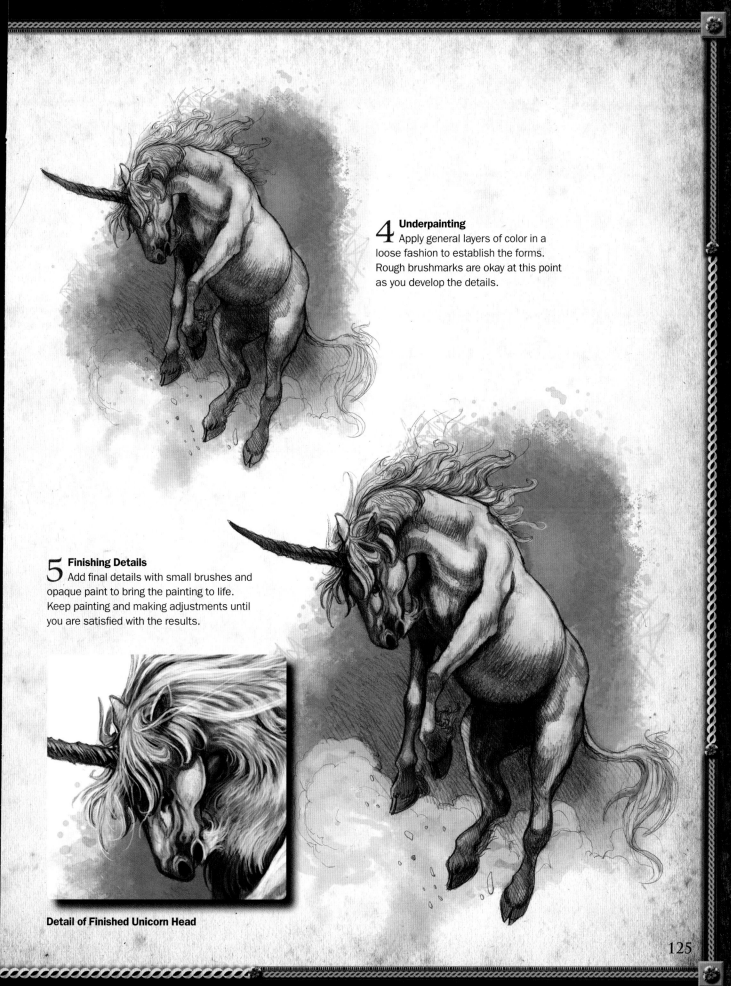

4 Underpainting
Apply general layers of color in a loose fashion to establish the forms. Rough brushmarks are okay at this point as you develop the details.

5 Finishing Details
Add final details with small brushes and opaque paint to bring the painting to life. Keep painting and making adjustments until you are satisfied with the results.

Detail of Finished Unicorn Head

125

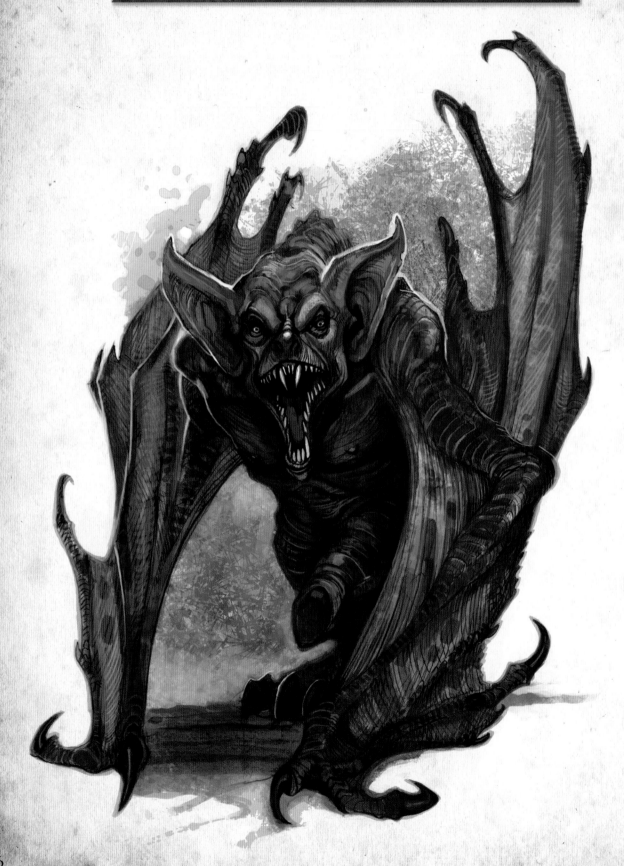

HISTORY

Romantic Gothic characters who populate the pages of contemporary fiction are not true vampires as depicted in medieval bestiaries. Real *vampires* were grotesque beasts most accurately depicted in medieval gargoyles. Vampires were fearsome nocturnal animals about the size of a dog with a 10 foot (3m) wingspan. They filled the nightmares of folklore and legends for centuries.

Cryptozoologists consider the vampire to be a European relative of the imp, while others suggest it's a distant cousin of the bat (*Chiroptera*). Whatever its origin these denizens of the night were large enough to carry off children and small animals while feeding on the blood of large cattle. Vampires were thought to carry diseases like rabies, similar to modern bats, and generated in humans the logical fear of contagious vampirism. In many contemporary stories vampires are able to transform into a variety of creatures including giant flying bats.

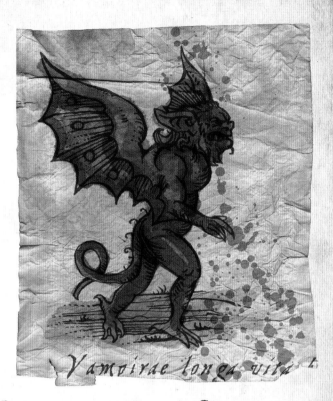

Various Depictions of the Vampire Throughout Medieval Bestiaries

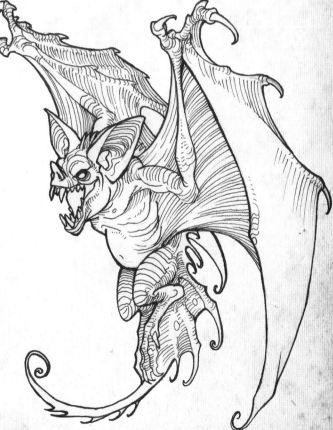

VAMPIRE

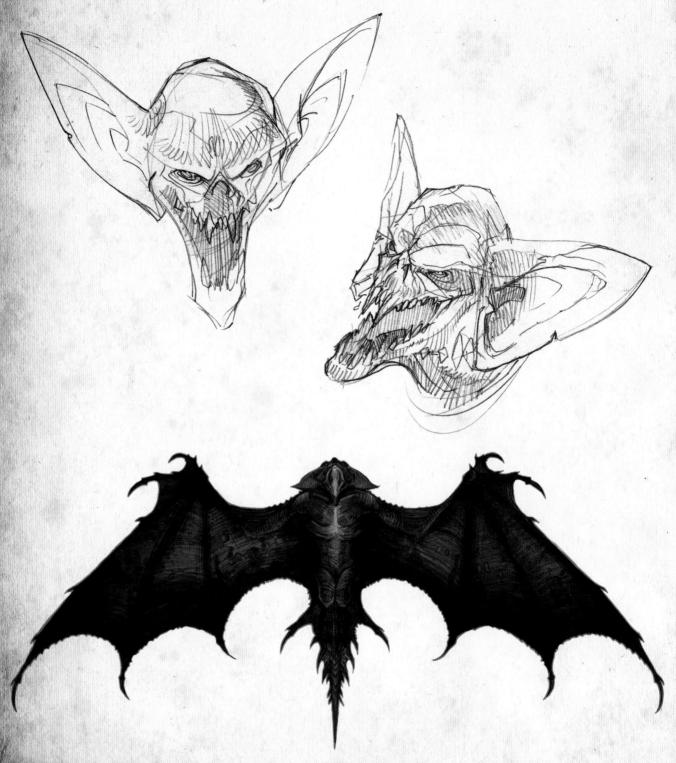

Aerial View of a Vampire, Wingspan 10' (3m)

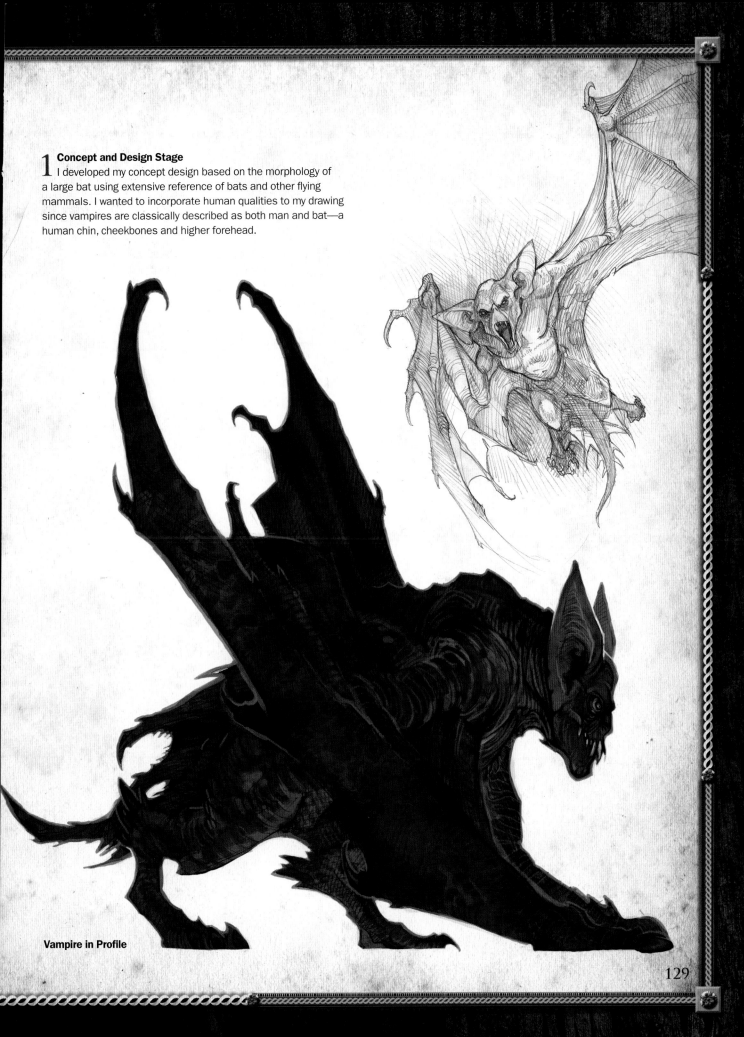

1 Concept and Design Stage

I developed my concept design based on the morphology of a large bat using extensive reference of bats and other flying mammals. I wanted to incorporate human qualities to my drawing since vampires are classically described as both man and bat—a human chin, cheekbones and higher forehead.

Vampire in Profile

2 Skeletal Frame Sketch
Visualize how the vampire might use his arms for both flying and walking and design the pose using the ball and stick construction. When drawing bat wings, envision a folding umbrella. If you have one laying around the house, observe how it opens and closes.

3 Detailed Pencil Sketch
Work on top of the armature sketch with pencil to render the musculature and surface details. Continue to check your reference to achieve accuracy.

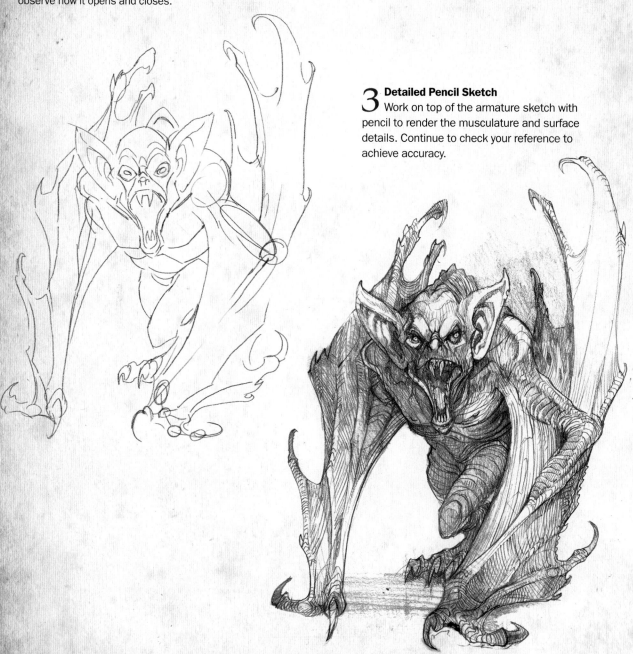

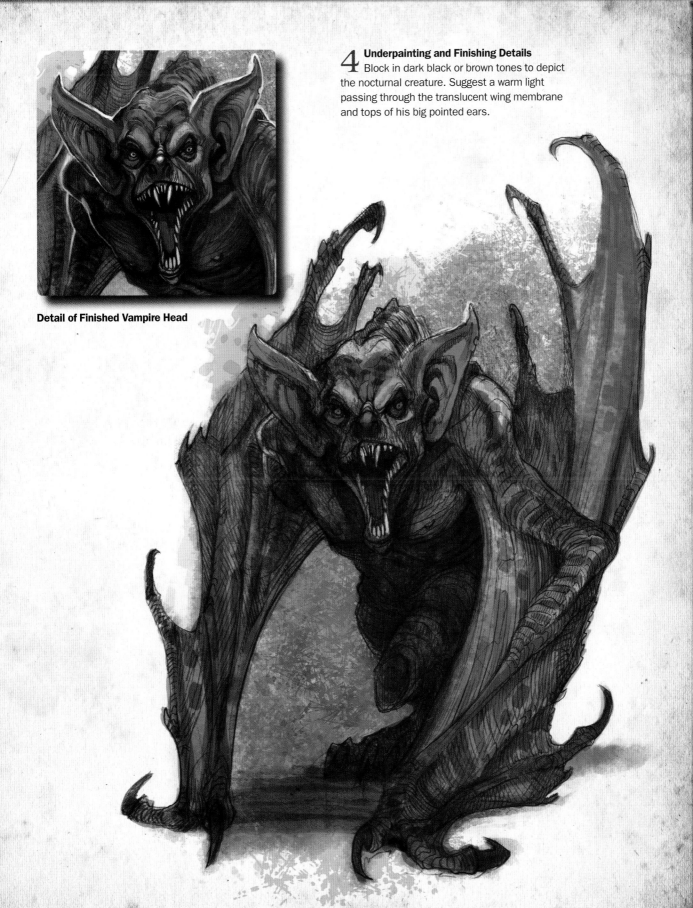

Detail of Finished Vampire Head

4 Underpainting and Finishing Details
Block in dark black or brown tones to depict the nocturnal creature. Suggest a warm light passing through the translucent wing membrane and tops of his big pointed ears.

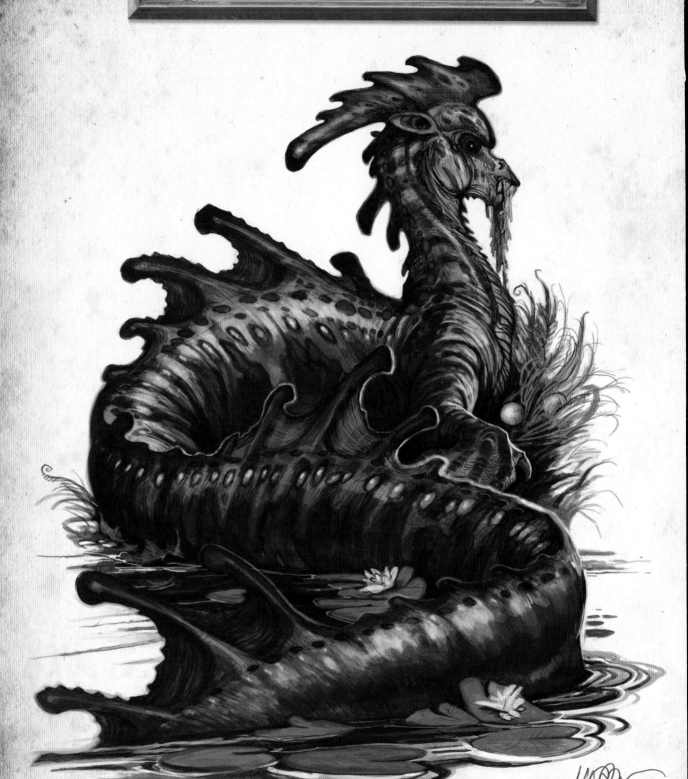

HISTORY

Throughout mythology the *waterhorse* has taken many different forms in different cultures. Whether the majestic Greek *hippocamp* or the Scottish kelpie, these animals relate to a variety of amphibious equine creatures of legend. Most of these legends doubtlessly gained their origin from the very real hippopotamus (Greek for river horse), manatee and species in the *Dugongidae* family.

The evolution of land mammals into aquatic mammals is well understood from the fossil record and by research on animals as diverse as seals to blue whales. This evolution is also well documented in other classes of animals such as reptiles and dinosaurs. It is possible that legends of the waterhorse allude to long extinct species of creatures like hadrosaurs and early whales.

Like they do for the *yeti*, cryptozoologists still hunt feverishly for the elusive waterhorse. Whether in the lochs of Scotland, the deep lakes of North America or the rivers of Africa, the search for this magnificent rumored species continues.

Waterhorse on a Scottish Coat of Arms

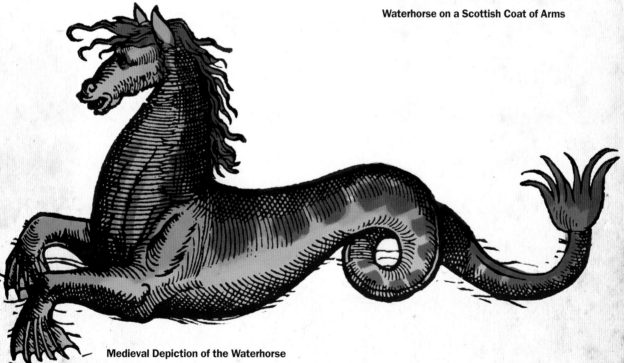

Medieval Depiction of the Waterhorse

WATERHORSE

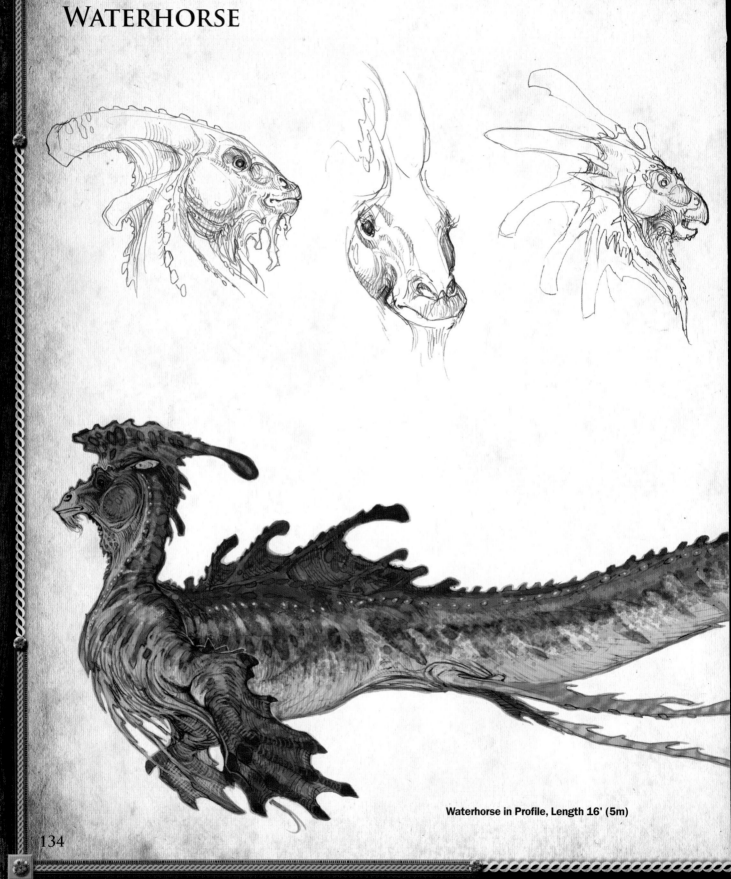

Waterhorse in Profile, Length 16' (5m)

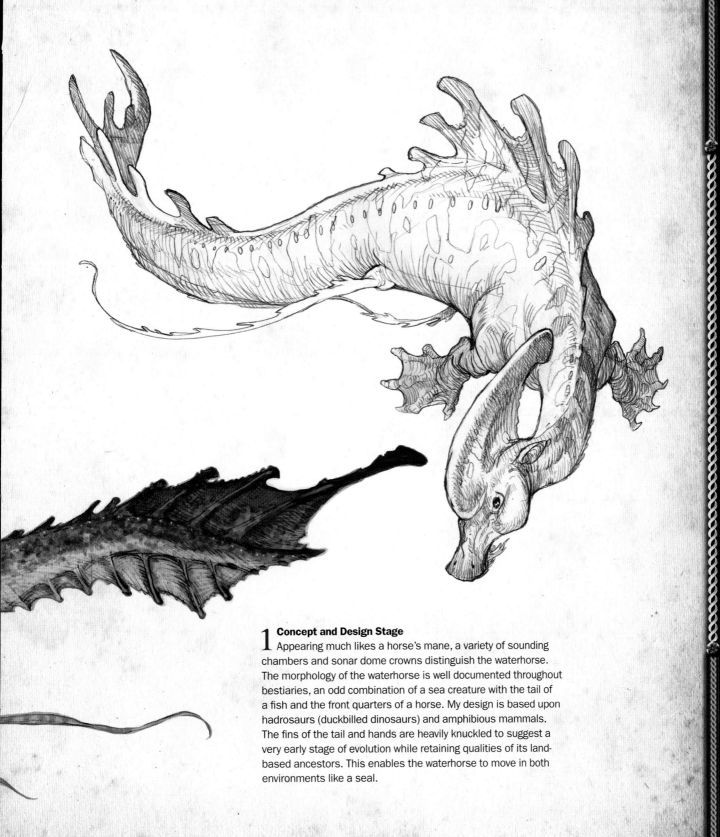

1 Concept and Design Stage

Appearing much likes a horse's mane, a variety of sounding chambers and sonar dome crowns distinguish the waterhorse. The morphology of the waterhorse is well documented throughout bestiaries, an odd combination of a sea creature with the tail of a fish and the front quarters of a horse. My design is based upon hadrosaurs (duckbilled dinosaurs) and amphibious mammals. The fins of the tail and hands are heavily knuckled to suggest a very early stage of evolution while retaining qualities of its land-based ancestors. This enables the waterhorse to move in both environments like a seal.

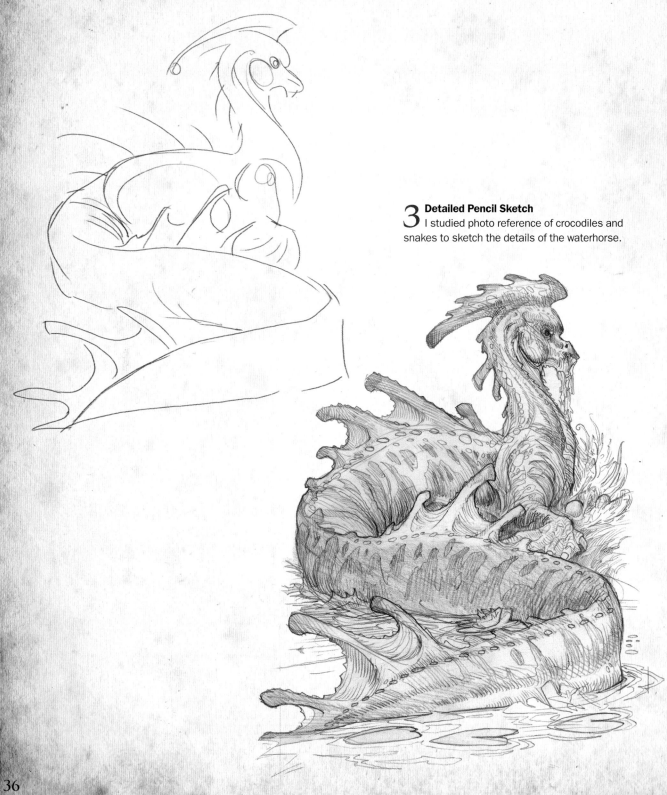

2 Skeletal Frame Sketch
Use foreshortening techniques to sketch the long serpentine body of the waterhorse.

3 Detailed Pencil Sketch
I studied photo reference of crocodiles and snakes to sketch the details of the waterhorse.

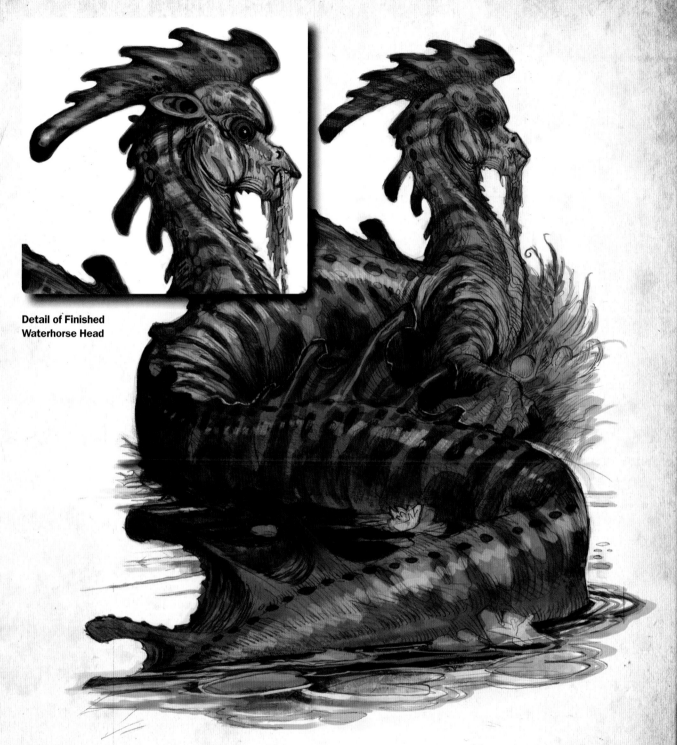

**Detail of Finished
Waterhorse Head**

4 Underpainting and Finishing Details

Lay in a transparent layer of color over the drawing to resemble camouflage providing security from predators. Bright markings and a slick, wet hide help complete the painting. Add phosphorescent spots along its back to aid in its visibility while in dark, murky swamps. This helps to support the legends of kelpies and will-o'-the-wisps that lured unsuspecting travelers into the swamp and to their doom.

HISTORY

Taken from the Greek *xeno*, meaning alien or stranger, the *xenobeast* is any monster that is not from this earth. Cryptozoologists have long hunted for evidence of alien creatures that may have visited this planet, but with no success. For now, the xenobeast exists in the imagination of the artist.

Around the world cryptozoologists and art historians have combined their data to piece together the mystery of the xenobeast. A common story or lore of a spirit, dragon or demon (usually accompanied by artwork) that arrived in conjunction with shooting stars and comets. Similar stories of an outerworld creature abound around the world and such data is now believed to reference the xenobeast.

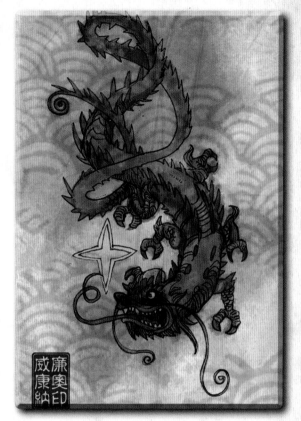

Japanese Depiction of a Xenobeast

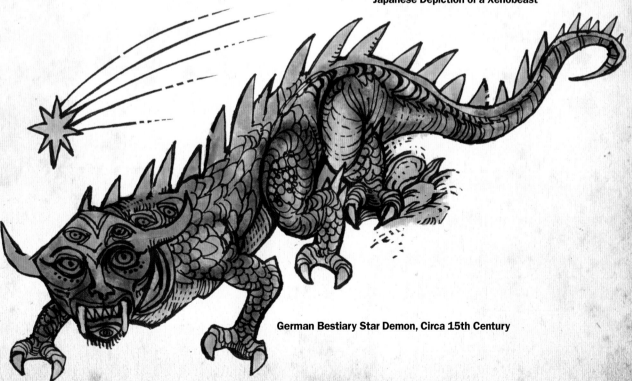

German Bestiary Star Demon, Circa 15th Century

XENOBEAST

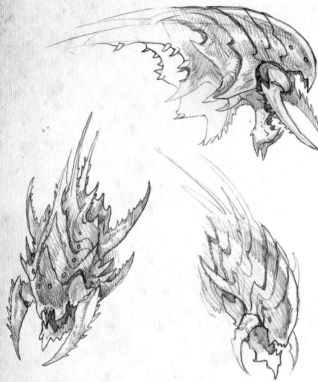

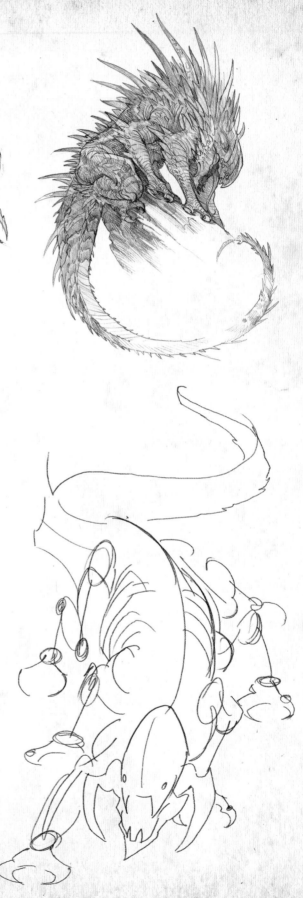

1 Concept and Design Stage

When designing a monster like the xenobeast, the challenge is to make the creature as alien as possible by using morphology not natural to the Earth. I decided six legs with two claws would create a strange aesthetic since I know of no animal on this planet with that combination. Adding other morphology not found in large predators from this world, such as multiple eyes and a plated exoskeleton, furthers its otherworldliness.

By combining elements from different animal types while still basing the creature in the necessity of form following function, you can create a beast that is completely unique but at the same time plausible. Try combining disparate animal morphology to see what kind of strange xenobeasts you can come up with.

2 Skeletal Frame Sketch

Lightly sketch the frame armature to visualize the xenobeast. Use various reference to make sure the structure and anatomy of the creature work logically.

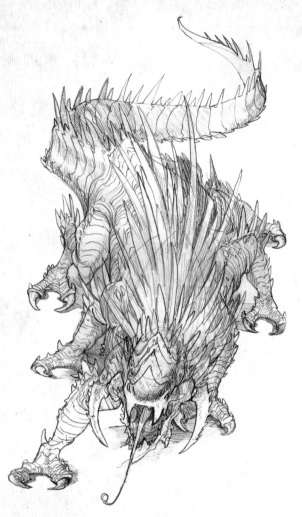

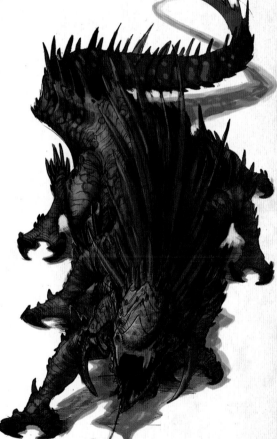

4 Underpainting and Finishing Details

I decided that this xenobeast would be nocturnal in order to make it more frightening and nightmarish. Use loose transparent colors to block in dark purple and blue markings. Have fun playing with the patterns and textural details of its carapace-like exoskeleton.

3 Detailed Pencil Sketch

Use a pencil to render the scales, spikes and plates of the xenobeast. Have fun—you are limited only by the extent of your imagination.

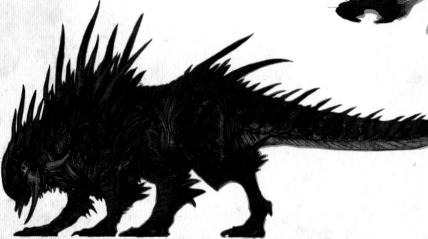

Xenobeast in Profile

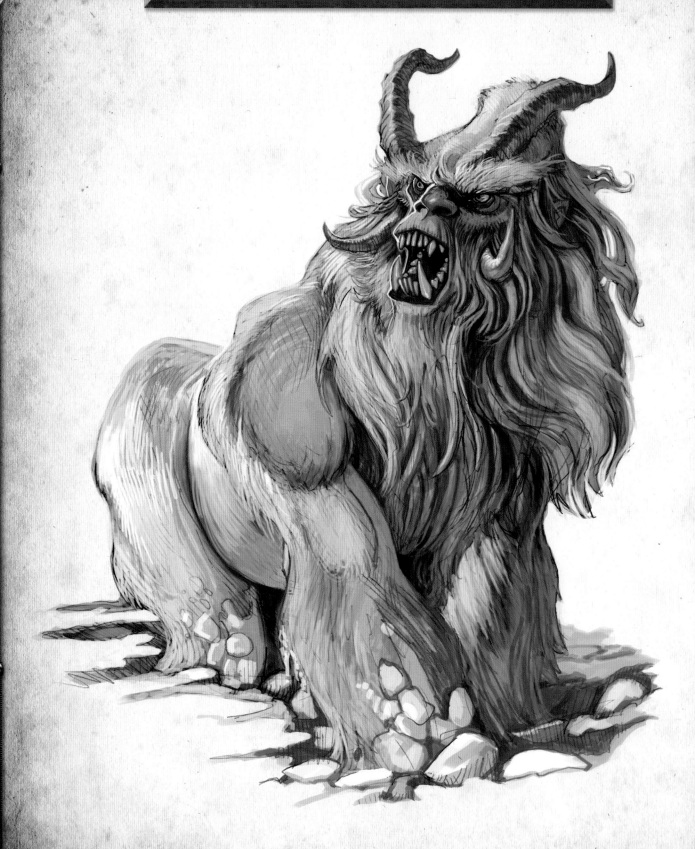

HISTORY

Whether it is called a *yeti*, Bigfoot, Abominable
Snowman, Sasquatch or Batutut, the legend of the giant
man-ape is a myth found all over the world. Even today,
cryptozoologists believe and search for the yet to be
discovered species. The discovery of the mountain gorilla
in the early twentieth century as well as the 9 foot (3m)
tall *Gigantopithecus* fossils have lead some scientists
to believe there may be remote alpine regions where
undiscovered apes still exist.

Today the legend of the yeti is alive and well with
numerous expeditions conducted every year around the
world to discover the elusive creature. Thousands of yeti
sightings are reported each year from Canada to Tibet.

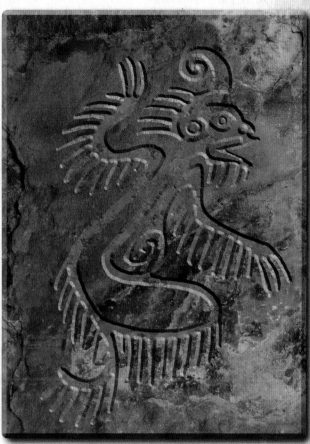

Petroglyph of a Mountain Ape

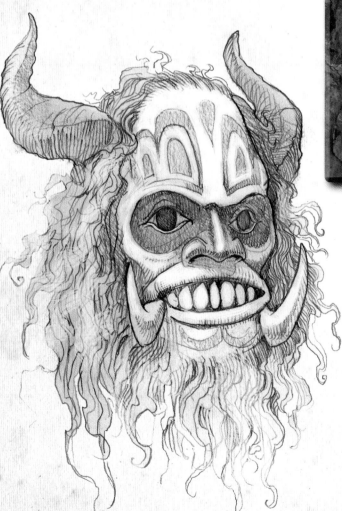

American Pacific Northwest Tribal Mask of Sasquatch

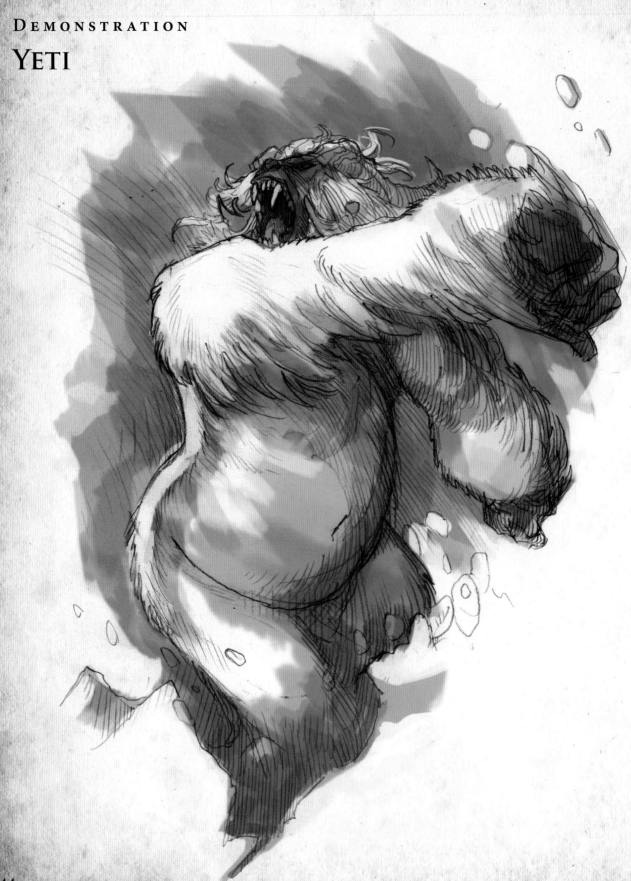

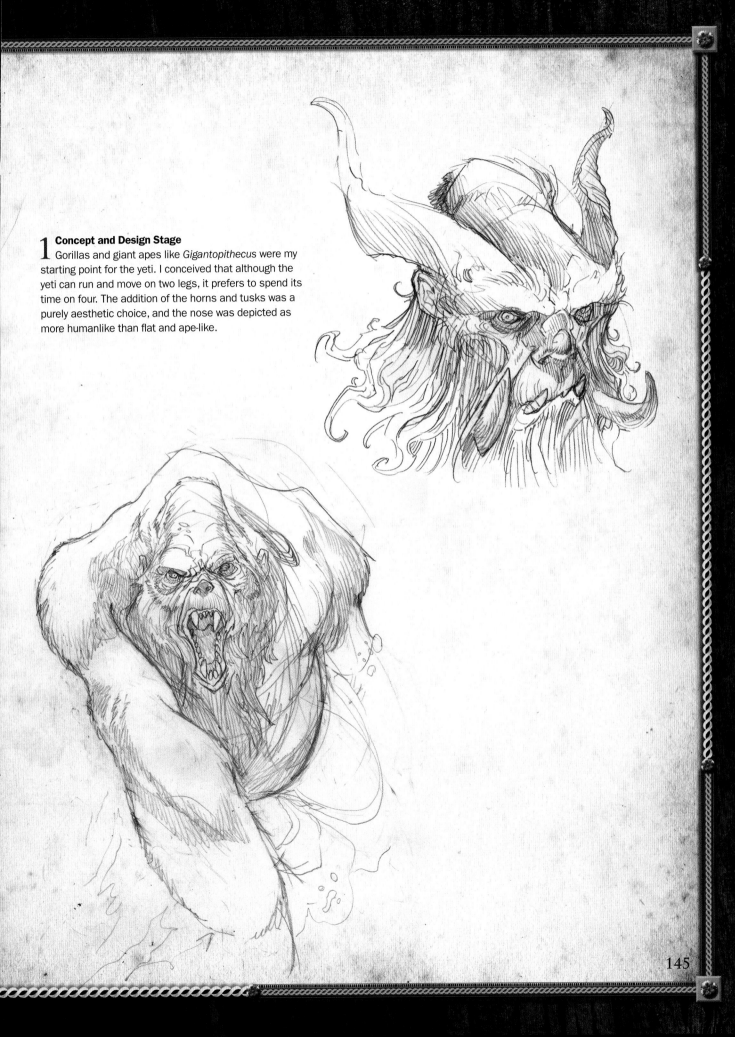

1 Concept and Design Stage

Gorillas and giant apes like *Gigantopithecus* were my starting point for the yeti. I conceived that although the yeti can run and move on two legs, it prefers to spend its time on four. The addition of the horns and tusks was a purely aesthetic choice, and the nose was depicted as more humanlike than flat and ape-like.

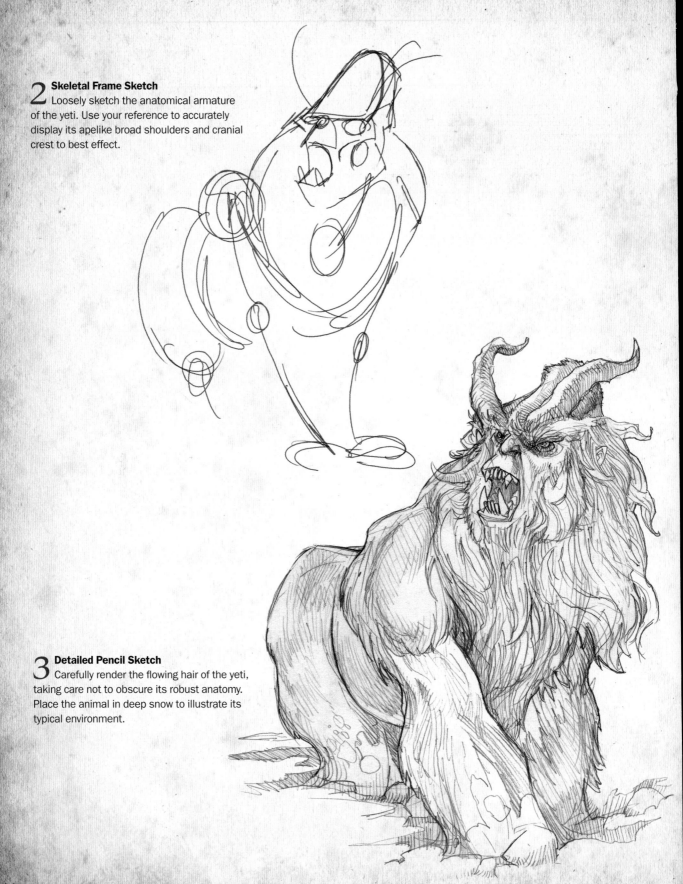

2 Skeletal Frame Sketch
Loosely sketch the anatomical armature
of the yeti. Use your reference to accurately
display its apelike broad shoulders and cranial
crest to best effect.

3 Detailed Pencil Sketch
Carefully render the flowing hair of the yeti,
taking care not to obscure its robust anatomy.
Place the animal in deep snow to illustrate its
typical environment.

146

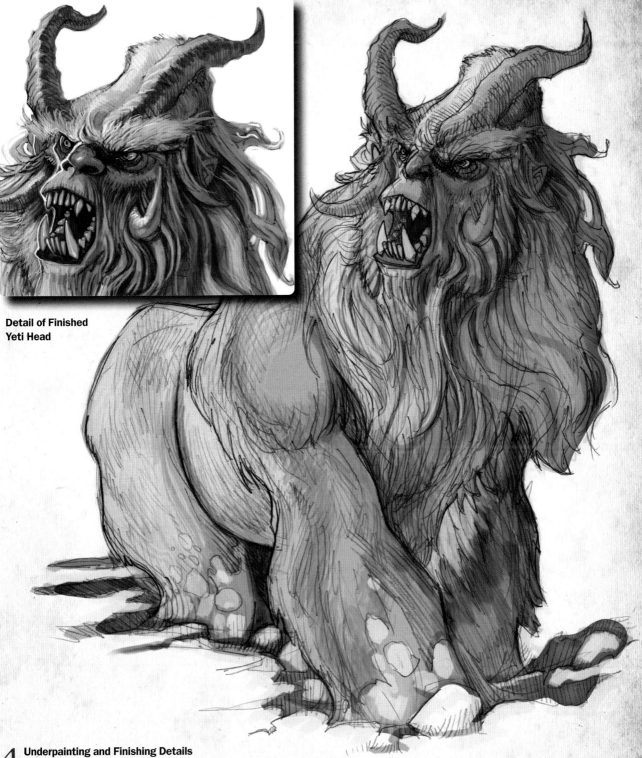

**Detail of Finished
Yeti Head**

4 Underpainting and Finishing Details
Cool shadows will add to the environmental design. Create subtle tonal differences between the white of the snow and the white of the yeti to help differentiate the forms. Render the final details of the yeti with opaque white paint with fine detail brushes. A hint of color around the face helps focus the image and bring life to this creature. The eyes are especially important. Color them green to suggest human demeanor and intelligence.

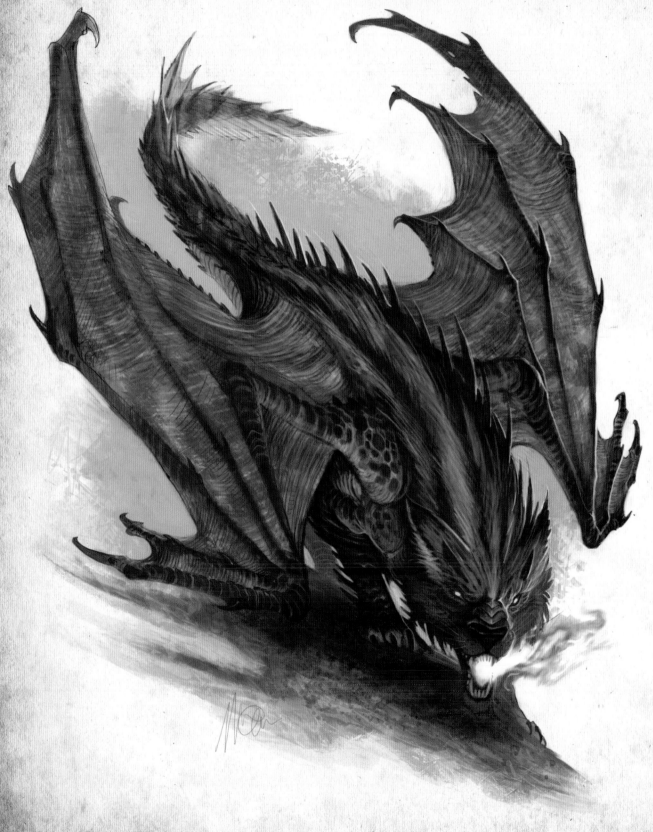

HISTORY

The *zburator* (*Dracone* or *Dacian Draco*) was long held as a powerful totem by the people of Dacia, modern-day Romania. Combining the power of the wolf with the anatomy of a dragon, the zburator became a symbol to be feared by the Roman Empire.

Living on the mountains of what was once Transylvania, the dragon-wolf zburator was a terror to local farmers, a formidable predator capable of breathing fire. During the Roman invasion of Dacia in 100 B.C., the Dacians used a depiction of the zburator as a war banner to strike fear into the hearts of their enemies.

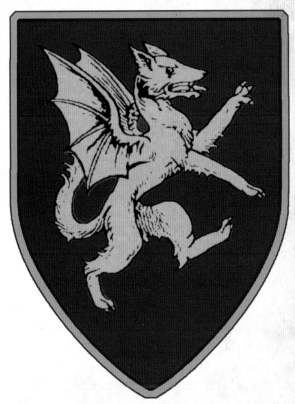

Zburator on a Medieval Coat of Arms

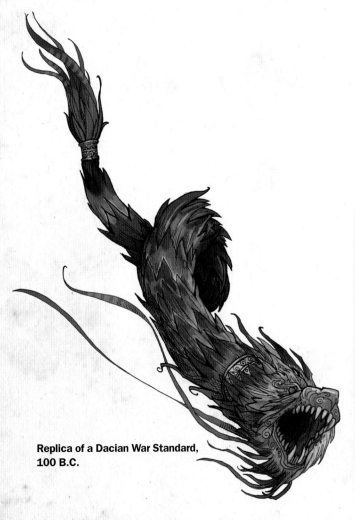

Replica of a Dacian War Standard, 100 B.C.

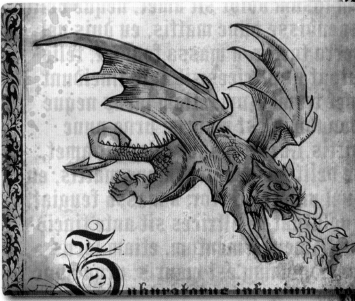

Zburator Depicted in a Medieval Bestiary

DEMONSTRATION
ZBURATOR

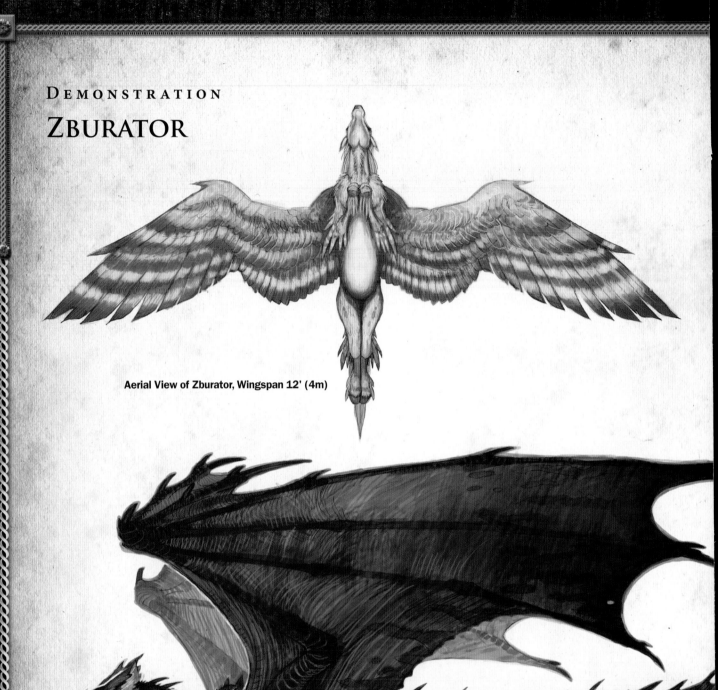

Aerial View of Zburator, Wingspan 12' (4m)

Zburator in Profile

150

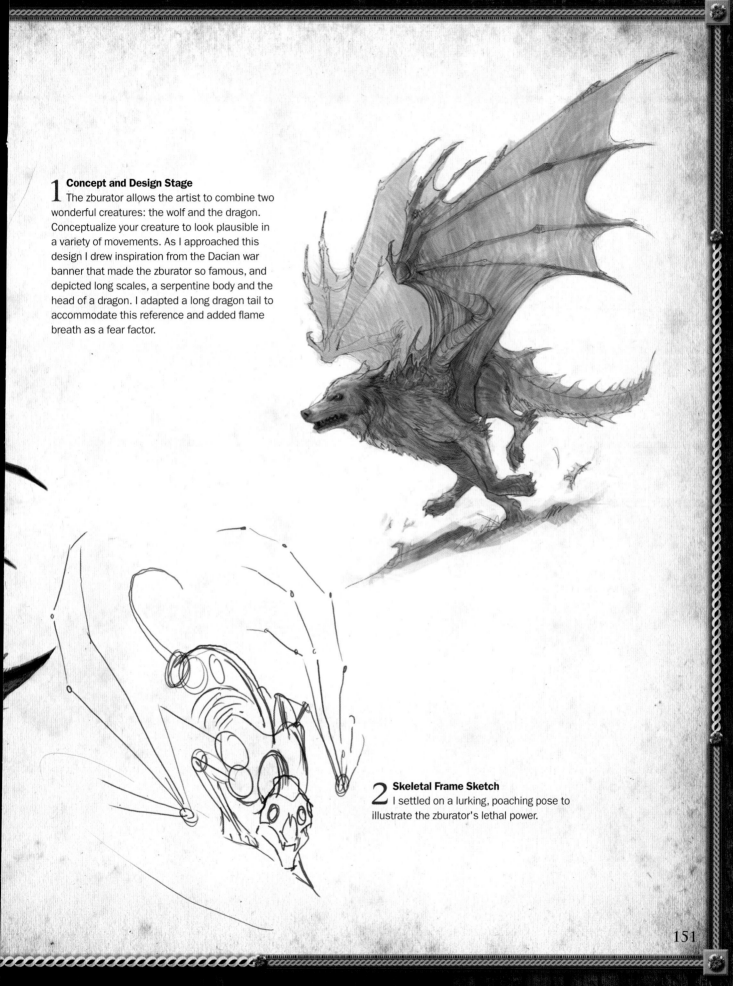

1 Concept and Design Stage
The zburator allows the artist to combine two wonderful creatures: the wolf and the dragon. Conceptualize your creature to look plausible in a variety of movements. As I approached this design I drew inspiration from the Dacian war banner that made the zburator so famous, and depicted long scales, a serpentine body and the head of a dragon. I adapted a long dragon tail to accommodate this reference and added flame breath as a fear factor.

2 Skeletal Frame Sketch
I settled on a lurking, poaching pose to illustrate the zburator's lethal power.

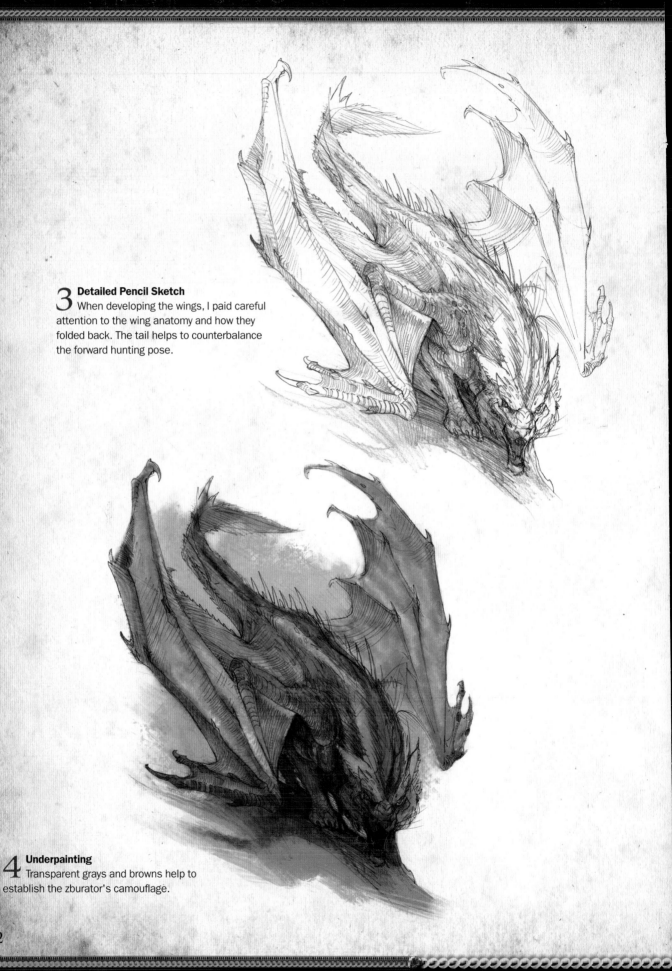

3 Detailed Pencil Sketch

When developing the wings, I paid careful attention to the wing anatomy and how they folded back. The tail helps to counterbalance the forward hunting pose.

4 Underpainting

Transparent grays and browns help to establish the zburator's camouflage.

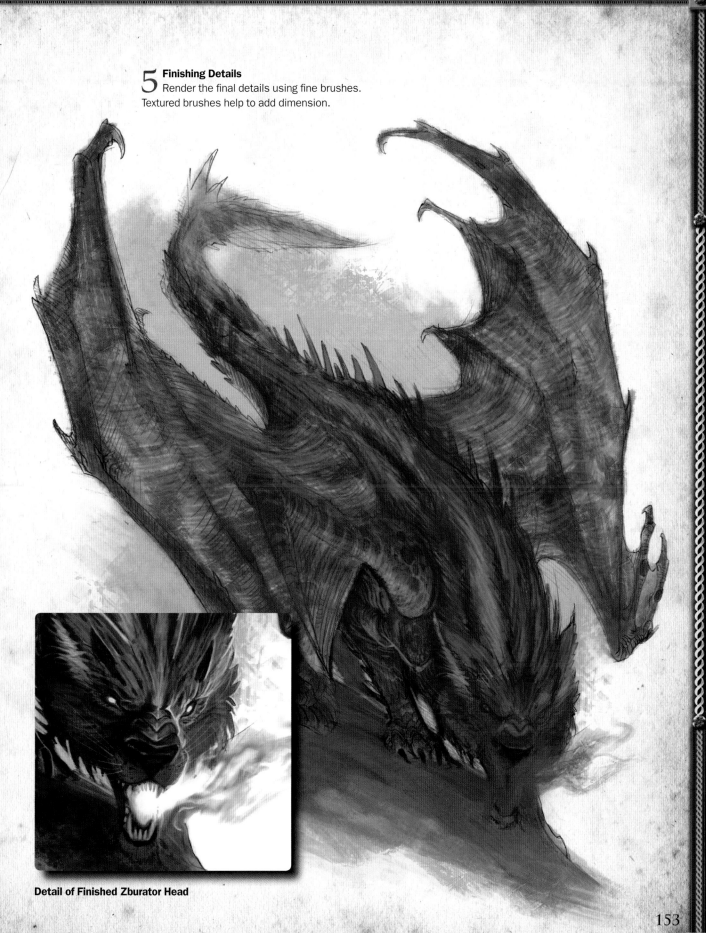

5 **Finishing Details**
Render the final details using fine brushes.
Textured brushes help to add dimension.

Detail of Finished Zburator Head

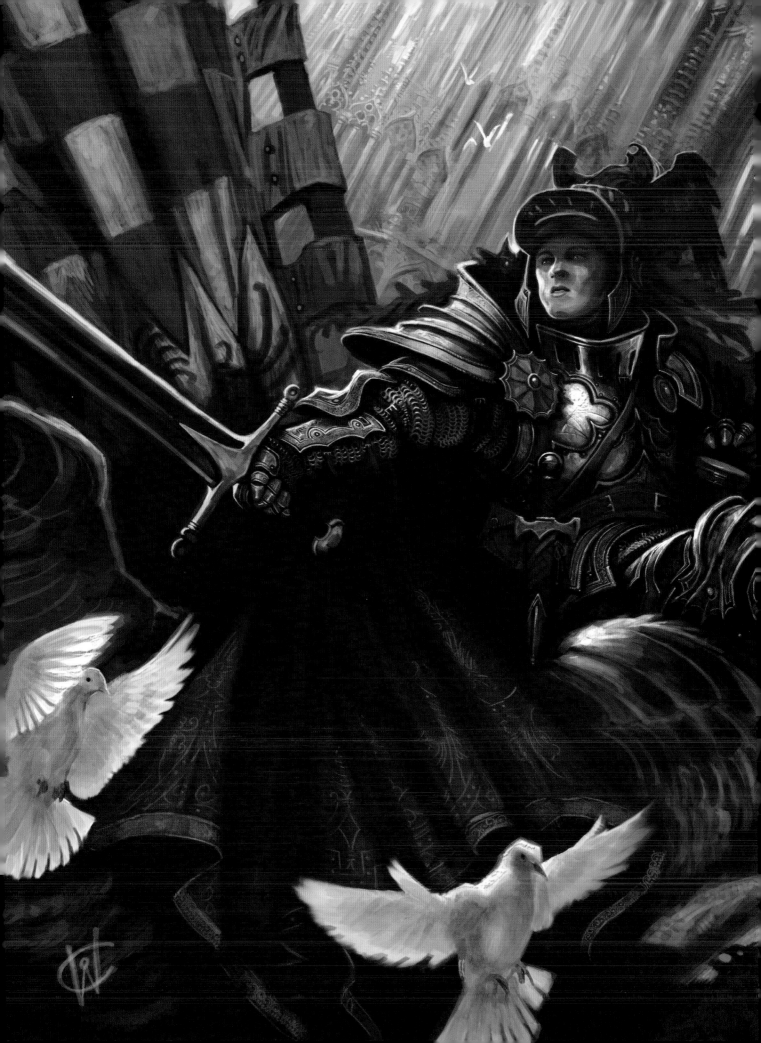

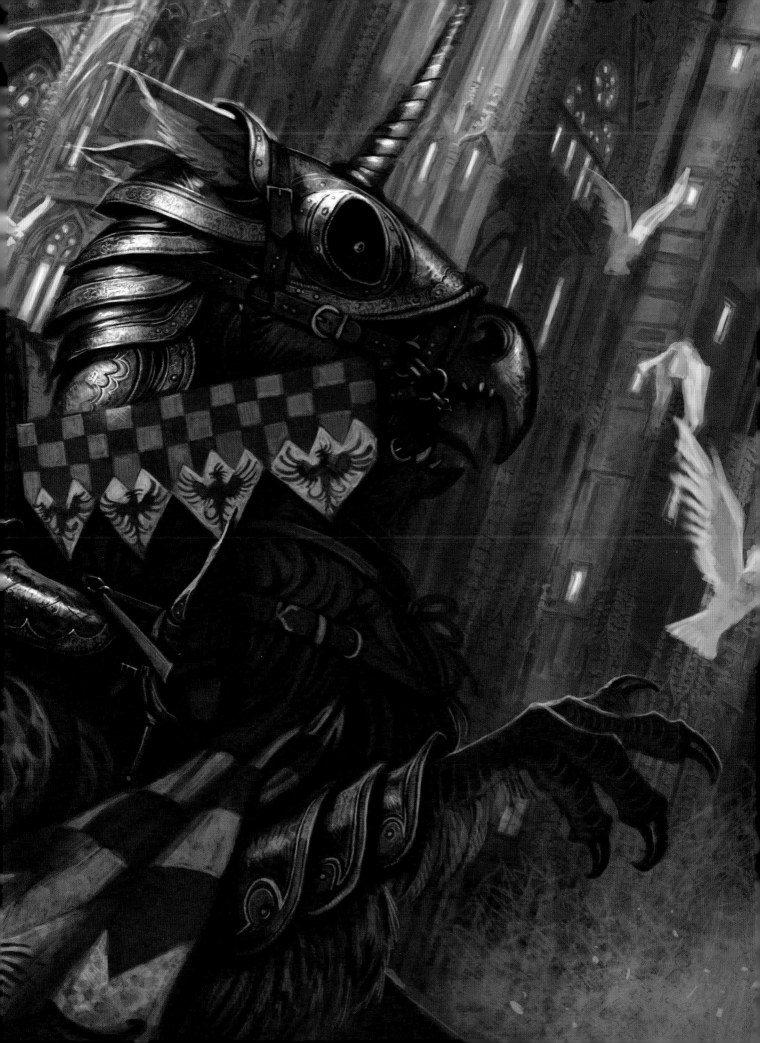

INDEX

Abominable Snowman, 143
Alphyn, 14–19
Animal anatomy, 12–13
Armor. *See* Plating

Basilisk, 117
Batutut, 143
Bestiaries, 6
Bigfoot, 143
Brushes, digital, 10
Buraq, 20–25, 53

Camouflage, 103, 119, 153
Chimera, 26–31
Claws, 64, 86, 102
Color palette, digital, 8, 11
Crowns, 22
Cryptozoology, 6

Dragon Turtle, 32–35

Enfield, 36–39

Fairies, 59
Feathers. *See* Plumage
Fins, 135
Fire, breathing, 29, 151
Freybug, 40–43

Giant Squid. *See* Kraken
Griffin, 44–51, 95, 111

Hellhound, 41
Heraldry, 15, 45, 89, 111, 121, 133
Highlights, 19
Hippocamp, 133
Hippogriff, 45, 52–57, 95
Horns, 22, 42, 60, 123, 145

Imp, 58–61, 127

Jorogumo, 62–65

Kraken, 66–71, 133

Lamassu, 21
Leviathan, 72–77
Lines, drawing, 8

Manes, 17, 22, 56
Manticore, 78–83
Mark-making, 8
Medium, selection of, 8
Morphology, 6
Mythology
 African, 59
 American Indian, 63
 Arabian, 45, 105
 Buddhist, 85
 Chinese, 33
 Egyptian, 45
 European, 15, 37, 41, 45, 53, 117,
 121, 127, 133
 Germanic, 59, 139
 Greek, 27, 45, 63, 95, 133
 Hindu, 85
 Japanese, 63, 139
 Native American, 89, 105
 Persian, 21, 79, 111
 Roman, 45
 Romanian, 149
 South American, 59

Naga, 84–87

Owlursus, 88–93

Pegasus, 53, 94–97
Pencils, 8
Photoshop, 8, 10–11

Plating, 42, 68, 118, 141
Plumage, 22, 55, 91–92, 96, 108, 114

Questing Beast, 98–103

Reference material, 9
Roc, 104–109

Sasquatch, 143
Scales, 86, 141, 151
Shadows, 19
Shedu, 21, 45, 110–115
Sketchbooks, 8
Sphynx, 79
Spikes, 42, 118, 141

Tails, 17, 48, 113, 151
Tarasque, 116–119
Templates, 12–13
Tentacles, 70
Tools
 digital, 10–11
 for drawing, 8
Totems, 89
Turtle shell, 34–35
Tusks, 145

Unicorn, 120–125

Vampire, 126–131

Warg, 41
Waterhorse, 132–137
Wings, 29, 38–39, 50, 61, 82, 96,
 107–108, 115, 130

Xenobeast, 138–141

Yeti, 142–147

Zburator, 148–153

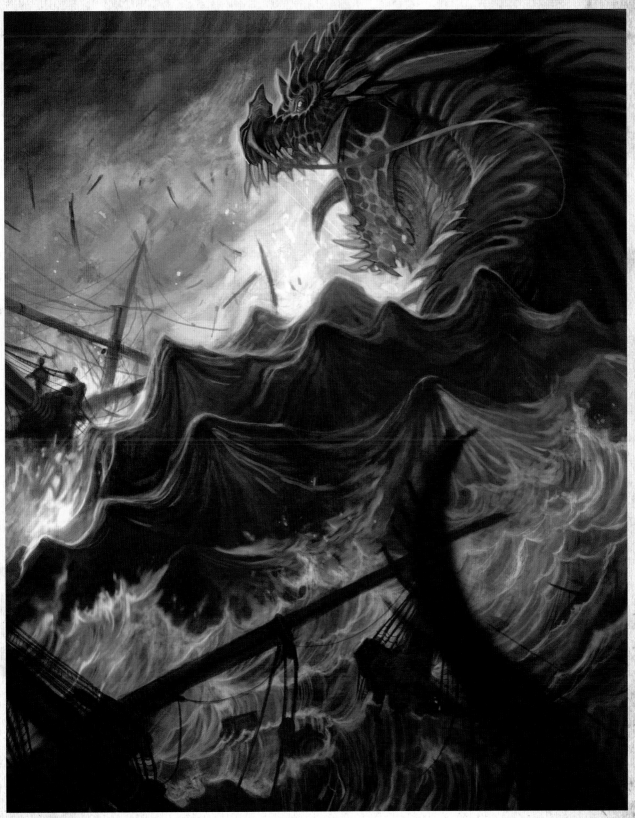

Dragon Turtle
Digital
18" × 12" (46cm × 30cm)

ABOUT THE AUTHOR

William O'Connor has been drawing monsters and dragons since he was a little boy, so he decided to make a career out of it. William is the artist of over 3,000 published illustrations for games, books and advertising over the past 20 years. Winning more than 30 awards for his work, William has contributed to *Spectrum: The Best in Contemporary Fantastic Art* seven times and has been nominated for several Chesley Awards for outstanding work in the field of fantasy illustration. Other titles in his bestselling *Dracopedia* series include *Dracopedia* and *Dracopedia: The Great Dragons*. Visit his website at wocstudios.com.

ACKNOWLEDGMENTS

I'd like to thank all the wonderful people at IMPACT Books who helped with this book, especially Sarah Laichas, Pam Wissman and Wendy Dunning for working under a difficult schedule. Jeff Menges for access to his archive of historical reference, Christina Yoder for her excellent sculpting skills and Jon Schindehette for the inspiration to make the bestiary.

fw media

Other fine IMPACT Books are available from your favorite bookstore, art supply store or online supplier. Visit our website at fwmedia.com.

17 16 15 14 13 5 4 3 2 1

DISTRIBUTED IN CANADA BY FRASER DIRECT
100 Armstrong Avenue
Georgetown, ON, Canada L7G 5S4
Tel: (905) 877-4411

DISTRIBUTED IN THE U.K. AND EUROPE
BY F&W MEDIA INTERNATIONAL, LTD
Brunel House, Forde Close, Newton Abbot, TQ12 4PU, UK
Tel: (+44) 1626 323200, Fax: (+44) 1626 323319
Email: enquiries@fwmedia.com

DISTRIBUTED IN AUSTRALIA BY CAPRICORN LINK
P.O. Box 704, S. Windsor NSW, 2756 Australia
Tel: (02) 4560 1600; Fax: (02) 4577 5288
Email: books@capricornlink.com.au

Edited by Sarah Laichas
Designed by Elyse Schwanke
Cover designed by Wendy Dunning
Production coordinated by Mark Griffin

Art on page 2:
Bellerophon
Digital
12" × 16" (30cm × 41cm)

Art on page 154:
Hippogriff Rider
Digital
13" × 19" (33cm × 48cm)

METRIC CONVERSION CHART

To convert	to	multiply by
Inches	Centimeters	2.54
Centimeters	Inches	0.4
Feet	Centimeters	30.5
Centimeters	Feet	0.03
Yards	Meters	0.9
Meters	Yards	1.1

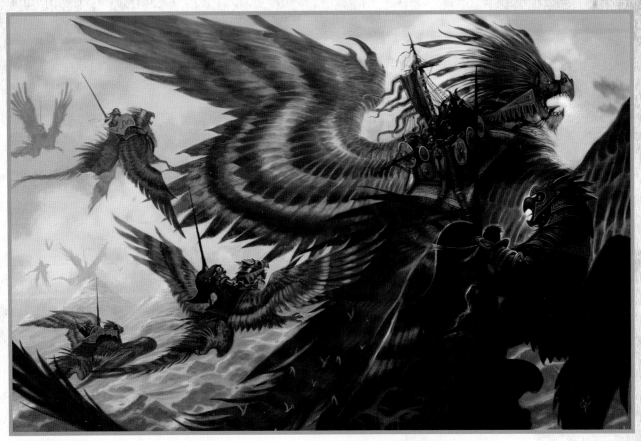

Roc Rider
Digital
14" × 22" (36cm × 56cm)

DEDICATION
For William

 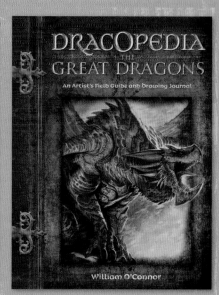

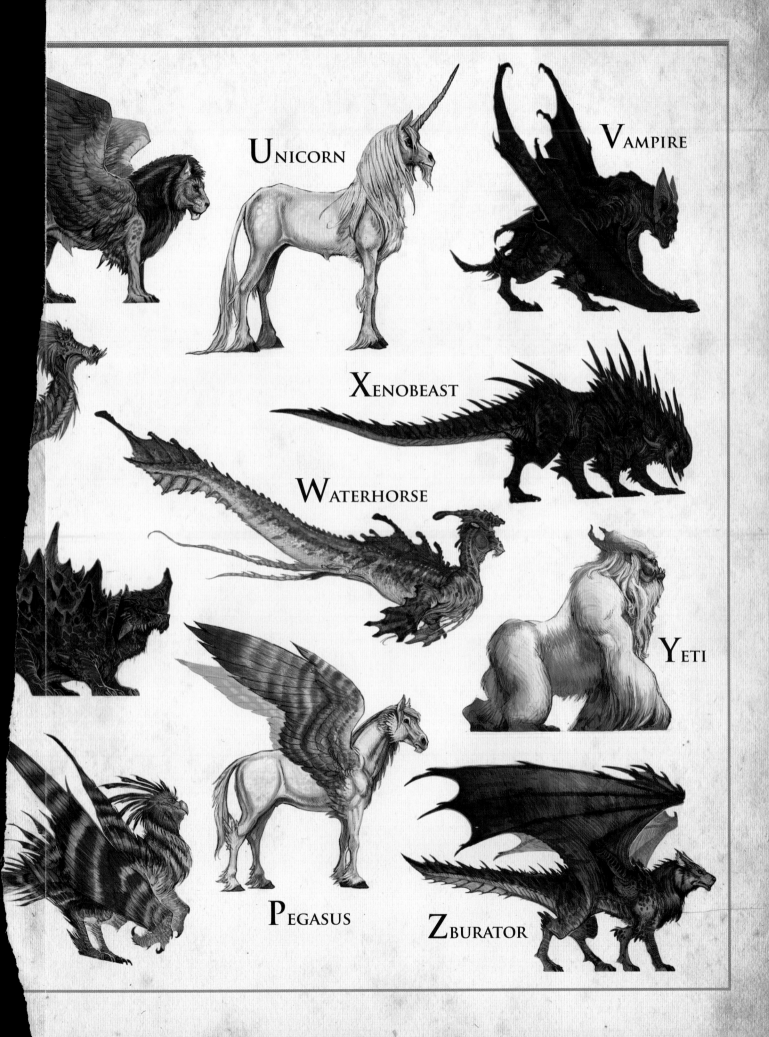

UNICORN

VAMPIRE

XENOBEAST

WATERHORSE

YETI

PEGASUS

ZBURATOR

LAND

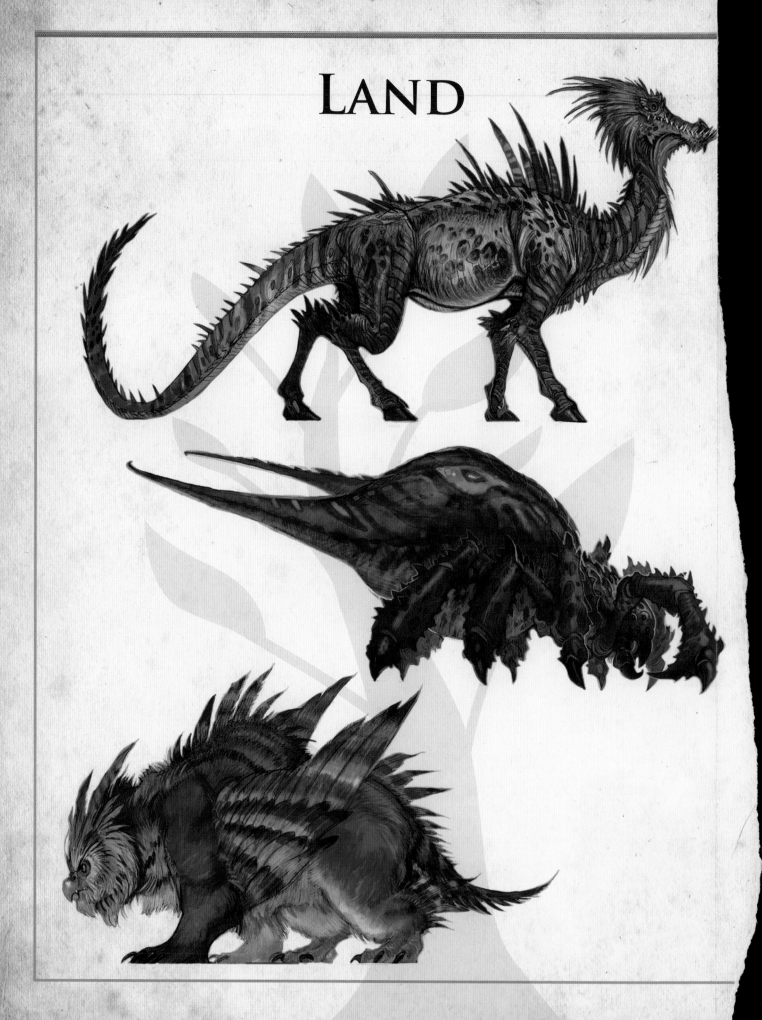

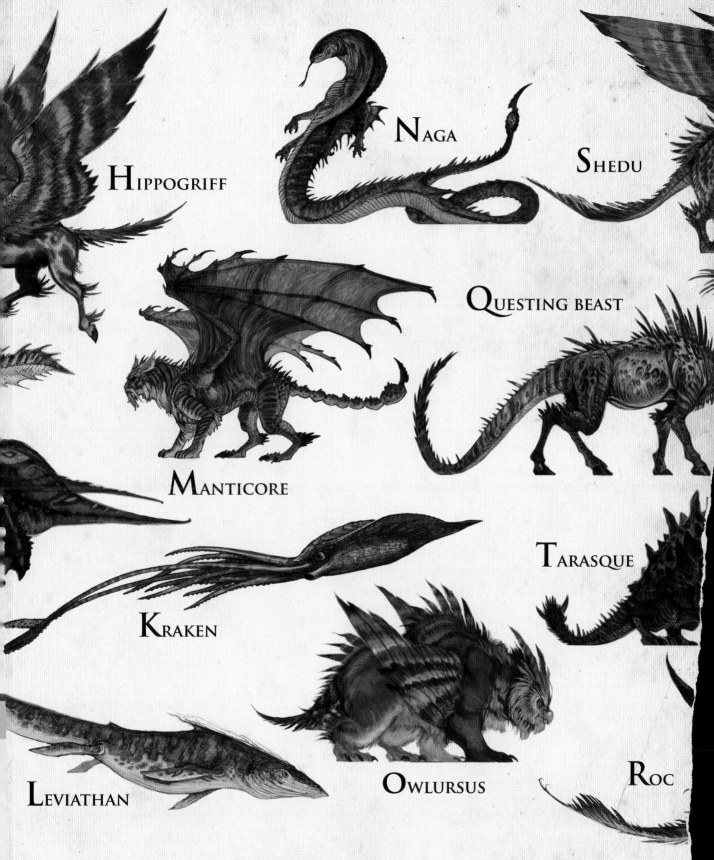

HIPPOGRIFF

NAGA

SHEDU

QUESTING BEAST

MANTICORE

TARASQUE

KRAKEN

OWLURSUS

ROC

LEVIATHAN

BEASTS OF THE WORLD

AIR

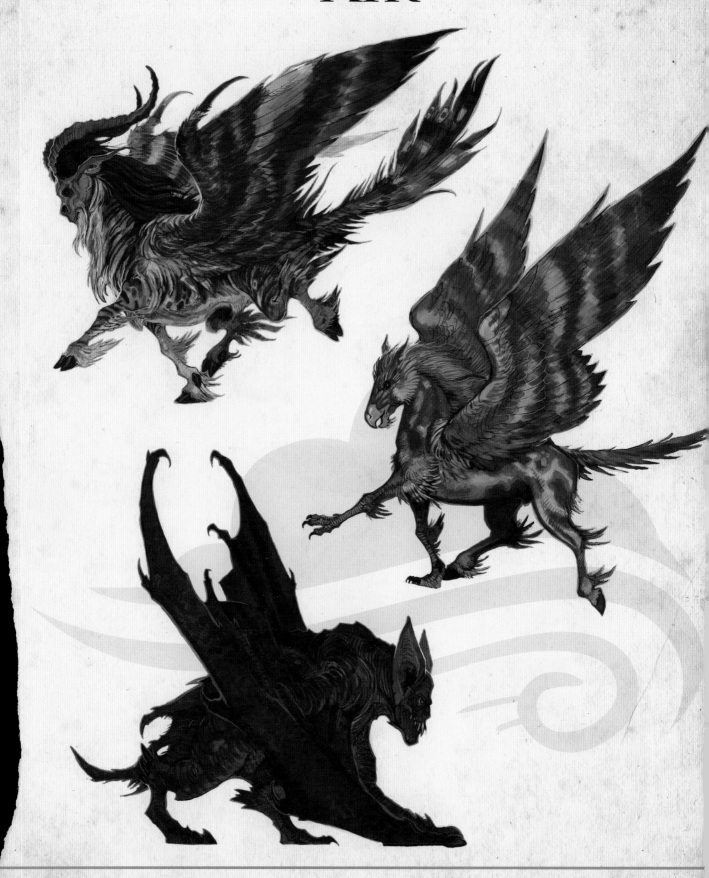

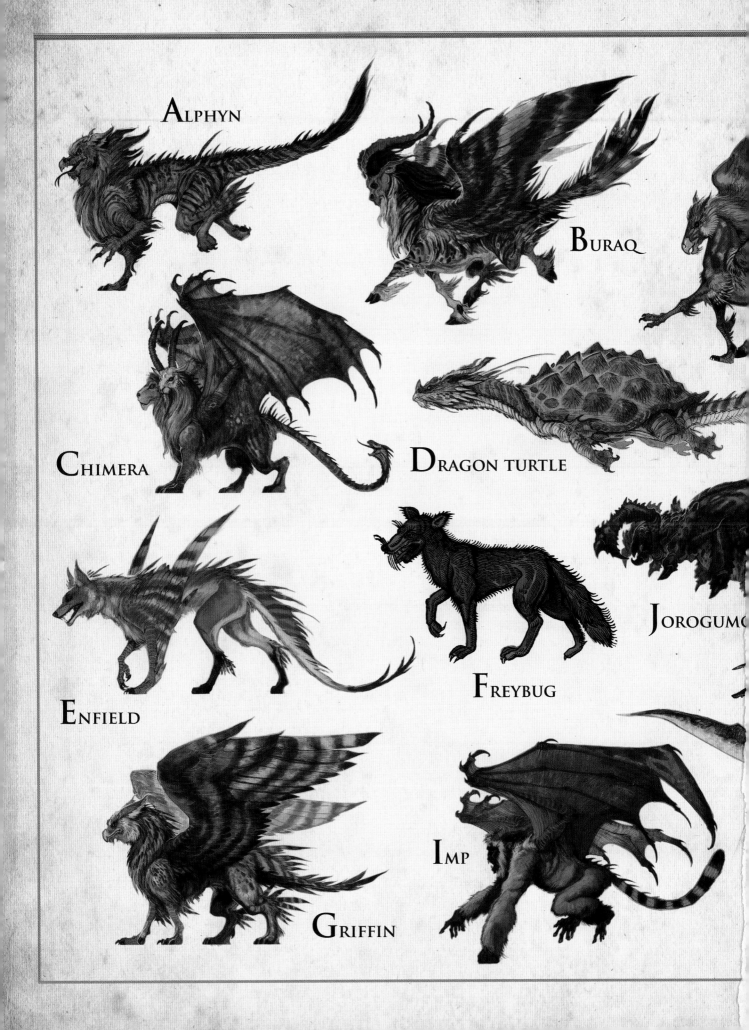

ALPHYN

BURAQ

CHIMERA

DRAGON TURTLE

ENFIELD

FREYBUG

JOROGUMO

GRIFFIN

IMP

SEA

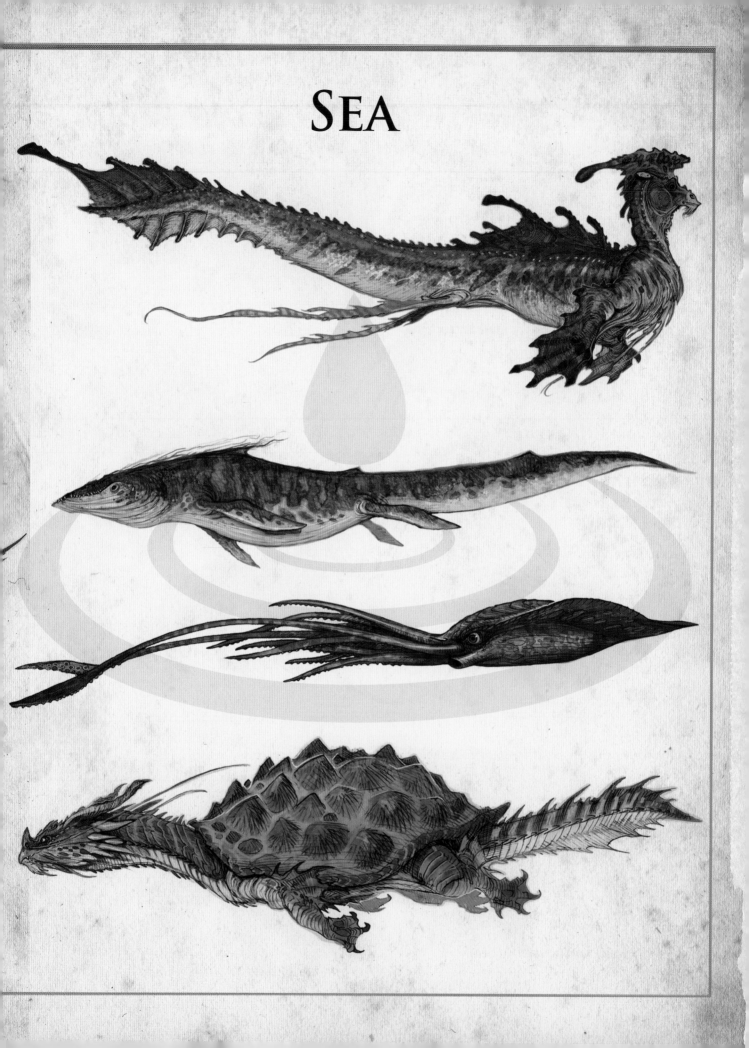